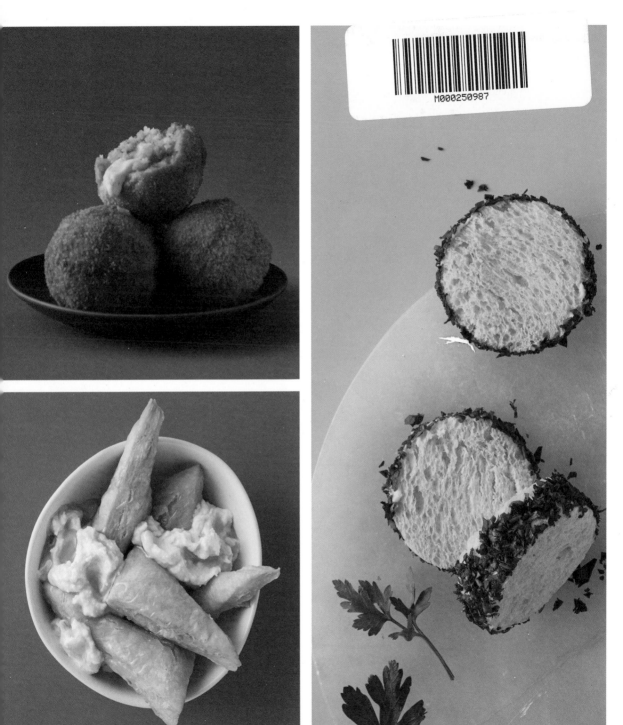

BAR MENU

100+ Drinking Food Recipes
for Cocktail Hours at Home

ANDRÉ DARLINGTON
co-author of *Booze & Vinyl*

PHOTOGRAPHY BY
NEAL SANTOS

RUNNING PRESS
PHILADELPHIA

Running Press
Hachette Book Group
1290 Avenue of the Americas, New York, NY 10104
www.runningpress.com
@Running_Press

Printed in Singapore

First Edition: October 2022

Published by Running Press, an imprint of Perseus Books, LLC, a subsidiary
of Hachette Book Group, Inc. The Running Press name and logo are trademarks
of the Hachette Book Group.

The Hachette Speakers Bureau provides a wide range of authors for
speaking events. To find out more, go to www.hachettespeakersbureau.com
or call (866) 376-6591.

The publisher is not responsible for websites (or their content) that are not
owned by the publisher.

Print book cover and interior design by Josh McDonnell.

Library of Congress Control Number: 2022930288

ISBNs: 978-0-7624-7436-3 (hardcover); 978-0-7624-7437-0 (ebook)

COS

10 9 8 7 6 5 4 3 2 1

Contents

Introduction xiii
The New Cocktail Kitchen xvi
How to Use This Book xvii
Pairing Cocktails & Food xviii
Quick Food & Cocktail Pairings xxii

CHAPTER 1
Quick Starts: Nuts, Olives,
Popcorn, Chips 1

Fried Peanuts and Lime Leaves 4
Smoky Rosemary Almonds 6
American Cocktail Pecans 7
Deviled Cashews 8
Persian Saffron Pistachios 9
Angostura Ricotta-Stuffed Dates 10
Citrus and Fennel Olives 11
Crunchy North African Chickpeas 13
Zesty Chili Popcorn 14
Jamón Serrano Potato Chips 15
Harissa Plantain Chips 17
Salt and Vinegar Lotus Root Chips 18
Hurried Bhel Puri
 (Savory Indian Snack) 19

CHAPTER 2
Fruits, Vegetables, Legumes 21

Boozy Watermelon Slices with
 Tajín and Lime 24
Kombu Cucumber 25
Edamame with Pecorino
 and Caraway 27
Rohkostplatte
 (a.k.a. Quick-Pickled Vegetables) 28
Miso–Malt Vinegar Shishito Peppers 29
Eggplant Caviar 30
Seedy Guacamole 31
White Bean Dip with
 Herbes de Provence 32
Indonesian Potato Salad 34
Smoky Spanish Mushrooms 35
Japanese Enoki
 Mushroom–Bacon Rolls 36
Fried Artichokes with
 Lemon and Mint 37
Crispy Eggplant Fries with Honey 38
Cauliflower "Wings" with
 Gochujang Sauce 40
Greek Tomato Fritters 41
Cuban Chickpea Fritters
 with Avocado Dipping Sauce 42
Red Devils
 (Thai-Inflected Hush Puppies) 43

CHAPTER 3
Cheese and Dairy 45

Frico Manchego 48
Sweet-and-Sour Burrata 49
Sky Cheese 50
The Cheese Ball, Reimagined 52
Liptauer Cheese 54
Fried Halloumi with Carob Syrup 55
Queso Frito with
 Guava Dipping Sauce 57
Fergese (Feta Fondue) 58
Blue Corn Quesadillas 59
Shepherd's Bulz
 (Cheese-Stuffed Polenta) 61

CHAPTER 4
Eggs 63

Cocktail Ramen Eggs 66
Pickled Eggs 67
Kuku Sabzi (Herbed Frittata) 69
Goji Jeon (Beef-Egg Pancakes) 70
Cacio e Pepe Frittata 72
Rolex (Breakfast Egg Wrap) 73

CHAPTER 5
Sandwiches 75

Strawberry-Ham Bocaditos 78
James Beard's Onion Cocktail
 Sandwiches 79
Balik Ekmek (Fish Sandwich) 81
Vada Pav (Potato Slider) 82

CHAPTER 6
Seafood 85

Gilda (Spanish Pintxo) 88
Crudo 89
Ceviche 90
Gin-Cured Gravlax 92
Swordfish Spiedini 93
Cocktail Pâté 94
Piri-Piri Shrimp Cocktail 95
Pickled Shrimp 97
Potted Shrimp 98
Génépy Trout Rillette 100
Cornmeal-Encrusted Oysters 101
Fried Mussels with
 Aleppo Pepper Sauce 102
Salt Cod Fritters 103
Sichuan-ish Salmon 105

CHAPTER 7
Poultry 107

Toki Chicken Nuggets 110
Georgian Chicken Salad 112
Vietnamese Chicken Wings 113
Butter Chicken Wings 114
Turkey Tsukune (Meatballs) 117

CHAPTER 8
Meat 119

Chorizo in Cider 122
Pho Marrow Bones 123
Cuban Ham Croquettes 125
Seven-Year Pork Belly 126
Beef Negimaki 129
Italian Riviera Meatballs 130
Cherry Kofte 132
Cevapcici (Sausage) 133
Vietnamese Lemongrass Skewers 134
Filipino-Style Barbecue
 Pork Skewers 135
Sticky Flanken Ribs 137
Ropa Vieja 138
Singapore Steamboat 140
Bak Kut Teh (Pork Rib Broth) 141
Monkey Gland Sauce 142

CHAPTER 9
Rice 145

Everything Onigiri 148
Calas 149
Buffalo Supplì 152
Smoked Jollof Rice 154

CHAPTER 10
Crackers, Biscuits, Dumplings, Noodles, and Bread 157

Fry Jacks with
 Honey-Whipped Ricotta 160
Festival (Jamaican Dumplings) 161
Fig & Blue Cheese Biscuit Coins 163
Jalapeño-Corn Sablés 164
Garam Masala Cocktail Puffs 166
The Cracker 167
Farinata with Blistered Tomatoes 168
Crispy Flatbread 170
Orange Pan con Tomate 171
Momos (Tibetan Dumplings) 172
Spaghetti Kee Mao 173
Soba Noodles 175

CHAPTER 11
Dessert
177

Oleo-Saccharum Sorbet 180
Negroni Panna Cotta 181
Mezcal Pudding 182
Almond, Date, and Fig Balls 183
Ginger "Schnapps" 185
Old-Fashioned Pralines 186
Apple Tansy 187
African Ginger Cakes 189
Semolina Cake in Boozy Syrup 190
Coconut-Cardamom Cake 191
Piña Colada Upside-Down Cake 192
Caribbean Black Cake 194
Chocolate Manhattan Cake 196

Party Menus 198
Pantry Essentials & Key Equipment 200
Cocktail Techniques 206
Select Bibliography 208
Index 209
Acknowledgments 218

Food is the curse of the drinking classes.

—Kingsley Amis

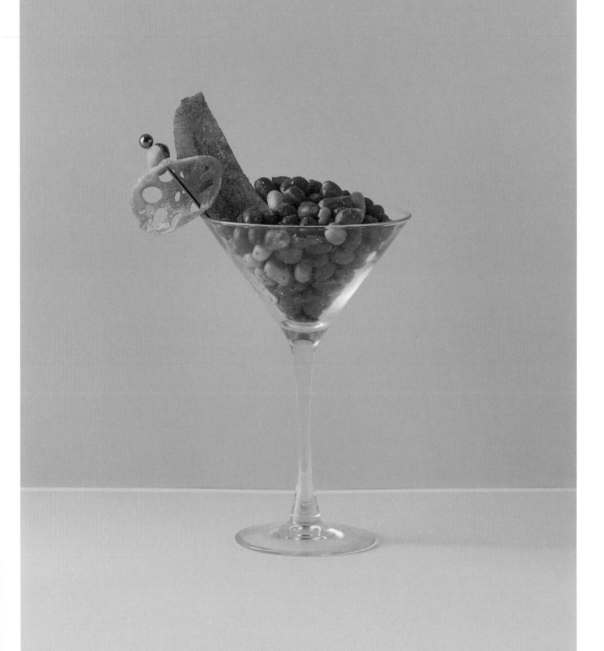

Introduction

I grew up at the end of the in-home hors d'oeuvre and canapés age, a time when middle-class Americans threw rather formal cocktail parties regularly. Such hospitality was part of the social fabric of the country in those days, an extended era of civilized entertaining that followed World War II. This culture was accentuated in my household, I believe, because my father was a concert violinist. My childhood featured many a postperformance buffet and light luncheon; weekends were a profusion of toothpicked meat, balled melon, and stuffed mushrooms. There were mousses and savory gelatin molds, deviled eggs, liver pâtés, and all manner of things folded into puff pastry. It was a world where musicians and the etiquette-inclined still wore tuxedos and gowns. I spent hours hovering awkwardly at these parties, trying to avoid conversation and grabbing handfuls of cocktail nuts—those giant Brazil nuts being the most prized.

The post–World War II cocktail party boom had its own bible—James Beard's book *Hors d'Oeuvre and Canapés*—a well-worn tome that competed with my mother's dog-eared copy of *The West Point Hostess* (my father was stationed at West Point during the Vietnam War). It was a timeless world with equally timeless cocktail foods that existed, as Beard points out in his introduction, outside the bounds of any traditional meal; the formal cocktail party was its own creature, and the foods found at such events were not to be confused with appetizers. This was decorative stuff, requiring hours of prep or a professional caterer.

Radical change was afoot in America, however, and soon our household was transported to a new epicurean realm that included the earthy *Moosewood Cookbook*, as well as worldly recipes from books and TV shows by the likes of Madhur Jaffrey and Martin Yan. We began going out for sushi and started cooking Indian and Chinese regularly. But if the era of the cocktail party came in with a bourgeois bang, it went out quite ignominiously in the late 1980s with a spinach dip whimper. (Although, as if in a hat tip to the wit of the bygone era, the latter was at least cleverly served in its own edible bread bowl.) Nowadays, the frozen section of Trader Joe's has likely taken over the prep responsibilities for the home cocktail parties that I remember from my childhood. Piping shrimp mousse into choux pastry? Who has the time or inclination?

But this is not to say the cocktail party ceased; the highly ritualized version simply morphed into something far more casual . . . but also more adventuresome. In fact, a renewed interest in cocktails has led to a return to quality and chefiness in mixed

drinks. As tastes have become increasingly more global over the past twenty years, drinking and dining has grown more thrilling and experiential. In fact, it is hard to tell whether the formal cocktail party has disappeared or the small bites style that once pervaded homes simply metastasized and took over restaurants. How is a contemporary, loud, and convivial restaurant serving intriguing small plates alongside rapid-fire mixed drinks any different from the cocktail party of yore—except that the guests are seated and don't know one another?

Our age is food- and cocktail-obsessed, but at the same time allergic to the word *entertaining*. Today, if you serve a classic cocktail sandwich, you had better be hosting a Prohibition party. Yet, if fussy finger foods are out, then what is in? The answer is: whatever people want. Gatherings have become unfettered affairs; I've been served cocktails with takeout, instant-cooker meals, pizza, and sheet-pan roasted veggies. The flavors have changed as well; instead of bland and predictable nibbles, cocktail foods have been ignited by the bold and unexpected. You will find hot peppers, kimchi, tahini, finger limes, chorizo, lemongrass, miso, and more. If this all sounds exactly opposite of the old never-let-anything-ruin-a-shirt world, it is. Today, if you serve Thai lettuce wraps—meant to be eaten sans utensils while juice runs down guests' arms—the fete will be a rousing success.

I have been hosting what James Beard would still recognize as "cocktail parties" during these meteoric changes in style and substance over the past couple of decades. Cocktails are now better than ever, taking center stage at home parties—no longer overshadowed by caviar and crème fraîche on cucumber slices. This has been a welcome change to true imbibers, who now get to focus on their liquor quality and garnishes rather than canapés. Bars and restaurants have proven that cocktail snacks can include both the familiar (updated deviled eggs) and the exotic (lotus root chips). If the American home kitchen has seen radical change over the past twenty years, so, too, has the American cocktail party kitchen.

Along with the country's renewed interest in mixed drinks, there has been a substantial sea change in the perception of cocktails' worthiness to pair with food. There used to be a pervasive school of thought that insisted cocktails ruined the palate for the more important wine that followed. This prejudice is happily a thing of the past. These days, a flavor-blasted Negroni is as likely to start a meal as a wan vodka soda. Diners and guests can now drink cocktails throughout the meal without feeling compelled to ever switch to wine. At the very

least, things are on a more equal footing. This change has opened an entirely new field of discovery that is still in its infancy.

Like my cocktail parties, this book is a raucous celebration of those once-taboo items—such as fish sauce, spicy peppers, and excessive garlic—becoming not only allowable, but encouraged. I remember the cocktail parties of my childhood not for the sumptuous food (although there was that), but as anxiety-producing events. For that reason, this book is short on hosting tips and long on simple, showstopping dishes that will pull you through any happy hour with success, because, well, you will be bringing joy to those around you. In this guide, I offer some updated familiar classics, sure, but many of the recipes are global dishes I've discovered on my travels (see my book *Booze Cruise*) that work perfectly with mixed drinks. Think of this as a compilation of my life in the cocktail party kitchen. I promise that, like all inveterate cocktailers, I have a healthy appreciation for dishes that I can make with a martini in one hand and a lazy eye on the food prep—so know that if one of these recipes requires a few steps, it will be absolutely worth it. Most of all, I hope this book encourages you to do whatever you damn well please—I'm simply offering a few helpful ways I've found to do just that.

The New Cocktail Kitchen

When Mrs. Julius S. Walsh Jr. of St. Louis, Missouri, hosted one of the first cocktail parties on record in the spring of 1917, she could not have predicted that her gathering would spark a trend that would become ritualized around the globe. She also had no way of knowing that, three years later, alcohol would be banned in the United States, forcing cocktails into precisely the kind of crowded private party atmosphere where convivial conversation and passed snacks mingled. In fact, we have Prohibition to thank for the development of American finger foods—those small items served to inebriated speakeasy customers, such as deviled eggs, radish roses, shrimp toasts, and cheese balls. Sending cocktails underground did not stop the drinking; it blurred the lines between bar and home, making cocktail parties fashionable. In those Prohibition years, the public learned how to mix their favorite libations—for the simple reason that everyone was making drinks at home.

We live in oddly similar times, when home enthusiasts are participating in cocktail culture as much as passively receiving it. But the cocktailer's kitchen has changed radically from our recent past. Now, a few tools of the mixologist's trade are helpful to create mixed drinks as we know them today (see page 204 for equipment suggestions) and pillaging both the spice cabinet and pantry for inspiration has become more the norm than the exception (see page 201 for pantry essentials). And, over the next few years we may see the addition of even more equipment, such as sous vide setups, dehydrators, and cocktail smokers; for the most part, I've avoided using such items in this book. The most striking change, however, is that as the craft cocktail renaissance continues to spread around the world, each culture is coming up with local foods that work as cocktail bar snacks. It's an exciting time, and we don't yet know all the dishes that will emerge. But what we can be sure of is that tired old bruschetta is out and *vada pav* (page 82) is in.

How to Use This Book

Most books devoted to cocktail fare are organized in one of three ways: dividing dips from canapés, proceeding from small nibbles to larger plates, or dividing cold starters from hot. I've done away with all that, relying on a taxonomy that is closer to a cookbook. It is more advantageous these days to be able to choose and find a regional flavor, or a base spirit, or a vegetarian option than the format, size, or temperature of the cuisine. But while today's cocktail party is a delightful free-for-all, that doesn't mean a book has to be unnavigable. Clearly demarcated sections will give quick access to recipes. You'll find a few sidebars sprinkled around the book that give additional information on interesting cocktailing topics. And while we're on the subject, there are a number of cocktail recipes accompanying pair-worthy food recipes; rather than have a separate cocktail section, I've placed them where I thought they'd provide you with instant inspiration. I don't think fetishizing certain cocktail and food pairings—as the wine world does—is particularly helpful, but sometimes it is nice to know that Pimm's Cups were developed for oysters. A quick list is on page xxi. Also, sometimes it is helpful to have suggestions for dishes to combine for parties, and a list of menus by season and occasion is on page 198.

Pairing Cocktails & Food

The idea that cocktails fatigue the palate is a bit of outdated wisdom we are putting to rest—or at least the idea that cocktails cannot pair with food because they have too much flavor. The following are a few things I've learned about matching cocktails and food.

- **Use cocktails to enhance flavors in the food, and vice versa.**
 Whiskey and steak works, whiskey and oysters does not. Know your flavors to bring out the best in both food and drink.

- **Big flavors complement other big flavors.**
 Blue cheese loves a good cocktail because they both have intense flavors. Fats also love alcohol, so fatty foods, such as cheese and cream-based desserts, will sing an aria together with mixed drinks.

- **Acid likes more acid.**
 Try a cocktail that has plenty of citrus if you plan on pairing it with a vinaigrette. Vinegar is a cocktail—and wine—killer unless you go against it hard.

- **Sweet loves salty. And bitter.**
 Cocktails that contain Campari or other amaros are sometimes great foils for food that is sweet, such as desserts—but also salty snacks. Don't discount a Negroni with salty meat, for example.

- **The opposite of sweet is not always sour.**
 Good cocktails are often a balance of sweet and sour. But whereas the opposite of sweet for a fruit is sour, the opposite of sweet in chocolate is bitter, and the opposite of sweet in a crunchy bar snack is salty. Playing with these elements in beverage and food form will ensure fantastic complementary flavors.

- **Create flavor bridges and use your aromatics.**
 Herbs in cocktails meld well with herbs in food. Including dill in a salad? Try aquavit as a base spirit and add a little dill to the cocktail. Common herbs, such as mint and basil, make a huge difference when pairing drinks to food. Also, keep an eye on citrus. If a dish would go better with a spritz of lemon rather than lime, don't expect gimlets to be a wow pairing.

- **Pay attention to body.**
 A light cocktail is often the perfect lift for heavy food, but heavy cocktails can also be lifted by a refreshing bite.

- **Know your region.**
 Tequila will pair well with Mexican fare, vermouth will pair well with southern European dishes, and so on. If you know where your liquor and liqueurs are from, you're more than halfway to knowing what to serve alongside them.

- **When in doubt, make a sour.**
 Much of the food around the world is highly flavorful and contains a myriad of balanced elements. If you haven't tried something before, chances are it will pair with a daiquiri.

Quick Food & Cocktail Pairings

Fried Peanuts and Lime Leaves +
Honey-Ginger Daiquiri
(pages 4 and 5)

Citrus and Fennel Olives + Cynar Spritz
(pages 11 and 12)

Jamón Serrano Potato Chips + Adonis
(pages 15 and 16)

Kombu Cucumber + Sake 75
(pages 25 and 26)

White Bean Dip with Herbes de Provence +
Vermouth and Grapefruit
(pages 32 and 33)

Crispy Eggplant Fries with Honey + Big Chief
(pages 38 and 39)

The Cheese Ball, Reimagined + Ward 8
(pages 52 and 53)

Fried Halloumi with Carob Syrup +
Cypriot Brandy Sour
(pages 55 and 56)

Blue Corn Quesadillas + Colibri
(pages 59 and 60)

Goji Jeon + Soju-to
(pages 70 and 71)

James Beard's Onion Cocktail Sandwiches + JBF
(pages 79 and 80)

Vada Pav + Indian Gin Old-Fashioned
(pages 82 and 83)

Potted Shrimp + Vesper
(pages 98 and 99)

Salt Cod Fritters + Ti' Punch
(pages 103 and 104)

Toki Chicken Nuggets + Toki Highball
(pages 110 and 111)

Butter Chicken Wings + Planter's Punch
(pages 114 and 116)

Seven-Year Pork Belly + Bumbo
(page 126 and 128)

Filipino-Style Barbecue Pork Skewers + Antrim
(pages 135 and 136)

Monkey Gland Sauce + Monkey Gland
(pages 142 and 143)

Calas + Sugarcane Sazerac
(pages 149 and 150)

Smoked Jollof Rice + Zobo
(pages 154 and 151)

Festival + Wray and Ting
(pages 161 and 162)

Jalepeño-Corn Sablés + David's Derby
(pages 164 and 165)

Soba Noodles + Sake-Lillet Spritz
(pages 175 and 174)

Almond, Date, and Fig Balls + Coffee Cocktail
(pages 183 and 184)

Apple Tansy + Cider Cup No. 1
(pages 187 and 188)

Piña Colada Upside-Down Cake + Airmail
(pages 192 and 193)

CHAPTER 1

QUICK STARTS: NUTS, OLIVES, POPCORN, CHIPS

A first cocktail bite should be the beginning of an adventure. It should draw you into a story and pair well with the first sip. It doesn't have to be complicated; it just needs to transport. Whether you're sitting elbows on a bar or standing in the middle of a backyard party, a starter sets the tone and builds anticipation.

If you are hosting, you want the initial salvo to be something easy to achieve but good-looking and memorable. Here's a secret: anything you serve will be a hit if it feels spontaneous to guests. This chapter is full of quick go-to recipes that pair well with mixed drinks and also serve as excellent conversation openers. From addictive North African chickpeas to an Indian snack that can work as a meal, these recipes will kick things off right.

p 4

p 5

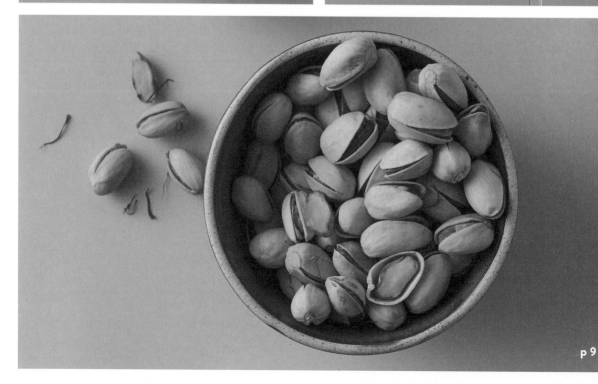

p 9

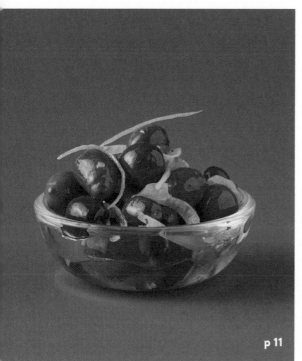

p 11

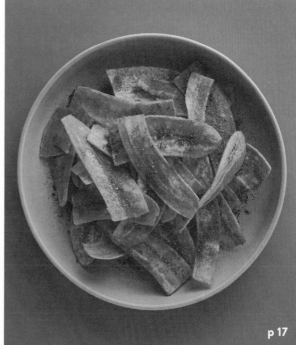

p 17

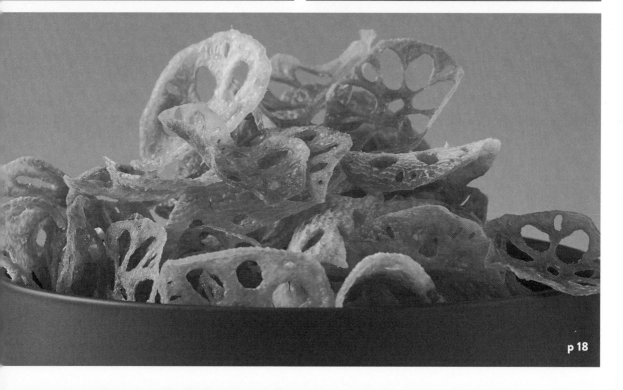

p 18

Fried Peanuts and Lime Leaves

SERVES 6

Impossibly crisp, wonderfully fragrant, and beautiful to behold, these Southeast Asian–inspired peanuts are a simple but seductive accompaniment to cocktails. Fried peanuts are found as a drinking snack all over the world, a welcome bar bite while waiting for additional food and drink to be prepared—they are the perfect salty-crunchy foil to alcohol. This bold version is particularly delicious with sours, such as daiquiris and gimlets. Note that lime leaves are widely available at Asian groceries; freeze extras for use in cocktails and curries.

2 teaspoons coriander seeds
1 teaspoon whole black peppercorns
2 teaspoons coarse sea salt
3 makrut lime leaves, sliced finely
Peanut or vegetable oil, for frying
2½ cups skin-on raw peanuts

Using a food processor or mortar and pestle, grind coriander, peppercorns, salt, and lime leaves. Transfer to a medium-size serving bowl. Heat oil (at least an inch deep) in a Dutch oven or sauce-pan to 365°F. Add half of the peanuts and cook, stirring frequently, until golden brown, about 2 minutes. Transfer peanuts to paper towels to drain. Repeat with remaining peanuts. Gently toss peanuts in the spice mixture until fully coated. Serve warm or at room temperature.

Honey-Ginger Daiquiri

Take daiquiris to the next level with this easy hack: replace the simple syrup in the standard recipe with a honey-ginger variation. With this subtle transformation, guests will be enthralled with your secret "house" version. The honey-ginger syrup adds flavor and has many other cocktail applications, such as in the famous Penicillin. It will transform a julep and even a French 75. Note that the syrup must be made a day in advance.

2 ounces light rum
1 ounce fresh lime juice
½ ounce honey-ginger syrup
Ginger coin, for garnish (if desired)

Shake ingredients with ice and strain into a cocktail glass. Garnish with a lime wheel.

HONEY-GINGER SYRUP:

1 cup water
1 (3-inch) piece fresh ginger, peeled and sliced
1 cup honey

In a small saucepan, combine water and ginger. Bring to a boil over medium-high heat; lower heat, and simmer for 5 minutes. Remove from heat and stir in honey until well combined. Pour mixture into a jar, cover, and refrigerate overnight. Strain out ginger and store honey-ginger syrup, sealed tightly, for up to 2 weeks in the refrigerator.

Smoky Rosemary Almonds

SERVES 6

Originally native to Persia, almonds eventually spread throughout the Mediterranean and on to southern Europe and North Africa. You'll frequently find them in this region of the world as part of mezes, tapas, and aperitivo spreads that accompany drinks. This complex, sweet-and-savory recipe works particularly well with the botanicals in Spanish-inspired gin and tonics as well as with Italian cocktails sporting amaro, such as Americanos and Negronis. The complex flavor of these nuts is ideal for keeping guests—or yourself—occupied while food is being prepared. They are also a hit at holiday gatherings.

2 cups whole raw almonds
2 tablespoons unsalted butter
1 tablespoon light brown sugar
1 tablespoon honey
½ teaspoon smoked paprika
1 tablespoon chopped dried rosemary
½ teaspoon kosher salt

Preheat oven to 325°F. Spread almonds evenly on a large parchment-lined baking sheet. Roast for 10 minutes and transfer to a bowl, returning the parchment to the baking sheet. In a medium-size saucepan, melt butter over medium-low heat and add brown sugar, stirring until it dissolves. Add honey, smoked paprika, rosemary, and salt; stir until well combined. Pour this mixture over the almonds and stir until coated. Spread almonds evenly in a single layer on the parchment-lined baking sheet. Roast for 20 to 30 minutes, or until golden brown. Remove from oven and allow to cool on the baking sheet before serving.

American Cocktail Pecans

SERVES 6

As the only nut native to North America, pecans occupy a special place alongside classic American libations. This recipe is likely their most classic preparation for the bar and features the venerable duo of Worcestershire and Tabasco sauce. Serve this iconic cocktail snack on Derby Day with juleps or at Thanksgiving accompanied by old-fashioneds. They are a signature delight of the United States.

2 tablespoons unsalted butter

1 tablespoon Worcestershire sauce

2 cups pecan halves

¼ teaspoon Tabasco sauce

½ teaspoon kosher salt

¼ teaspoon freshly ground black pepper

Preheat oven to 350°F. Melt butter in a medium-size saucepan over medium heat and add Worcestershire sauce. Add pecans, Tabasco, salt, and pepper; stir briefly over medium heat until nuts are coated. Transfer nut mixture to a large parchment-lined baking sheet and roast for 8 to 10 minutes, shaking the pan occasionally so the nuts cook evenly. Transfer nuts to paper towels to cool.

Deviled Cashews

SERVES 6

Cashews were a cocktail-accompanying sensation in the early twentieth century and made a grand comeback after Prohibition ended in 1933. In fact, a 1934 advertisement in the *Artistry of Mixing Drinks* claims that "no bar is up to date without them." It's hard to disagree; cashews are truly addictive—especially in this spicy, salty, and sweet preparation based on a Sri Lankan version called *kadju badun*. Pair with rum- and-gin-based cocktails.

½ teaspoon ground cumin
¼ teaspoon ground coriander
¼ teaspoon ground turmeric
¼ teaspoon cayenne pepper
1 teaspoon kosher salt
2 tablespoons unsalted butter
2 teaspoons sugar
2 cups cashews

In a medium-size bowl, combine cumin, coriander, turmeric, cayenne, and salt and set aside. In a medium-size saucepan, melt butter over medium-high heat and add sugar and cashews. Fry, stirring frequently, until cashews are beginning to darken, about 3 minutes. Transfer cashews to the bowl of spice mixture and toss until fully coated. Allow to cool before serving.

Persian Saffron Pistachios

SERVES 6

The bright color and seductive flavor of saffron provide the foil for pistachios in this magical Iranian-inspired recipe. The trick is creating a saffron brine to impart a beautiful hue and distinctive aroma. I appreciate pistachios at gatherings because, in addition to being delicious, they give guests something to do; put out a bowl of these and conversation is sure to get off to a great start—if you want to share them at all, that is. These alluring nuts pair well with gin and tonics.

¼ teaspoon saffron threads

2 tablespoons kosher salt

2 cups water

16 ounces raw, in-shell pistachios (about 4 cups)

In a medium-size stockpot, bring saffron, salt, and water to a boil. Remove from heat and pour into a large, sealable container. Add pistachios. Brine overnight at room temperature. Preheat oven to 400°F. Drain pistachios from saffron water and arrange on a wire rack set atop a large baking sheet. Roast for 10 minutes. Lower heat to 250°F and roast for an additional 20 minutes, stirring occasionally. If pistachios need additional time to dry, leave in oven off with the door slightly ajar. Remove from oven and let cool for 15 minutes before serving.

Angostura Ricotta-Stuffed Dates

MAKES 12 STUFFED DATES

Large, meaty Medjool dates provide the backdrop for a refreshing filling in this recipe based on a Middle Eastern classic. It's an irresistible combination that is also a healthy snack. Traditionally, the dates are stuffed with marzipan—but a combination of almond extract and ricotta yields a similar flavor without the hassle. These festive treats work with dry as well as sweet cocktails—equally great with a Manhattan or Jungle Bird.

12 pitted Medjool dates
½ cup ricotta cheese
1 teaspoon lemon zest
1 teaspoon sugar
½ teaspoon Angostura bitters
¼ teaspoon almond extract
1 tablespoon unsweetened shredded
 coconut, for garnish

Cut dates lengthwise on one side, opening them without separating the halves. In a small bowl, combine ricotta, lemon zest, sugar, Angostura bitters, and almond extract. Fill each date with stuffing (about ¾ teaspoon) and garnish with shredded coconut; it may be easiest to roll or dip the dates in the coconut. Dates can be stuffed in advance and refrigerated but should be served at room temperature.

Citrus and Fennel Olives

SERVES 4

Marinated olives are served all over the Mediterranean, but Italy's Amalfi Coast is the inspiration for this fetching starter. Zingy citrus and herbaceous fennel lift what otherwise might be a lackluster olive tray to something sublime. What's more, these olives don't require an overnight marinade, so they're easy to whip up before a cocktail party—or even after (oops!) guests have arrived. For an elegant look, use a channel knife to cut lemon peels and then cut the resulting spiral into inch-long pieces. Spritzes are the go-to pairing here, but other aperitivo cocktails, such as Americanos and Negronis, also partner well.

1 cup mixed olives
½ fennel bulb, sliced thinly
Peel of 1 lemon, cut into
 1-inch-long strips
½ teaspoon crushed red pepper flakes
½ cup olive oil
1 tablespoon fresh lemon juice

In a medium-size bowl, toss all ingredients to combine. Let rest at room temperature for at least 15 minutes before serving. Olives and fennel will keep for up to 4 days in the refrigerator.

Cynar Spritz

You've likely had, or at least seen, spritzes made with Aperol and Campari—both are brightly colored Italian liqueurs with a touch of bitterness. But the next time you are in the mood for an aperitivo, give dark and bittersweet Cynar a try. Made with herbs and artichokes, Cynar offers greater herbal complexity, and just might be your new favorite sipper.

2 ounces Cynar
3 ounces Prosecco
1 ounce club soda
Lemon wheel, for garnish
2 Castelvetrano olives, for garnish

Combine Cynar and Prosecco in a goblet or wineglass filled with ice. Top with club soda and garnish with a lemon wheel and olives.

Crunchy North African Chickpeas

SERVES 6

Crispy chickpeas have become a popular, modern accompaniment for cocktails; they are all crunch and flavor without the calorie payload that comes with other fried snacks. Here, they are tossed in a North African spice blend called *ras el hanout*—which roughly translates as "top of shelf" (as in, the best spices available). The handy recipe for ras el ranout is also good on chicken, fish, or dusted on grilled vegetables, such as zucchini—so consider making extra to use later. Gin-based cocktails are the go-to pairing here, although tequila works as well.

CHICKPEAS:

4 teaspoons ras el hanout
 (recipe follows)
2 (15½-ounce) cans chickpeas,
 drained and rinsed
½ cup olive oil

Place ras el hanout in a medium-size bowl and set aside. Pat chickpeas dry. Heat oil in a large skillet over medium-high heat. Working in batches so as not to overcrowd the pan, add chickpeas and sauté, stirring frequently. Fry chickpeas until they are browned and crispy, 5 to 7 minutes. Using a slotted spoon, transfer chickpeas to paper towels to dry. When mostly cooled, add them to the ras el hanout and toss to coat evenly.

RAS EL HANOUT SPICE MIX:

1 teaspoon ground cumin
½ teaspoon ground coriander
½ teaspoon ground allspice
½ teaspoon ground ginger
¼ teaspoon cayenne pepper
¼ teaspoon ground cinnamon
½ teaspoon kosher salt
½ teaspoon freshly ground black pepper

Combine all ingredients in a nonreactive bowl.

Zesty Chili Popcorn

SERVES 4

My flavored popcorn obsession began when I learned that wine importer Kermit Lynch sprinkled Provençal herbs over his popped kernels to pair better with the complementary flavors of French rosé (try it and see). After playing with variations on this theme, I found that more aggressive spice flavors work well with cocktails—cayenne, cinnamon, rosemary, and even clove. Then, I discovered the power of citrus zest on popcorn. Together, a strong spice and a hit of zest produces exceptional, showstopping popcorn. Mixed drinks based on whiskey or tequila are the ideal foil here.

⅓ cup unpopped popcorn kernels
3 tablespoons vegetable oil
1 teaspoon sea salt
2 teaspoons chili powder
Grated lime zest, for garnish

In a measuring cup, measure popcorn and pour oil over the kernels to coat. Heat a medium-size Dutch oven or saucepan over medium-high heat, add popcorn and oil, and cover with a lid. Cook for 2 to 3 minutes, shaking the pan occasionally, or until popcorn stops popping. Remove popcorn from the heat and pour into a paper bag. Add salt and chili powder; toss thoroughly until popcorn is coated. Serve in bowls topped with grated lime zest.

Jamón Serrano Potato Chips

SERVES 6

Wherever you are in the world, convenience stores sell potato chips with local flavors. Spain is no exception. I have often found myself nursing a bottle of sherry with ham-flavored chips following a late-night flight, long after restaurants have closed. The pairing reminds me of travel, and I can achieve the experience—and improve on it—at home with this recipe inspired by Basque chef Elena Arzak, who uses powdered serrano ham in her dishes. Needless to say, guests adore it. As you might imagine, "ham dust" is just as wonderful on deviled eggs (see page 66) and salads. You can also use store-bought potato chips for this recipe by heating them, but beware that the vinegar used in even non-vinegar-flavored commercial chips can overpower the ham; better to make them from scratch. The ideal pairing is sherry cocktails, such as the Bamboo and Adonis (recipe follows).

POTATO CHIPS:

2 medium-size russet potatoes, sliced thinly

2 tablespoons kosher salt

2 cups water

3 tablespoons ham dust (recipe follows)

3 cups peanut or vegetable oil

Soak potatoes in salt and water for 30 minutes, then pat dry completely. Heat oil in a medium-size Dutch oven or saucepan to 365°F. Fry a handful of chips at a time for 2 minutes, or until golden. Using a slotted spoon, transfer to paper towels or a rack. Immediately sprinkle with jamón serrano dust (recipe follows) and salt.

JAMÓN SERRANO DUST:

4 thin slices jamón serrano ham

Preheat oven to 200°F. Arrange ham slices in a single layer on a baking sheet and bake until crisp, about 1 hour. Remove from oven, blotting any moisture with a paper towel, and allow to cool. Use a food processor or spice grinder to reduce slices to a powder.

Adonis

The little-known Adonis cocktail was created in the nineteenth century and named after a popular musical. It is a delightful, low-proof showcase for sherry. Fino or Manzanilla sherry work best, combined with a quality sweet vermouth. Oils in the orange peel are expressed over the drink by squeezing it, skin side out, over the glass.

1½ ounces sherry
1½ ounces sweet vermouth
1 orange peel

Stir sherry and vermouth with ice and strain into a chilled glass. Express orange peel over top of drink and discard.

Harissa Plantain Chips

SERVES 6 TO 8

Fried plantains are one of the world's most delicious cocktail accompaniments. They are found wherever the trees grow: Africa, the Caribbean, Central and South America, and Southeast Asia. In the US, plantains are frequently employed as a crispy and tasty vehicle for guacamole and salsas—but here they stand on their own with a hearty pop of flavor. Harissa is a North African spice paste with many variations—this abbreviated recipe is a snap to assemble. Harissa's arid flavors make it a great accompaniment to rum and gin drinks.

3 green plantains, peeled

3 cups peanut or vegetable oil

2 teaspoons harissa spice blend
(recipe follows)

Cut plantains in half crosswise and use a mandoline to make thin slices lengthwise. If you don't have a mandoline, cut bananas crosswise on the diagonal into ovals. Heat oil in a Dutch oven or saucepan to 365°F. Add plantains to the hot oil without overcrowding. Fry in batches until chips are golden, 3 to 4 minutes. Remove using a slotted spoon and drain on a wire rack or plate lined with paper towels. Sprinkle liberally with harissa spice blend (recipe follows).

HARISSA SPICE BLEND:

MAKES ¼ CUP BLEND

1 tablespoon cayenne pepper

1 tablespoon ground cumin

2 teaspoons ground coriander

2 teaspoons ground caraway seeds

½ teaspoon smoked paprika

½ teaspoon garlic powder

1 teaspoon kosher salt

Stir together all ingredients in a small bowl and store, covered, at room temperature. To make into a paste for other recipes, slowly add a small amount of olive oil while stirring to combine.

Salt and Vinegar Lotus Root Chips

SERVES 4

Crispy lotus root offers a wow factor without much work. When sliced, the root reveals holes that make for an elegant, beautiful chip. This is an Asian–meets–English pub version with an acidic kick that has universal appeal. Note that lotus root is widely available in Asian grocery stores.

1 lotus root, peeled and sliced thinly
½ cup distilled white vinegar
2 cups water
3 cups peanut or vegetable oil
1 teaspoon sea salt

Submerge lotus root in vinegar and water at room temperature for at least 1 hour and up to four. Rinse, drain, and pat slices dry. Heat oil to 365°F and fry in batches until crispy and golden, 3 to 4 minutes. Let cool on a wire rack or plate lined with paper towels. Sprinkle with sea salt and serve.

Hurried Bhel Puri
(Savory Indian Snack)

SERVES 6

Bhel puri is a popular snack from the beaches outside Mumbai that has taken all of India by storm. It's easy to see why; the complex mixture is reminiscent of a wild salad with flavors and textures that are out of this world. Although the ingredient list can get quite long, this is an abbreviated version; think of the following ingredients as the bare minimum to bring bhel puri together. Feel free to use this as a guideline and make your own riff; have fun with it! At parties, I like to put out the ingredients in little bowls, like a self-serve taco station. All ingredients can be found at Indian grocery stores and online. Bhel puri is the ultimate snack with gin and tonics.

2 cups unsweetened puffed rice

1 cup spicy Indian snack mix
(such as Haldiram's Navrattan Mix)

1 tablespoon chaat masala powder

½ teaspoon kosher salt

1 large white onion, chopped finely
(about 2 cups)

2 medium-size tomatoes, chopped finely
(about 2 cups)

1 medium-size cucumber, peeled and
chopped finely (about 2½ cups)

¼ cup prepared tamarind chutney

¼ cup prepared mint chutney

2 tablespoons finely chopped fresh
cilantro leaves, for garnish

In a large bowl, combine puffed rice, snack mix, chaat masala powder, and salt. Add onion, tomato, and cucumber; stir gently until combined. Finally, add the chutneys and stir until just mixed. Garnish with cilantro and serve.

CHAPTER 2

FRUITS, VEGETABLES, LEGUMES

Once upon a time, vegetables were a rare sight in American bars; if they appeared at all, it was in a Bloody Mary. And if veggies were invited to a cocktail party, they were relegated to lowly crudités, dips, or the occasional cucumber canapé. Now, Brussels sprouts, cauliflower, green beans, shishito peppers, and even kale have become popular poster children for a new wave of veggie-centric bar bites.

Although relatively new to the US, the combination of veggies and booze is one that other food cultures have been exploring for a long time; Italy, Spain, and Japan all spring to mind as countries where a mixed drink has long been accompanied by marinated, pickled, sliced, diced, or fried veggies. This chapter collects a few classic dishes that are great drinking fare from around the world—everything from a cool cucumber dish that pairs with sake to smoky mushrooms that love sherry. Whether you're a veggie veteran or newbie, these hits offer something for every palate. I have also included a couple of my favorite fruit recipes, as well as the world's ultimate chickpea and daiquiri pairing.

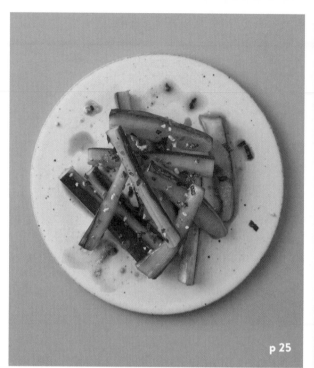

p 25

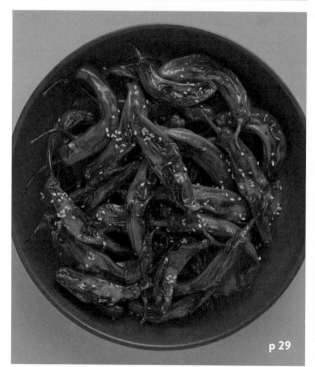

p 29

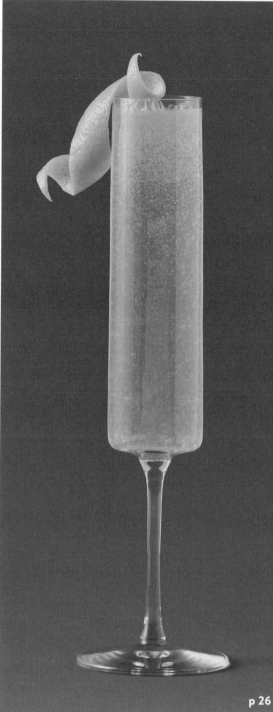

p 26

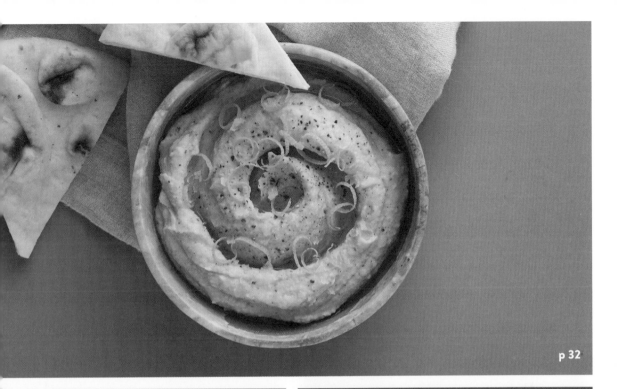

p 32

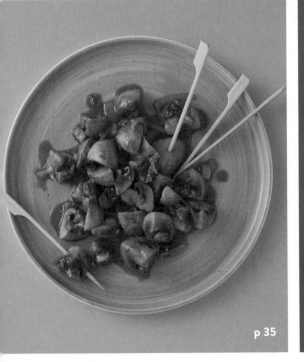

p 35

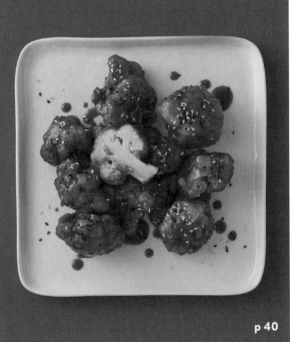

p 40

Boozy Watermelon Slices
with Tajín and Lime

SERVES 4

This is the sophisticated version of pouring a bottle of liquor into a watermelon. These melon slices are far more flavorful—essentially margaritas suspended in fruit. They are lighthearted party favorites that are a snap to prepare and work well at outdoor fetes. Tajín—a tangy Mexican condiment—is used to salt the rim on cocktails, and is a great item to have in your spice arsenal. It is widely available in Mexican grocery stores and online.

½ cup water
½ cup sugar
4 ounces tequila
2 ounces triple sec
1 small seedless watermelon, quartered
 and cut into 1-inch wedges
2 limes, cut into wedges
Tajín, for garnish

Heat water in a nonreactive saucepan to just boiling and remove from heat. Add sugar and stir until dissolved. Add tequila and triple sec. Arrange watermelon wedges in large baking dishes; pour liquid mixture over them and refrigerate for at least an hour. To serve, remove watermelon from syrup and arrange on a plate. Squeeze lime wedges over melon and garnish liberally with Tajín.

Kombu Cucumber

SERVES 4 TO 6

This cooling umami-laden appetizer is based on a celery dish at the Japanese-inspired Bar Goto in New York City. Here, cucumber takes center stage and makes for a perfect accompaniment to sake, sochu, and gin cocktails. It also makes a wonderful side for grilled meats. Furikake is a dried condiment often employed in Japanese cooking to sprinkle on rice. It is widely available at Asian grocery stores and online.

2 medium-size cucumbers, peeled
1 tablespoon toasted sesame oil
1 teaspoon soy sauce
1 tablespoon furikake

Cut cucumbers in half lengthwise and remove seeds. Cut into ½-inch-wide, 4-inch-long strips. In a medium-size bowl, toss cucumber, sesame oil, soy sauce, and furikake.

Sake 75

I love to serve French 75s as a welcome drink at my parties. Everyone loves the combination of gin, lemon, and bubbly. This twist on the classic employs sparkling sake—a fun category to explore—in place of Champagne, and is a delightful variation that rivals the original. Ideal with sushi, fried chicken, noodles, or barbecue.

1 ounce gin
¾ ounce fresh lemon juice
½ ounce simple syrup
2 ounces sparkling sake
Lemon twist, for garnish

Shake gin, lemon juice, and simple syrup with ice and strain into a cocktail glass or Champagne flute. Top with sparkling sake and garnish with a lemon twist.

Edamame with Pecorino and Caraway

SERVES 4

Need a speedy-yet-spectacular snack? This edamame (young soybean) recipe does the trick. I learned this winning flavor combination in Italy, where favas are the beans of choice with Pecorino, a hard sheep's milk cheese that is an addictive umami-bomb. Favas can be a pain to both source and prepare, but this version has all of the flavor without any of the fuss. Frozen edamame is widely available in grocery stores.

2 cups in-shell edamame
1 teaspoon caraway seeds
1 teaspoon olive oil
1 tablespoon grated pecorino cheese

Cook edamame according to package instructions; drain, and allow to cool briefly in a medium-size bowl. In a small sauté pan or skillet, toast caraway seeds over medium heat. Meanwhile, drizzle olive oil onto edamame and toss until coated. Add toasted caraway seeds and pecorino, tossing again until coated. Transfer to a serving bowl and serve with an empty bowl to collect shells.

Rohkostplatte
(a.k.a. Quick-Pickled Vegetables)
SERVES 4 TO 6

Germany and . . . vegetables? Surprisingly, I've had some of the best crudités of my life while gazing over the Rhine River. This quick-pickling marinade proves that the land of schnitzel knows what to do with a carrot. Traditionally, the assorted veggies are arranged in a pinwheel so they are especially beautiful to behold. Who knew raw and vegan could be so delicious with a martini?

MARINADE:
¼ cup rice vinegar
¼ cup olive oil
1 tablespoon minced shallot
1 tablespoon minced fresh dill
½ teaspoon salt
¼ teaspoon freshly ground black pepper
¼ teaspoon sugar

VEGETABLE PINWHEEL:
Carrots, peeled and cut into ½-inch strips
Celery stalks, cut in half lengthwise and
 into 3-inch strips
2 medium-size tomatoes, sliced
6 radishes, quartered
1 endive
8 lettuce leaves
8 cabbage leaves

Combine marinade ingredients in a bowl and then add veggies. Marinate at room temperature for 15 minutes. Arrange vegetables in a pinwheel on a platter and serve.

Miso–Malt Vinegar Shishito Peppers

SERVES 4

At some point in the 2000s, bars and restaurants in the United States went mad for shishito peppers. The peppers came prepared in all ways, slathered in everything from unctuous Caesar dressings to light lemony vinaigrettes. But it is preparation more than flavor that separates the best from the rest; shishitos that are properly blistered on the outside while retaining crunch are always winners. In Japan—where these peppers originated—they arrive smoking hot, doused in miso and mirin (rice wine). I use malt vinegar instead because the rich taste pairs well with cocktails. Be sure to dry the peppers thoroughly after rinsing them so they fry properly.

1 tablespoon white miso paste
3 tablespoons malt vinegar
2 tablespoons peanut or grapeseed oil
½ pound shishito peppers (about 24),
 rinsed and dried
½ teaspoon toasted sesame seeds,
 for garnish

In a medium-size bowl, stir together miso paste and malt vinegar until the mixture becomes a slurry. Heat oil in a large skillet over high heat. When the oil is hot, add peppers and cook for 2 minutes, shaking pan occasionally; be wary of splattering oil. Using tongs, flip peppers and cook until they are blistered all over, about 2 minutes. Transfer peppers to the bowl containing the miso mixture and stir to coat. Garnish with sesame seeds and serve.

Eggplant Caviar

SERVES 4 TO 6

The story goes that sturgeon fishermen in Russia could not afford their own catch and made an alternative eggplant topping for their bread—thus "poor man's caviar" was born. A similar dip can be found in France, where it is made with lemon and herbs. I love this recipe because it is quick to prepare, brings exotic flavor to the table, and can be made with near-infinite variations. Pair with vodka cocktails.

1 eggplant, washed and sliced in
 half lengthwise
3 tablespoons olive oil
⅛ teaspoon crushed red pepper flakes
1 cup finely chopped onion
¼ cup chopped roasted red pepper
¼ cup grated carrot
¼ cup tomato sauce
1 garlic clove, minced
½ teaspoon kosher salt
¼ teaspoon freshly ground black pepper

Preheat oven to 450°F. Cook eggplant halves, face down, on a foil-lined, rimmed baking sheet for 35 minutes. Transfer eggplant to a bowl and cover tightly with a lid or plastic wrap for 15 minutes so as to loosen skin. Heat oil in a medium-size saucepan over medium-high heat; add red pepper flakes and onion. Sweat onion until translucent, about 2 minutes. Add roasted red pepper and carrot; sauté for another 2 minutes. Remove skin from eggplant and discard; chop eggplant into 1-inch pieces. Add eggplant, tomato sauce, garlic, salt, and black pepper to the onion mixture and cook until flavors meld, about 5 minutes. Serve with flatbread or cut vegetables.

Seedy Guacamole

SERVES 4

Chef Jean-Georges Vongerichten inspired this light guacamole recipe that is encrusted with a thick layer of toasted sunflower and pumpkin seeds. The result packs a crunch that also brings out unique flavors in tequila- and mezcal-based cocktails. You have to try it to believe it. Serve with tortilla chips or The Cracker (page 167).

4 avocados, peeled and pitted
Juice of 2 limes
¼ cup finely chopped scallion
2 teaspoons finely chopped
 jalapeño pepper
1 teaspoon fine sea salt
¼ teaspoon freshly ground black pepper
6 tablespoons chopped fresh cilantro
1 tablespoon toasted sunflower seeds
1 tablespoon toasted pumpkin seeds

In a medium-size bowl, mash avocados together with lime juice. Add scallion, jalapeño, salt, black pepper, and 4 tablespoons of the cilantro. To serve, top with sunflower seeds, pumpkin seeds, and remaining 2 tablespoons of cilantro.

White Bean Dip
with Herbes de Provence

SERVES 4

A can of white beans is a lifesaver when you need a fast snack or an additional side dish for guests. It's a time-honored host secret to always have one on hand to make a classic Tuscan salad of white beans and tuna. Far more often, however, I find myself making this white bean dip for the simple reason that it is unbeatable. Why? Because every bite is different—an herbaceous wonderland, thanks to the herbes de Provence. Serve with flatbread (page 170), The Cracker (page 167), or even Farinata (page 168). Great with gin, vermouth (Vermouth and Grapefruit recipe follows), and Champagne cocktails.

½ cup minced shallot (1 to 2 shallots)

¼ cup extra-virgin olive oil

1 (15-ounce) can cannellini beans,
 drained and rinsed

1 tablespoon fresh lemon juice

1 teaspoon herbes de Provence

¼ teaspoon freshly ground black pepper

¼ teaspoon kosher salt

2 teaspoons cold water

1 teaspoon lemon zest, for garnish

Flaky sea salt, for garnish

In a sauté pan over medium heat, sweat shallot in 2 tablespoons of the olive oil until translucent. In a food processor, combine shallot, cannellini beans, lemon juice, herbes de Provence, black pepper, salt, remaining 2 tablespoons of olive oil, and the cold water. Serve topped with lemon zest and flaky sea salt.

Vermouth and Grapefruit

Vermouth is one of those misunderstood cocktail ingredients that is ever-present in drinks but too rarely consumed on its own. It's a shame, because a pour of vermouth is one of the world's greatest—and easiest—afternoon sippers. Remember to keep your vermouth cold; because it is low proof, it only lasts a couple of weeks after the bottle is opened. This dead-simple drink not only helps to use any aging vermouth you might have, but just might become your new favorite ritual.

3 ounces dry vermouth
1 grapefruit peel

Pour vermouth into a rocks glass over ice. Express grapefruit peel over the top of the drink.

Indonesian Potato Salad

SERVES 4

This recipe is inspired by my encounters with Indian and Indonesian potato salads that do not contain eggs. Instead of mayonnaise, coconut milk lends the moisture and silky texture here. Whereas many potato salads rely on celery and vinegar to provide crunch and flavor, this one pops with ginger, turmeric, mustard seeds, and fresh basil. I love ghee (clarified butter), but swap it out for coconut oil if you'd like to make this vegan. Serve with gin and tonics.

2 pounds baby red or yellow potatoes

1 shallot, roughly chopped

3 garlic cloves, roughly chopped

1 tablespoon peeled and roughly chopped fresh ginger (about a ¾-inch piece)

1 teaspoon ground turmeric

2 teaspoons black mustard seeds

½ teaspoon red pepper flakes

1 tablespoon ghee or coconut oil

⅓ cup coconut milk

½ teaspoon kosher salt

1 tablespoon fresh lemon juice

Small bunch basil leaves, shredded, for garnish

Fill a large pot halfway with water and boil potatoes until tender, about 10 minutes. Drain and let cool. In a food processor, combine shallot, garlic, ginger, turmeric, mustard seeds, and red pepper flakes. In a medium-size sauté pan over medium-high heat, heat ghee and add the shallot mixture; fry until fragrant and mustard seeds begin to pop. Transfer to a bowl large enough to fit the potatoes and stir in coconut milk, salt, and lemon juice. Cut potatoes in half and combine with mixture. Garnish with basil.

Smoky Spanish Mushrooms

SERVES 4

Out with stuffed mushroom caps—always fussy, never as good as you'd hoped—and in with whole Spanish mushrooms. I've never understood why stuffed mushrooms are served at American cocktail parties; they consistently have a dry exterior and flavorless interior, despite being butter-laden calorie bombs. What a relief to find cocktail mushrooms around the Mediterranean, where the Italians pickle or roast them and the Spanish lavish them in paprika. I make this recipe at almost every cocktail occasion—not just because they thrill vegetarian guests, but because these mushrooms are great accompaniments to a wide variety of drinks featuring gin, whiskey, and sherry.

3 tablespoons extra-virgin olive oil
1 finely chopped shallot
¼ teaspoon crushed red pepper flakes
3 garlic cloves, minced
1 pound button mushrooms, quartered
½ teaspoon paprika
½ teaspoon smoked paprika
¼ teaspoon kosher salt
¼ teaspoon freshly ground black pepper
1 teaspoon cornstarch
¼ cup dry Spanish sherry or
 dry white wine
1 tablespoon chopped fresh flat-leaf
 parsley, for garnish

In a medium-size pan over medium-high heat, heat oil and sauté shallot and red pepper flakes for 1 minute. Add garlic and cook for another minute. Add mushrooms, paprika, smoked paprika, salt, and black pepper. In a small bowl or cup, combine cornstarch with 1 tablespoon of the sherry to make a slurry and add to mushrooms along with the remaining 3 tablespoons of sherry. Cook for 5 minutes, or until mushrooms are tender, stirring frequently, and transfer to a serving dish. Garnish with parsley and serve with toothpicks.

Japanese Enoki Mushroom–Bacon Rolls

MAKES 12 ROLLS

An ideal pairing with whiskey—Japanese or otherwise—these bacon-wrapped mushrooms are a sight to behold and a delight to taste. Enoki mushrooms have a firm texture that makes them a substantial appetizer. Conveniently, they grow in clusters that are easily broken apart before rolling into thin slices of pork. While this recipe may look a little fussy, it really isn't that bad—and besides, these rolls are unforgettable showstoppers.

8 ounces enoki mushrooms
12 slices uncooked bacon
1 teaspoon cornstarch
2 tablespoons water
1 tablespoon oyster sauce
2 teaspoons soy sauce
1 teaspoon sugar
¼ teaspoon freshly ground black pepper

Preheat oven to 425°F. Divide mushrooms into 12 small clusters. Trim about ½ inch off the bottoms of the sections and wrap each bundle with a bacon slice; secure with a toothpick. Arrange bundles so they are not touching on a wire rack set atop a large baking sheet. In a small bowl, combine cornstarch and water. In another small bowl, combine oyster sauce, soy sauce, sugar, and pepper. Add cornstarch mixture to the sauce mixture and stir to combine thoroughly. Baste mushroom rolls with the oyster sauce mixture and roast for 20 minutes, or until bacon is crispy, basting again halfway through baking.

Fried Artichokes with Lemon and Mint

SERVES 4

Roman-style fried artichokes famously hail from Trastevere, once home to the Eternal City's Jewish community. There, chalkboards announce their availability with the scrawl *carciofi alla giudia* (Jewish-style artichokes). These little gems are shockingly crisp, earthy, brightly flavored—and elegant in their simplicity. They work wonderfully as a bar snack or as an appetizer to an Italian feast. Pair with spritzes, Americanos, and Negronis. I like to give the artichokes a lift with mint—a classic combination—but it can be omitted if desired.

3 cups vegetable oil

¼ cup cornstarch

½ teaspoon salt

¼ teaspoon freshly ground black pepper

1 pound artichoke hearts (if using frozen, thaw and drain)

½ teaspoon fresh lemon juice, for garnish

¼ teaspoon minced fresh mint, for garnish

In a Dutch oven or saucepan, heat oil to 365°F. In a medium-size bowl, combine cornstarch, salt, and pepper. Working in batches, toss three or four artichokes at a time in the cornstarch mixture until coated; fry artichokes for 4 to 6 minutes until browned. Drain on a wire rack or plates lined with paper towels. To serve, arrange in a shallow bowl and top with lemon juice and mint.

Crispy Eggplant Fries
with Honey

SERVES 4

Galatoire's Restaurant in New Orleans is famous for its fried eggplant sticks dusted with confectioners' sugar and accompanied by Tabasco sauce. The Creole combination of bitter eggplant, sweet sugar, and hot sauce makes for a decadent flavor and texture symphony. The result is something like a wild, vegetal French toast. I use the same method here, but prefer a drizzle of honey and a sprinkle of toasted sesame seeds. These fries are a cocktail-friendly surprise for guests, and pair well with all of those New Orleans favorites, such as Sazeracs, Vieux Carrés, and Big Chiefs (recipe follows).

1 large eggplant

3 cups peanut or vegetable oil

1 large egg

½ cup milk

¼ teaspoon salt

¼ teaspoon freshly ground black pepper

¼ teaspoon cayenne pepper

½ cup cornstarch

1 tablespoon honey

½ teaspoon toasted sesame seeds,
 for garnish

Peel eggplant and cut to ¾-inch-wide fries. Soak for 30 minutes in salted water, placing a plate over the bowl to keep the eggplant submerged. In a saucepan or Dutch oven, heat oil to 365°F. Rinse eggplant and pat dry. In a medium-size bowl, combine egg and milk; season with salt, black pepper, and cayenne. Put cornstarch on a plate. To assemble, dip eggplant into egg batter, roll in cornstarch, and deep-fry until golden brown, turning on all sides, about 3 minutes. Transfer eggplant to a plate lined with paper towels or a wire rack to dry and cool slightly. Sprinkle with additional salt and serve drizzled with honey and garnished with sesame seeds.

Big Chief

Considered a modern classic, the Big Chief was created in New Orleans by Abigail Gullo at the restaurant Compère Lapin. It celebrates the city's Italian heritage with Averna, an amaro hailing from Sicily. The flamed peel feels like vintage NOLA (New Orleans) bar showmanship and makes for a drink that is a delight to imbibe and behold. One for lovers of Manhattans and all things New Orleans.

2 ounces bourbon
½ ounce Averna
½ ounce Punt e Mes
Orange peel, for garnish

Stir bourbon, Averna, and Punt e Mes with ice and strain into a Nick and Nora or coupe glass. Using a match or lighter, ignite oil in the orange peel as you express it over the drink and drop it into the glass.

Cauliflower "Wings"
with Gochujang Sauce

SERVES 4

So many cauliflower recipes call for bread crumbs—and most of them disappoint. There always seems to be residual grit and the result is never crunchy enough. After making these "wings," which use a batter instead, I think you'll agree—this is the crispy cauliflower recipe you've been looking for. I was inspired by a Chinese-meets-Indian dish named gobi Manchurian, which is an indulgent convergence of flavors. Here, garam masala–dusted cauliflower meets a sweet-and-sour sauce with Korean gochujang. The result is maximal. Pair with gin and rum cocktails.

CAULIFLOWER:

3 cups peanut or vegetable oil

⅓ cup all-purpose flour

⅓ cup cornstarch

1 teaspoon chili powder

½ teaspoon garam masala

¼ teaspoon salt

¼ teaspoon freshly ground black pepper

½ cup water

4 cups medium-size cauliflower florets
 (about 1 small head)

Sesame seeds, for garnish

In a Dutch oven or saucepan, heat oil to 365°F. In a medium-size bowl, combine flour, cornstarch, chili powder, garam masala, salt, and black pepper with water. Dredge cauliflower pieces in batter. Working in small batches, fry until golden, 3 to 4 minutes. Transfer cauliflower to a wire rack or plates lined with paper towels and let cool. To serve, toss in gochujang sauce (recipe follows) and garnish with sesame seeds.

GOCHUJANG SAUCE:

3 tablespoons gochujang paste

1 tablespoon soy sauce

1 tablespoon rice vinegar

1 tablespoon sugar

¼ teaspoon toasted sesame oil

In a small saucepan, heat together all sauce ingredients over medium-high heat until simmering. Transfer to a bowl and allow to cool.

Greek Tomato Fritters

SERVES 4 TO 6

Tomato fritters are one of those culinary discoveries that can never come early enough in life. The most famous version is from the island of Santorini, known for its especially sweet and acidic cherry tomatoes. By using firm Roma tomatoes and a handful of herbs, it is possible to replicate this fresh dish—which will immediately become part of your regular rotation of cocktail foods. Serve drizzled with a touch of olive oil alongside cool yogurt and crusty bread. Best consumed with ouzo-, gin-, or tequila-based cocktails.

3 cups peanut or vegetable oil
1 cup all-purpose flour
1 teaspoon baking powder
1½ cups finely chopped Roma tomatoes
1 cup finely chopped onion
1 cup cubed feta cheese
1 tablespoon finely chopped fresh
 basil leaves
1 tablespoon finely chopped fresh
 flat-leaf parsley
1 teaspoon dried oregano
¼ teaspoon kosher salt
¼ teaspoon freshly ground black pepper

In a Dutch oven or saucepan, heat oil to 365°F. In a large bowl, mix flour, baking powder, tomatoes, onion, feta cheese, basil, parsley, oregano, salt, and pepper until thoroughly combined. Working in small batches and using a spoon, drop tablespoon-size fritters into the oil and fry until browned, about 3 minutes per side. Transfer to a wire rack or plates lined with paper towels and let dry before serving.

Cuban Chickpea Fritters
with Avocado Dipping Sauce

SERVES 6

These delightfully crispy and slightly spicy fritters boast an incredible contrast between funky paprika and a bright, acidic dipping sauce. This is a great example of a single dish that can make an entire cocktail party, no additions necessary. Whip up a batch of these and invite friends over for—what else?—daiquiris (page 5). Also born in Cuba, the daiquiri is the perfect foil for these addictive treats. Pro tip: Keep your batter in the refrigerator while frying in batches.

FRITTERS:

3 cups vegetable oil

2 (15-ounce) cans chickpeas,
 drained and rinsed

1 large egg

2½ tablespoons all-purpose flour

½ teaspoon baking powder

½ teaspoon ground cumin

½ teaspoon paprika

¼ teaspoon cayenne pepper

1 tablespoon finely chopped fresh
 flat-leaf parsley

1 teaspoon kosher salt

In a Dutch oven or saucepan, heat oil to 365°F. In a food processor, puree chickpeas and egg. Add flour, baking powder, cumin, paprika, cayenne, parsley, and salt; combine until smooth. Using a spoon, form tablespoon-size balls and fry in batches until golden brown, about 3 minutes. Transfer fritters to a wire rack or large plate lined with paper towels. Serve warm with avocado dipping sauce (recipe follows).

AVOCADO DIPPING SAUCE:

2 ripe avocados, peeled and pitted

2½ tablespoons fresh lime juice

⅓ cup finely chopped pimiento-stuffed
 Spanish olives

½ teaspoon ground coriander

½ teaspoon kosher salt

¼ teaspoon freshly ground black pepper

2 tablespoons olive oil

In a small bowl, mash avocados and add lime juice, olives, coriander, salt, and pepper. Mix well and add olive oil. Refrigerate, covered, until ready to serve.

Red Devils
(Thai-Inflected Hush Puppies)

MAKES ABOUT 16 FRITTERS

My obsession with johnnycakes, hoecakes, and hush puppies began as a search into the beginnings of American cuisine. They were a huge part of early settler life (the first recorded corn cake recipe is from 1665). Of course, the search was fueled by the fact that corn cakes and fritters are the ideal accompaniment to bourbon, our signature North American tipple. Corn cakes can be found all over the world, from Italian fried polenta to Indian *pakora* to Indonesia's *bakwan jagung*. These spicy, Thai-inflected winners are the result of my quest for an updated, flavorful corn fritter that does not require a sauce. They're perfect for parties—I always have them on hand at cookouts, paired with summery cocktails and, of course, anything with whiskey.

1 cup cornmeal
½ cup all-purpose flour
1 teaspoon baking powder
½ teaspoon baking soda
1 tablespoon sugar
1½ teaspoons salt
2 garlic cloves, minced
⅓ cup finely chopped white onion
2 teaspoons cider vinegar
1 tablespoon red curry paste
 (such as massaman)
1 large egg
½ cup plain yogurt
½ cup water
3 cups peanut or vegetable oil

In a medium-size bowl, combine cornmeal, flour, baking powder, baking soda, sugar, and salt and stir well. In a small bowl, mix together garlic, white onion, vinegar, and curry paste. In a large bowl, combine egg, yogurt, and water; add garlic mixture and stir to incorporate. Add cornmeal mixture and stir. In a saucepan or Dutch oven, heat oil to 365°F. Form mixture into golf ball–size fritters and drop in oil for 3 to 4 minutes, or until golden brown and crispy. Transfer fritters to a wire rack or large plate lined with paper towels and let drain.

CHAPTER 3

CHEESE AND DAIRY

Is there anything easier (or better) than putting out a plate of cheese with cocktails? *Fromage* might be the best ready-made pairing for mixed drinks; the alcohol cuts the fat in the cheese and the two enhance each other's flavor. For an exploration of cocktail and cheese pairing, see page 51.

In this chapter, cheese is the star ingredient in essential cocktail bites that can be the focal point to any boozy gathering. From a romantic cherry-burrata starter to an update of that venerable party guest, the cheese ball, this section will ooze its way into your food repertoire.

p 49

p 52

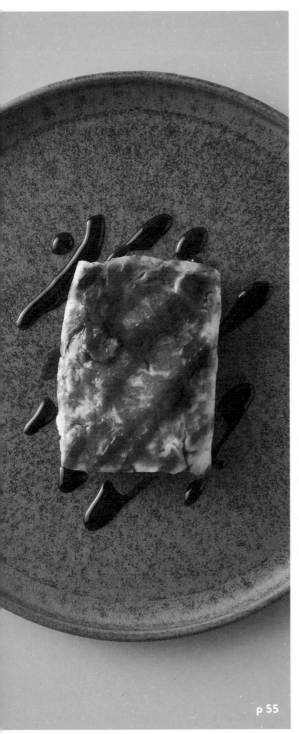

p 55

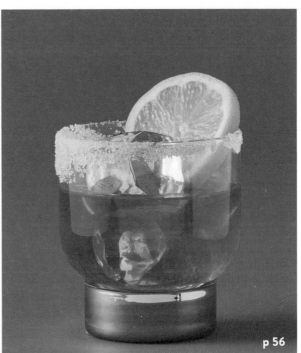

p 56

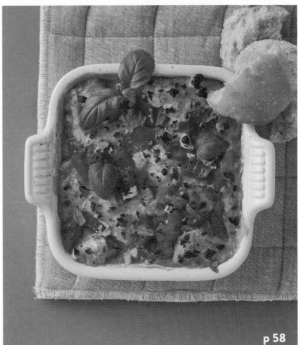

p 58

Frico Manchego

SERVES 6

Walnuts and Spanish Manchego cheese are a classic umami-laden pairing. Why not combine them in a convenient tuile that will have your guests clamoring for more? *Frico* is a cheese crisp originally from the Friuli region of Italy—so, apologies, Friuli—I'm stealing the name. I like to offer these still warm from the oven as guests arrive; I am of the firm mind that there is no better way to kick off a fete. Enjoy these knockout cheese crisps with Manhattans and old-fashioneds.

3 cups medium-grated Manchego cheese
1 tablespoon all-purpose flour
¼ teaspoon cayenne pepper
¼ cup chopped walnuts

Preheat oven to 375°F and line two baking sheets with parchment paper. In a medium-size bowl, mix cheese, flour, and cayenne until thoroughly combined. Using a spoon, drop tablespoon-size mounds of cheese mixture onto parchment and press into 6-inch rounds. Sprinkle walnuts evenly over the cheese rounds. Bake until cheese is golden and browning, about 5 minutes. Transfer parchment to a wire rack or cutting board; using a spatula, transfer frico to a serving board or large plate. Frico can be stored between layers of waxed paper in an airtight container at room temperature for up to a week.

Sweet-and-Sour Burrata

SERVES 2

This recipe is sexy. It joins together oozy, woozy burrata and a vibrant sweet-and-sour sauce made from Amarena cherries. Funny enough, this dish began its life humbly as a way to use up a jar of leftover juice after the cherries were gone. It transformed over time to become one of the very best things I make to accompany cocktails (it loves a Manhattan or anything with amaro). The cherry sauce over cheese is holy matrimony, and I assure you this is the burrata of your dreams.

1 teaspoon cornstarch

1 tablespoon water

8 Amarena cherries

2 tablespoons rice vinegar

1 teaspoon soy sauce

1 tablespoon sugar

½ teaspoon tomato paste

1 (4-ounce) burrata cheese,
 at room temperature

Combine cornstarch with water in a small bowl or cup until it forms a slurry, then set aside. In a small saucepan over medium heat, combine cherries, rice vinegar, and soy sauce. Gently stir cherries around the saucepan until they are free of their syrup; using a slotted spoon, transfer them to a small dish and set aside. Add sugar and tomato paste to the saucepan. Stir until sugar dissolves and increase heat to medium-high. Add cornstarch mixture and cook until sauce thickens, about 2 minutes. To serve, place cheese in a serving dish or on a large plate; return cherries to the sauce and pour over the burrata.

Sky Cheese

SERVES 4

Quirkily named "sky cheese" hails from Konya in central Anatolia, Turkey. In Turkish, the dish is called *gök peyniri*, *gök* meaning "sky," or blue. It is made by wrapping fresh cheese in goat or sheep skin and burying it in the ground for months. The resulting moldy, blue-green cheese is then made into this dish. I have adapted my version from Musa Dağdeviren's; he is a renowned culinary personality who is a force in the preservation of traditional Turkish foods. Ideally, you want to use a sheep's milk cheese, such as Roquefort, but other blues will work.

2 cups finely diced onions
1 teaspoon olive oil
4 ounces crumbled blue cheese,
 at room temperature
2 tablespoons honey
¼ cup chopped roasted walnuts

Preheat oven to 350°F. On a baking sheet, toss onions with olive oil and bake for 30 minutes, or until soft and just browning. Remove from oven and allow onions to cool. In a large bowl, combine blue cheese, honey, and onions. Transfer a serving bowl or platter and sprinkle with walnuts. Serve with toast or crispy flatbread (page 170).

Cheese and Cocktail Pairing

If you're building a cheeseboard for your next cocktail session, here are a few need-to-know tips to create the most successful experience possible. First, offer several varieties. Three or four thoughtfully chosen cheeses make for a nice mix of colors, textures, and flavors. Next, remember to let the cheese rest at room temperature so you can experience the flavor to its fullest. Finally, consider the season; talk to your cheesemonger to determine what is available and what is currently the most interesting. On the board, organize your cheeses in progression from mildest to strongest so it is easy to remember flavors.

There are no hard-and-fast rules to cheese and cocktail pairing—feel free to experiment!

- Pair cheese with the base spirit unless the cocktail has other strong elements.
- When in doubt, gin pairs with most cheese; same with bourbon.
- Soft cheese loves bubbles. Try a Champagne cocktail with Brie.
- Rum is fantastic with cheeses that like sweet pairings on the board; if a cheese is great with dried cherries or jam, chances are it works with rum. This includes hard cheeses (e.g., Gouda), alpines (e.g., Emmentaler), and blue cheese.
- Whiskey and cognac will often have hints of char and oak, making them ideal for strong, aged cheeses. Try whiskey with a strong Cheddar.
- Salty cheeses, such as Parmesan, work well with most cocktails.

The Cheese Ball, Reimagined

SERVES 4 TO 6

Although the cheese ball has entered the realm of American kitsch foods, it has an important history as a Prohibition staple. The molded balls covered in nuts were often served in speakeasies and, as such, they are part of the cocktail food canon. Wanting to salvage this historic cocktail pairing from nervous laughter at my parties—while everyone loves a cheese ball, few will admit it—I looked for inspiration in the city of Tabriz in Iran, a former Spice Route stop. There, I found a dish called *dooymaj*, which includes feta, walnuts, fresh herbs, butter, and lavash bread. I spun this into an Americana version of a cheese ball . . . and the result is a thing of beauty.

8 ounces mascarpone
4 ounces blue cheese, crumbled
¼ cup chopped pecans
1 tablespoon finely sliced scallion
2 teaspoons hot sauce, such as Tabasco
2 teaspoons Worcestershire sauce
¼ teaspoon salt
¼ teaspoon freshly ground black pepper
¼ cup chopped dried cranberries
1 tablespoon finely chopped fresh basil
1 tablespoon finely chopped fresh chives
1 tablespoon finely chopped fresh dill

In a large bowl, combine mascarpone, blue cheese, pecans, scallion, hot sauce, Worcestershire sauce, salt, pepper, and ⅛ cup of the cranberries. Form the mixture into a ball and refrigerate, covered, for 30 minutes. Mix together remaining ⅛ cup of cranberries, basil, chives, and dill on a large plate and roll the cheese ball around to cover all sides. Serve with The Cracker (page 167) and cut veggies.

Ward 8

The Ward 8 is a classic Prohibition cocktail that never achieved the same popularity as other drinks of the era, such as the sidecar, Mary Pickford, or Bee's Knees. Admittedly, I rarely considered the Ward 8 until I was looking for a drink that pairs well with cheese. Contrary to gin-based drinks that can be a little thin, flavorwise, with bold cheese—this snazzy Jazz Age tipple has enough fruitiness to bring out amazing flavor.

2 ounces rye whiskey
½ ounce fresh lemon juice
½ ounce fresh orange juice
1 bar spoon grenadine
2 Amarena cherries, for garnish

Shake whiskey, lemon juice, orange juice, and grenadine with ice and strain into a cocktail glass. Garnish with cherries threaded on a cocktail pick.

Liptauer Cheese

SERVES 6

Liptauer cheese spread can be found alongside wine and beer in taverns across Austria and neighboring countries. It also happens to be a fantastic pairing for mixed drinks; there is just the right amount of spice, smoke, and tang to make for an intriguing combination. It is never out of place, even at a fancy cocktail party. Serve with pumpernickel or rye bread, or The Cracker (page 167).

8 ounces cream cheese, at room
 temperature
8 tablespoons (1 stick) salted butter,
 at room temperature
2 tablespoons minced shallot
1 tablespoon capers, drained and chopped
1½ teaspoons paprika
1 teaspoon caraway seeds
1 teaspoon Dijon mustard
¼ teaspoon kosher salt
¼ teaspoon freshly ground black pepper

In a medium-size bowl, combine all ingredients with an electric hand mixer until slightly fluffy. Refrigerate in an airtight container for at least 1 hour before serving. Cheese will keep up to 3 days in the refrigerator.

Fried Halloumi
with Carob Syrup

SERVES 4

A semihard cheese made on the island of Cyprus, halloumi has a high melting point that makes it perfect for cooking. In a skillet, the cheese gets a wonderful, crispy crust without the help of bread crumbs or deep-frying. My favorite way to serve halloumi is with carob syrup, a decadent addition that makes an excellent flavor bridge to cocktails. The carob's earthy caramel notes love whiskey and brandy (see the following recipe). Carob syrup is available in Middle Eastern grocery stores and online.

8 ounces halloumi cheese

2 tablespoons carob syrup

Heat a skillet over medium-high heat. Add halloumi and fry, until browning, on both sides, about 2 minutes per side. Transfer cheese to a plate and drizzle with carob syurp. Serve warm.

Cypriot Brandy Sour

This excellent brandy sour was developed for King Farouk of Egypt when he stayed on the island of Cyprus in the early 1930s. Created to look like iced tea, it disguised the king's predilection for alcoholic drinks. The lemons on Cyprus are bitter and require creating a "squash" to make them more palatable. This is a cocktail that will instantly transport you to the Mediterranean; sit back with a book by Lawrence Durrell (who lived on the island and wrote about it) and while away the afternoon.

<div align="center">

1 teaspoon sugar, to rim the glass
1 lemon slice
2 ounces brandy
3 ounces lemon squash (recipe follows)
2 drops bitters (Angostura or Cypriot Cock Drops brands)

</div>

Spread sugar in a circle on a plate. Wet the rim of a rocks glass with lemon slice and dip glass into the sugar. Fill glass with ice, then add brandy, lemon squash, and bitters. Stir and garnish with the lemon slice.

LEMON SQUASH:

1 cup fresh lemon juice
1 cup sugar

In a small saucepan over medium heat, combine lemon juice and sugar, stirring to dissolve. Heat until just boiling and transfer to a bottle to cool. Mixture will keep for up to 2 weeks in the refrigerator.

Queso Frito
with Guava Dipping Sauce

SERVES 4

Similar to halloumi (see page 55), queso frito is panfried unripened cheese. It can be found all over the Caribbean and Latin America and makes for a great snack with those cocktails that you expect to find on vacation; think rum punches and Coco Locos. Here, it is accompanied by a delightfully fruity and tangy guava sauce. Tropical cheese? Sign me up.

QUESO FRITO:

1 pound queso blanco or queso fresco

Cut cheese into 1-inch cubes. Heat a sauté pan over medium-high heat and add cheese. Cook until browning, 1 to 2 minutes per side, until cheese is golden on all sides. Remove from pan and serve with guava dipping sauce (recipe follows).

GUAVA DIPPING SAUCE:

1 cup guava paste

½ cup water

¼ cup pineapple juice

⅛ teaspoon ground cinnamon

In a small saucepan, heat guava paste and water over medium-low heat until melted and smooth. Add pineapple and cinnamon; stir and serve.

Fergese
(Feta Fondue)

SERVES 4

Roasted red pepper in feta fondue?! *Fergese*—an Albanian treat—is a flavorful blend of melted cheese and yogurt. Traditionally baked in a clay pot, this hit party offering originated in the capital, Tirana, and deserves to be better known. Add a little zip from hot pepper and fresh basil, and you've got a killer snack or appetizer. What's more, though fondue is usually confined to cooler months, fergese is not out of place as a summer barbecue starter or side. Note that the dish is typically made with *gjizë*, a kind of sour ricotta, but feta is a great substitute.

1 tablespoon olive oil

1 cup diced onion

¼ teaspoon crushed red pepper flakes

½ cup diced roasted red pepper

2 cups diced tomatoes

2 tablespoons unsalted butter

2 tablespoons all-purpose flour

6 ounces feta cheese, crumbled

¼ cup Greek yogurt

¼ teaspoon freshly ground black pepper

2 tablespoons chopped fresh basil,
 for garnish

Preheat oven to 350°F. In a medium-size sauté pan, heat oil over medium-high heat and add onion and red pepper flakes. Cook onion until translucent, about 3 minutes. Add roasted red pepper and tomato; cook for about 5 minutes, or until most of the moisture is gone. Transfer mixture to a 9 x 9-inch baking dish. In the same sauté pan, over medium-high heat, melt butter and stir in flour. Cook until flour begins to brown. Add feta and stir until melted. Add yogurt and stir to combine thoroughly. Add to tomato mixture and stir until combined. Bake, uncovered, for 30 minutes. Serve with crusty bread, cut veggies, or The Cracker (page 167).

Blue Corn Quesadillas

MAKES 8 QUESADILLAS

Blue corn quesadillas served curbside in Mexico are simply the best. Once you've had them, every other quesadilla feels lackluster. The problem is that it's a tough experience to repeat back at home. That is, unless you commit to making them for friends at a cocktail gathering . . . which is exactly what I'm suggesting because you probably can't get quesadillas like this any other way. Once you begin, manufacturing the tortillas is simple and fun. I like to make a blue corn quesadilla party a yearly event.

QUESADILLAS:

1 tablespoon olive oil

1 cup cremini mushrooms, sliced thinly

¼ teaspoon kosher salt

16 blue corn tortillas (recipe follows)

3 cups queso de Oaxaca, or similar mild melting cheese

¼ cup finely chopped white onion, for garnish

¼ finely chopped fresh cilantro, for garnish

In a medium-size sauté pan, heat oil over medium-high heat. Add mushrooms and salt; cook until mushrooms brown and release their juices, about 5 minutes. Set aside. Heat a griddle or sauté pan over medium heat. Divide mushrooms and cheese among eight of the tortillas. Top with remaining tortillas. Working in batches, cook quesadillas until browning and cheese is melting, about 2 minutes per side. To serve, garnish with white onion and cilantro.

BLUE CORN TORTILLAS:

MAKES 16 TORTILLAS

2 cups blue corn masa

½ teaspoon kosher salt

1¼ cups water, plus more if needed

In a medium-size bowl, mix masa, salt, and water together for about 5 minutes. If dough is too dry, add more water, 1 tablespoon at a time. Let dough rest, covered with a towel, for 15 minutes. Divide and roll dough into sixteen golf ball–size portions. Using a tortilla press or your hands, flatten the balls until they are about 5 inches in diameter. On a griddle or in a skillet over medium heat, cook tortillas for 30 seconds, then flip and cook for 30 seconds more before flipping back for another 30 seconds. Place tortillas under a clean cloth to keep moist and warm until serving.

Colibri

There are several variations of the Colibri. This one is a mezcal number by San Francisco bartender Guadalupe Jaques Jr. I love this crowd-pleaser because three liquors come together in perfect harmony—and you can still taste the mezcal. While the Colibri is great with all kinds of foods, it really loves blue corn tortillas. Make up a big batch in advance by converting the ounces to cups in the following recipe.

1 ounce espadin mezcal
1 ounce Aperol
1 ounce Domaine de Canton liqueur
1 ounce fresh lime juice
Grapefruit peel, for garnish

Shake all ingredients, except garnish, with ice and strain into a cocktail glass. Garnish with grapefruit peel.

Shepherd's Bulz
(Cheese-Stuffed Polenta)

SERVES 6

I am a polenta skeptic. I've experienced far too many presentations of dried, yellow pucks hiding beneath whatever sauce has been used in an attempt to infuse the rubbery, grainy thing with flavor and flair. These *bulz* are something else entirely. Shepherd's bulz are cheese-filled polenta balls from Romania that are a cocktailer's dream snack: flavorful, intriguing, and filling. They are the trifecta of entertaining ease—a snap to prep, they soak up booze, and make no mess—plus, they don't even require serving plates!

½ cup whole milk

2½ cups water

1 cup cornmeal

¼ teaspoon salt

¼ teaspoon freshly ground black pepper

Butter, for baking sheet

2 cups grated fontina cheese

Bring milk and water to a boil in a medium-size saucepan over medium-high heat. Pour in cornmeal, stirring constantly so it does not clump. Add salt and pepper. Lower heat to low and cook for 25 to 30 minutes, covered, stirring occasionally. Spread polenta on a cutting board to cool. Preheat oven to 375°F and butter a large baking sheet. Shape polenta into walnut-size balls and drop 1 inch apart onto the pan; using your finger, poke a hole in each ball and fill it with a heaping teaspoon of fontina. Bake for 15 minutes; turn and bake for 10 minutes more, or until just beginning to brown and a crust has formed. Serve hot.

CHAPTER 4

EGGS

While eggs are often an ingredient in mixed drinks, they have also long accompanied drinks as a way to sober up boozy guests. During Prohibition, boiled and deviled eggs were popular at speakeasies. It makes sense; eggs are inexpensive, keep well, and a shot of protein helps the inebriated. Some veteran drinkers go so far as to consume raw eggs before a cocktail session, to prevent a hangover—and while I can't speak to that method, eggs certainly prove effective in post-excessive consumption cures. Here's the science: The egg's amino acid—N-acetyl-cysteine—helps the body expel toxins from alcohol. For more remedies, see "Hangover Helpers" (page 68). In this section, there are egg-based recipes for every persuasion—from an updated deviled egg recipe for when you're feeling scrambled to a German hangover cure perfect for that headache at the crack of dawn, the recipes in this section are hard to beat (sorry, I couldn't resist).

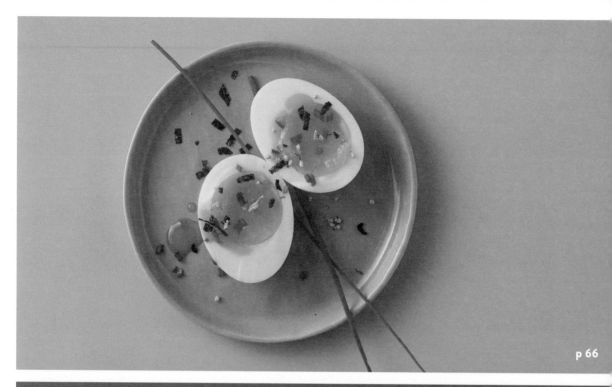

p 66

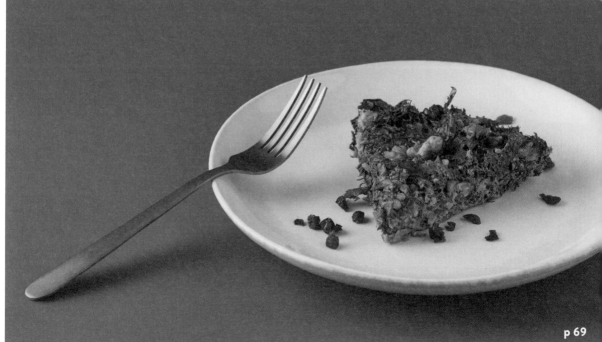

p 69

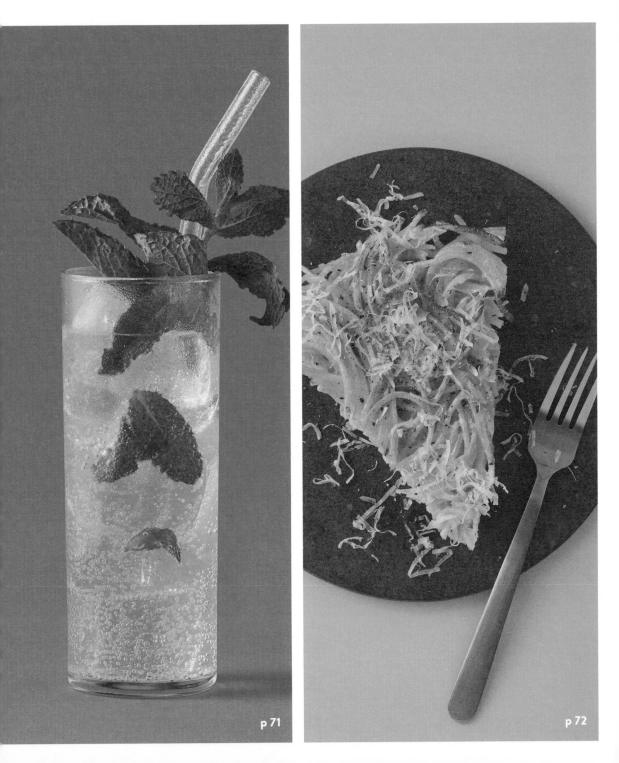

p 71

p 72

Cocktail Ramen Eggs

MAKES 12 DEVILED EGG HALVES

Deviled eggs have been a constant companion of the cocktail since at least Prohibition. My issue is that I hate making them: the fuss of boiling the eggs, creating a stuffing with the yolks, and then returning the mixture to the whites. So . . . I don't. Instead, I make ramen eggs. You know, the ones with the beautiful, gooey centers you find nestled on top of your noodle bowl. Then, I sprinkle on a variety of toppings, such as black sesame seeds, chives, Tajín (page 24), furikake (page 25), and ham dust (page 15). Alternatively, serve the eggs whole with soy sauce, chili oil, or a dollop of wasabi. It's that easy. Get out your stopwatch, because that is all you need to make the perfect eggs to accompany your beverage of choice.

6 large eggs

1 tablespoon spices, seeds, and herbs, such as chives or furikake, for garnish

In a large bowl, combine 1 cup of ice with 4 cups of cold water. Fill a large saucepan halfway with water; bring to a boil. Using a slotted spoon, lower eggs into the boiling water and cook for precisely 6½ minutes. Transfer eggs to ice water bath and chill for 2 to 3 minutes. Remove eggs from water, dry, peel, and cut in half, garnished with spices, seeds, and herbs.

Pickled Eggs

MAKES 9 PICKLED EGGS

Walk into any dive bar in America worth its name and you will likely find a jar of pickled eggs behind the counter. If you've never been loosened up enough to order one of said eggs, you are missing out. Pickled eggs are a textural wonderland—creamier than you would expect, and the seasoning makes a great accompaniment to cocktails. Think of this as a master recipe—feel free to replace any of the spices with your own. If the serving size seems strange, it's because nine eggs are all I've ever been able to fit in a 1-quart jar with the onions and herbs.

1 cup distilled white vinegar

1 cup water

2 tablespoons kosher salt

1½ tablespoons sugar

1 garlic clove

½ white onion, sliced thinly

9 hard-boiled eggs, peeled and cooled

4 dill sprigs

2 bay leaves

In a medium-size saucepan, heat together vinegar, water, salt, sugar, garlic, and onion until just boiling. Remove from heat and let cool completely. In a 1-quart jar, combine eggs, dill, and bay leaves. Top with vinegar mixture, distributing onion evenly in the jar. Cover and refrigerate eggs at least overnight before serving. Consume within 3 to 4 months for best flavor.

Katzenjammer

Katzenjammer is a German word for "hangover." It translates to "cat's wail" (the sound in your head when you have had one too many the night before). The best cure for said condition, according to the Germans, is egg: a whole raw egg. But have no fear—if tossing back unaccompanied uncooked eggs doesn't appeal to you, this cocktail will fix what ails you.

1 egg yolk
1 tablespoon honey
8 ounces warm milk
2 ounces brandy

In a glass, combine egg yolk and honey. Add milk and brandy; stir.

Hangover Helpers

While there are almost as many folk hangover remedies as there are classic cocktails, a few recipes do seem to help and are included in this book. Remember that there is no better way to cure a hangover than to prevent one; drink plenty of water before going to sleep.

- Katzenjammer (above)
- Leche de Tigre (page 91)
- Sichuan-ish Salmon (page 105)
- Bak Kut Teh (page 141)
- Spaghetti Kee Mao (page 173)

Kuku Sabzi
(Herbed Frittata)

SERVES 4

Kuku sabzi means "forget frittatas" in Farsi. Kidding. But you will likely never go back after trying this Persian egg pancake loaded with fresh herbs. Typically served at Nowruz, the Persian New Year, you may find yourself making it for every weekend brunch. Although the ingredient list is long, it is a cinch to construct. And don't worry too much about amounts; just throw whatever scallions, parsley, cilantro, and dill you have into a food processor. This dish loves gin and is also a perfect pairing with the herbaceous liqueur, Chartreuse.

2 tablespoons olive oil

6 large eggs

1 teaspoon baking powder

1 teaspoon kosher salt

¼ teaspoon freshly ground black pepper

½ teaspoon ground cardamom

½ teaspoon ground cumin

½ teaspoon ground turmeric

¼ teaspoon ground cinnamon

2 garlic cloves, minced

½ cup toasted and chopped walnuts

½ cup chopped scallions

1 cup chopped fresh flat-leaf parsley

1 cup chopped fresh cilantro

1 cup chopped fresh dill

1 tablespoon barberries or dried
 cranberries (optional), soaked
 in water for 15 minutes

Preheat oven to 375°F. Line a 9-inch round cake pan with parchment and spread with olive oil. In a medium-size bowl, lightly beat together eggs, baking powder, salt, pepper, cardamom, cumin, turmeric, and cinnamon. Using a spoon, fold in garlic, walnuts, scallions, parsley, cilantro, and dill. Pour mixture into prepared cake pan and bake for 20 minutes, or until firm when jiggled and slightly browning on top. Remove from oven and allow to cool slightly. To serve, turn out kuku sabzi onto a plate and top with berries (if using). Serve slices warm or at room temperature.

Goji Jeon
(Beef-Egg Pancakes)
SERVES 4

Leave it to the Koreans to come up with one of the world's ultimate drinking snacks. The name may get translated as "pancakes," but *goji jeon* are more like mini hamburgers fried in an egg batter—served with a zippy sweet and spicy sauce. A brilliant accompaniment to those big Korean drinking sessions, these little pancakes work as an appetizer but can also make a meal. Soju cocktails (recipe follows) are the right move here, although whiskey- and rum-based drinks are a stellar accompaniment as well.

8 ounces ground beef

8 ounces ground pork

¼ cup finely chopped onion

2 garlic cloves, minced

1 tablespoon unsalted butter, melted

½ teaspoon salt

¼ teaspoon freshly ground black pepper

2 teaspoons sugar

¼ cup all-purpose flour

¼ cup cornstarch

3 tablespoons vegetable oil

2 large eggs, beaten

SOY-GOCHUJANG SAUCE:

2 tablespoons gochujang paste

1 tablespoon soy sauce

1 tablespoon rice vinegar

¼ teaspoon toasted sesame oil

1½ teaspoons honey

In a large bowl, combine beef, pork, onion, garlic, melted butter, salt, pepper, and sugar. Form mixture into golf ball–size portions, about 2 tablespoons each, and press into small patties. In a shallow bowl, combine flour and cornstarch. Heat oil in a large sauté pan over medium-high heat. Dip meat patties into flour mixture and then into eggs. Without overcrowding the pan, fry patties until just beginning to brown on both sides, about 2 minutes per side. Transfer to wire racks to drain and repeat with remaining patties. Serve with soy-gochujang sauce (recipe follows).

Combine all sauce ingredients in a small bowl.

Soju-to

It might surprise you to learn that Korean soju—a clear, flavorless liquor typically made from rice—is the world's best-selling liquor. It's a versatile bottle to have on hand, and because it is typically low-proof, it is great for longer drinking sessions, such as those backyard parties that stretch on all afternoon. An easy way to get into soju is to make a Mojito variation. Skip the muddling—doing so will stream-line the process for big-batch gatherings.

2 ounces soju
¾ ounce fresh lemon juice
½ ounce simple syrup
4 fresh mint leaves, plus a sprig for garnish
2 ounces club soda

Shake soju, lemon juice, simple syrup, and mint leaves with ice; pour into a highball glass. Top with soda and garnish with a mint sprig.

Cacio e Pepe Frittata

SERVES 6

A pasta frittata is filling, versatile, and keeps well. I've had some of my favorite versions at Italian convenience stores and coffee shops when I've needed something to hold me over until dinner. They are great to take on the go, and I've hiked around the Amalfi coast with a slice in my bag for sustenance. This version won't make it that far, however—because combining *cacio e pepe* (cheese and pepper) pasta with a frittata makes for a shockingly addictive substance. Serve with Italian aperitivo cocktails, such as spritzes and Americanos. It also pairs well with any drink containing lemon.

12 ounces uncooked spaghetti

4 tablespoons (½ stick) unsalted butter

4 large eggs

¾ cup freshly grated Parmigiano-
 Reggiano cheese

½ teaspoon freshly ground black pepper

Bring a large pot of salted water to a boil; cook spaghetti according to package instructions and drain well using a colander. Add 2 tablespoons of the butter to the pasta in the colander; stir until combined and allow to cool. In a large bowl, combine eggs, cheese, and pepper. Add spaghetti and toss to coat thoroughly. Heat remaining 2 tablespoons butter in a 12-inch skillet over medium heat until melted. Pour spaghetti mixture into skillet and cook, covered, for 10 minutes. Remove cover; place a plate over the top of the pan large enough to cover it. Flip pan and the frittata onto the plate, and then slide frittata back into the pan on the uncooked side. Cook, uncovered, for another 4 to 5 minutes. Serve sliced into wedges.

Rolex
(Breakfast Egg Wrap)

MAKES 1 ROLEX

Rolex is a popular Ugandan street food composed of eggs and veggies wrapped in chapati (flatbread), rolled in newspaper, and eaten hot off the griddle. Why the name? Originally, vendors called it a "rolled egg," but when spoken quickly, the name sounded like "rolex." The fun new name stuck. Make a big batch and share them with your friends for a low-key brunch—or make them for your guests at bar time. There is no bad time to experience the popping crunch and fresh flavor of a rolex. Although they are made with chapatis in Uganda, readily available fajita-size tortillas work just as well. For added kick, add a little diced habanero. Good morning (. . . or afternoon . . . or evening)!

2 large eggs, beaten

⅓ cup thinly sliced green cabbage

¼ cup chopped tomato

1 tablespoon finely chopped red onion

⅛ teaspoon habanero hot sauce

⅛ teaspoon sea salt, or to taste

⅛ teaspoon freshly ground black pepper, or to taste

1 tablespoon peanut or vegetable oil

1 large tortilla

In a bowl, combine eggs, cabbage, tomato, red onion, hot sauce, salt, and black pepper. In a medium-size sauté pan or skillet, heat oil over medium-high heat and swirl to cover the bottom of the pan evenly. Add egg mixture and cook until browned on one side, about 2 minutes. Flip and cook for 1 minute more. To remove, place a tortilla on top of the eggs and turn the pan over onto a piece of parchment paper. Roll up in the paper and serve immediately.

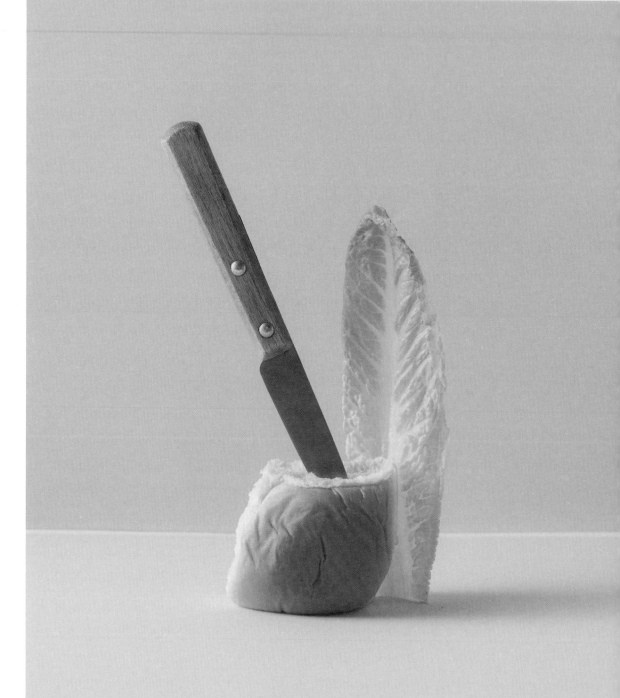

CHAPTER 5

SANDWICHES

Sandwiches are not only a great accompaniment to cocktails, but their very existence is tied to mixed drinks. The word *sandwich* was first mentioned in print in 1762, when a Londoner described a group of London men drunk on rum punch and eating cold meat between bread slices. Interestingly, the word *canapé* appeared in France around the same time; people thought the bread with a topping looked like someone sitting on a couch (the word *canapé* originally translated to "sofa"). Written for wealthy American housewives, the hilariously titled 1897 book *Beverages and Sandwiches for Your Husband's Friends* demonstrates that the cocktail-sandwich connection became explicit; the guide offers various punches and cups alongside caviar and woodcock sandwich recipes. And the rest, as they say, is history; the sandwich and its open-face versions went on to become very popular accompaniments at cocktail parties. These days, cocktail sandwiches are a bit outmoded, and you might not run into one outside of a Derby party or stuffy fund-raiser. This chapter offers a couple of relevant, unfussy classics modern cocktailers should know—plus two of the world's great sandwiches that should be inducted into the cocktail-fare hall of fame.

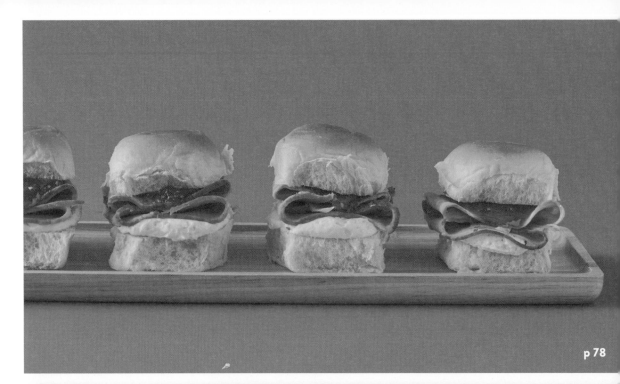
p 78

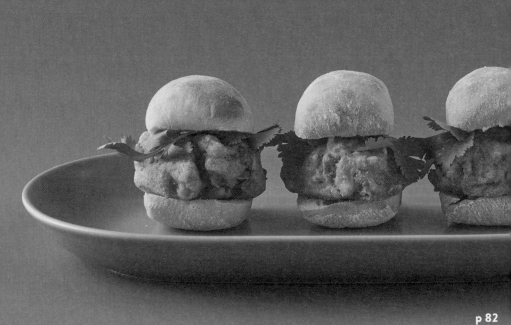
p 82

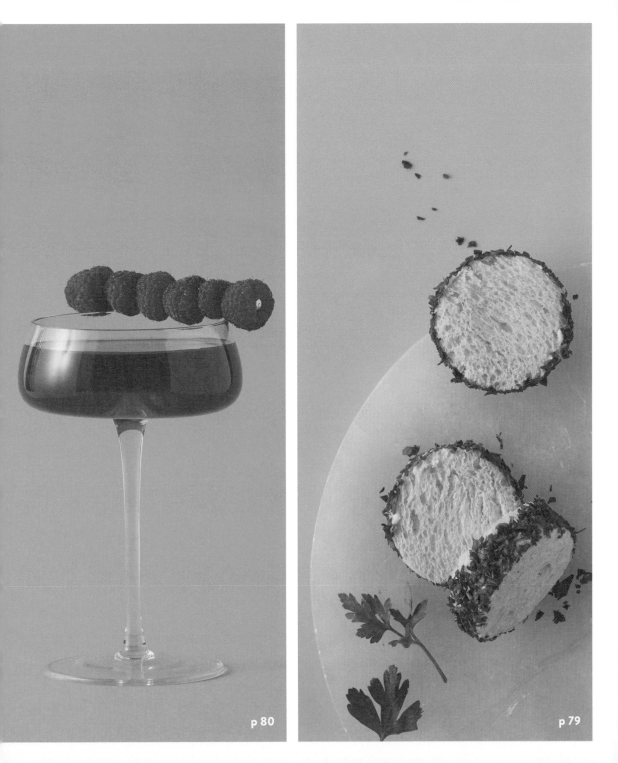

p 80

p 79

Strawberry-Ham Bocaditos

MAKES 6 BOCADITOS

Bocaditos are little Cuban finger sandwiches—the word means "little bite" or "small mouthful" in Spanish. Typically, the sandwiches include a cream cheese filling with such add-ins as chopped olives or chicken breast. If you're thinking 1950s American party food, then you're not far off. This stunning bocadito is adapted from a famous version called the Elena Ruz (served in Miami Cuban restaurants), one that transcends them all with its combination of soft cheese, strawberries, and turkey—although I think ham works better. I am also of the opinion that these bites are the very essence of what a fun, retro cocktail sandwich should be. They love all kinds of cocktails, especially fruit-forward drinks popular during Prohibition, such as Mary Pickfords, Clover Clubs, and Ward 8s (page 53). And, of course, they are a brilliant pairing with daiquiris and Mojitos.

6 Hawaiian rolls, halved
5 tablespoons whipped cream cheese
3 tablespoons strawberry preserves
3 ham slices, cut in half

Smear the inside of the bottom roll halves with cream cheese. Spread strawberry preserves on the inside of the top halves. Fold ham in half to make little squares and place on the bottom roll halves. Close sandwiches and serve.

James Beard's
Onion Cocktail Sandwiches

MAKES 12 SANDWICHES

Cocktail parties launched the career of legendary foodie James Beard. When his Broadway dreams didn't pan out, he started a catering business, and was soon inspired to write a book. *Hors d'Oeuvre and Canapés with a Key to the Cocktail Party* was an instant hit and led to Beard's friendship with Julia Child and a giant career in food writing. This is my favorite sandwich of his, a delightful catering-friendly recipe that is as simple as it is elegant—a little taste of Beard's company, Hors d'Oeuvre Incorporated. Serve with vodka-based drinks and the JBF cocktail (recipe follows).

1 loaf challah or brioche,
 sliced ¼-inch thick
1 cup mayonnaise
1 white onion, sliced thinly
1 tablespoon coarse sea salt
2 tablespoons finely chopped
 fresh flat-leaf parsley
2 tablespoons finely chopped
 fresh chives

Cut bread slices with a biscuit cutter to form two dozen rounds and spread mayonnaise on one side of all slices. Arrange bread in pairs and top half of the slices with onion and salt. Close sandwiches gently. Combine parsley and chives on a plate and roll the sandwich edges in mayonnaise and then the herbs. Serve immediately or refrigerate, covered.

JBF

James Beard loved framboise—and also vodka. He admired vodka because it does not "ruffle your taste buds so you miss the true flavor of wines served at dinner." This cocktail is a light predinner drink that JB would approve of—an aperitif that is part martini and part daiquiri, with a healthy whiff of raspberry brandy. JBF stands for the James Beard Foundation, an organization that carries on the famous gourmand's legacy.

1 ounce dry vermouth
¾ ounce raspberry brandy
1 ounce vodka
¼ ounce fresh lime juice
Raspberry, for garnish

Stir ingredients with ice and strain into a cocktail glass. Garnish with the raspberry.

Balik Ekmek
(Fish Sandwich)

SERVES 4

Oh, to stand next to the Bosporus in Istanbul and devour a piping-hot mackerel sandwich fresh off the grill. Like all great cocktail food, *balik ekmek* is loaded with flavor. Since the beginning, cocktail sandwiches have veered toward the rich—caviar, foie gras, bottarga—and this humble street snack checks all of the right boxes. It deserves a place of honor in the cocktail world because it pairs so well with so many mixed drinks. A word of caution: mackerel can make a mess out of a grill if not cooked properly; I panfry the fillets here for ease.

8 small or 4 large mackerel fillets

2 teaspoons ground sumac

1 teaspoon red pepper flakes

2 tablespoons extra-virgin olive oil

4 (7-inch) baguette pieces, cut in
 half lengthwise

2 tablespoons fresh lemon juice

½ teaspoon freshly ground black pepper

4 romaine lettuce leaves

2 medium-size tomatoes, sliced

½ red onion, sliced thinly

In a medium-size bowl, sprinkle mackerel fillets on both sides with sumac and red pepper flakes. Drizzle olive oil over fillets to coat both sides. In a large sauté pan over high heat, fry mackerel, skin side down, until just beginning to brown, 2 to 3 minutes. Flip and brown other side, an additional 2 to 3 minutes. Divide fish between four baguette bottoms. Top fillets with lemon juice, black pepper, lettuce, tomatoes, and onion. Close baguettes and serve immediately.

Vada Pav
(Potato Slider)

MAKES 6 VADA PAV

Vada pav is a famed snack from Mumbai composed of a bun (*pav*) with a spiced potato patty (*vada*). The combination of crunchy croquette and fluffy bun is pure magic—reminiscent of the best fried chicken sandwich. Except—wait for it—it's vegetarian. This is fantastic party fare. While my recipe makes larger sandwiches—perfect for serious drinking food—vada pav can be made on mini-buns, such as sliders. Pair with gin and tonics, although tequila cocktails also work well.

VADA:

1 tablespoon vegetable oil

½ teaspoon brown mustard seeds

4 garlic cloves, minced

6 curry leaves, chopped finely

⅛ teaspoon asafetida powder

⅛ teaspoon ground turmeric

⅛ teaspoon cayenne pepper

1 pound potatoes, peeled, cooked, and mashed

1 tablespoon finely chopped fresh cilantro

¼ teaspoon salt

3 cups peanut or vegetable oil

6 dinner buns, toasted and sliced

BATTER:

1 cup chickpea flour

⅛ teaspoon asafetida powder

⅛ teaspoon ground turmeric

¼ teaspoon baking soda

¾ cup water

½ teaspoon salt

In a medium-size sauté pan, heat oil over high heat. Add mustard seeds and fry until seeds begin to pop. Add garlic, curry leaves, asafetida, turmeric, cayenne, cilantro, and salt and cook until fragrant, about 5 seconds. Add spice mixture to potatoes and stir until combined thoroughly. Form into balls the size of lemons, flatten slightly, cover, and set aside. In a Dutch oven or saucepan, heat oil to 365°F. Working in batches, dip potato rounds into the batter (recipe follows), coating evenly, and fry until golden brown on all sides. Remove with a slotted spoon and drain on a wire rack or plates lined with paper towels. Assemble in buns and serve immediately.

In a medium-size bowl, stir together all batter ingredients until thoroughly combined and there are no lumps.

Indian Gin Old-Fashioned

India has joined the Ginaissance—as the recent global gin boom is called—and is producing a number of bottles that are worth sampling. Jin Jiji, Hapusa, Jaisalmer, and Greater Than all spring to mind as gins that bring wonderful flavor to cocktails—and they are also excellent on the rocks. Using Indian gin in old-fashioneds allows the botanicals to shine, and is also a perfect match to its mother country's cuisine.

1 sugar cube
2 dashes Angostura bitters
2 ounces Indian gin
Orange peel, for garnish

In a cocktail glass, muddle together sugar cube and bitters until dissolved. Add gin and ice; stir. Garnish with an orange peel.

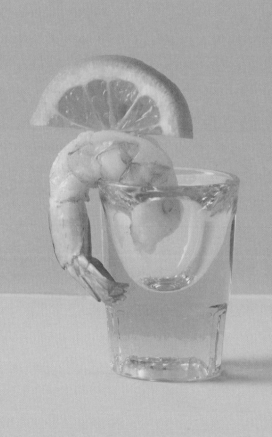

CHAPTER 6

SEAFOOD

On barstools all over the world, you will find people feasting on shrimp, oysters, and the fresh catch of the day with a cocktail beside them. I used to think the drinks in such spots were a secondary attraction—merely a way to wash down gifts from the ocean. But over the years, I've come to understand that cocktailers have a special lust for the sea. They are called by the siren song of fresh catch for the same reason they respond to ice rattling in a shaker: There is a special sporting attraction to the finer things this planet has to offer. More often than not, seafood follows drinkers and not the other way around. Step into any steak house with its menu of shrimp cocktails, oysters, and seafood towers, and the relationship is clarified.

In this chapter, we are going to explore a simple but mighty Basque appetizer, an updated shrimp cocktail (think char and spice), revel in James Bond's favorite drink and seafood pairing, plus discover two hangover cures. In addition, there's a wowing dish from the edge of the Muslim world, as well as highlights from France, Italy, and the American South. Ready your lure and net, because we're about to get wet.

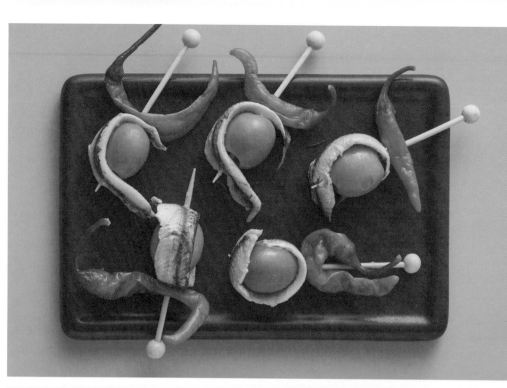
p 88

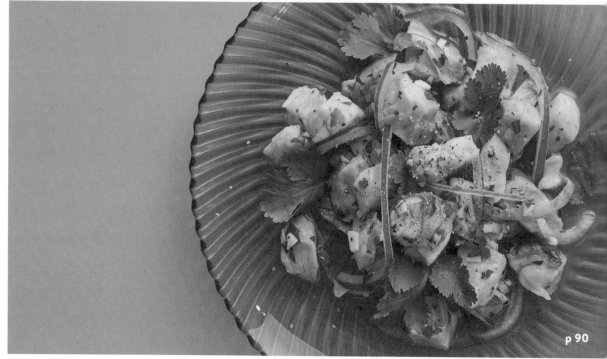
p 90

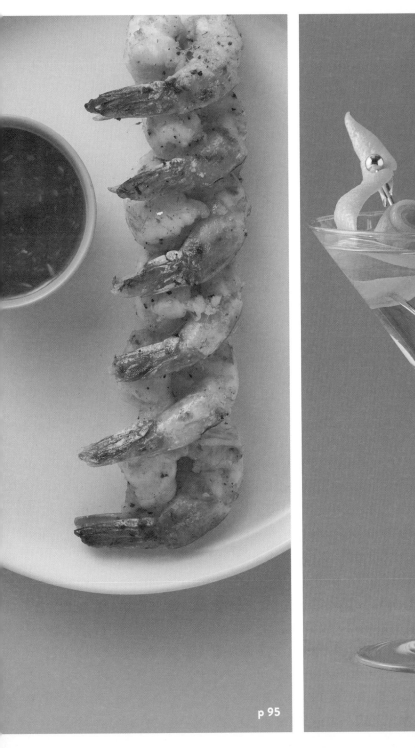

p 95

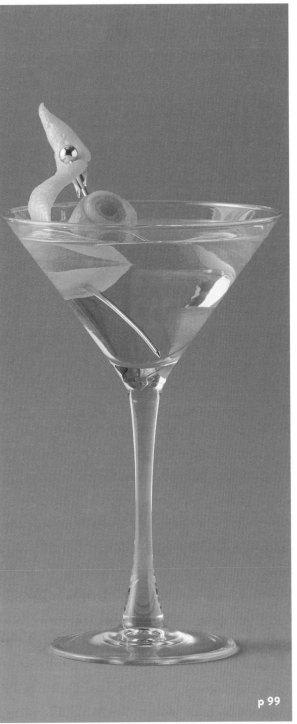

p 99

Gilda
(Spanish Pintxo)

MAKES 12 GILDAS

Gildas are popular tapas, or *pintxos*, as smaller bites are called in Spain's Basque region; they are often the first thing you pop in your mouth as you begin an evening's carousing. The flavorful dose of umami and spice makes for an epic bite that enlivens the senses. If you recognize the name of this dish as a film title, you are right; the Gilda is named after the 1946 movie starring Rita Hayworth, who is similarly salty and spicy. Piparra peppers (long and mild) and white anchovies (less salty than their cousins) are available at stores and online—and these are necessary ingredients that should not be substituted. Pair with sherry, cider, and sparkling cocktails.

12 piparra peppers
12 white anchovies
12 Spanish olives, pitted

Skewer each pepper onto a toothpick. Next, attach one end of a white anchovy followed by an olive. Finally, attach the other end of the anchovy around the olive. Repeat until all are assembled. Serve immediately.

Crudo

SERVES 4

Crudo is the Italian version of sushi-grade raw fish. Often, a fresh catch is simply doused in olive oil and finished with a scant flick of sea salt. It's simple and heavenly. Once you realize how easy crudo is to make at home, you will be sorely tempted to begin every cocktail session with a bite of spice-laced raw fish. This version employs ripe peach and jalapeño for nicely contrasting sweetness and spice. Many varieties of fish will work for this recipe, but look for yellowtail, tuna, or snapper. I like an ice-cold martini with my crudo, but tequila-based drinks as well as spritzes work too.

2 tablespoons diced peach

1 jalapeño pepper,
 seeded and sliced thinly

1 tablespoon minced red onion

¼ teaspoon kosher salt

8 ounces sushi-grade fish, cut into
 ¼-inch-thick slices

2 tablespoons extra-virgin olive oil

¼ teaspoon sea salt

1 lemon wedge, for garnish

In a small bowl, toss peach, jalapeño, and red onion with salt. To serve, arrange fish on a plate and top each slice with peach mixture. Finish with olive oil and sea salt; garnish with the lemon wedge.

Ceviche

SERVES 4 TO 6

It seems to me that ceviche is less a dish than a way of life. When I'm in the tropics, it's easy for me to consume it every day. It's fresh. It's light. It's acidic. It positively glows with vibrant flavors and textures. This is a quick scratch method I use often, more of a template than a recipe. Feel free to add whatever you like; avocado, corn, mango, tomato, and shrimp are some of my favorite add-ins. Note that you want to completely submerge the fish in the lime juice to "cook" it.

1 pound red snapper, grouper, or flounder, cut into ¼- to ½-inch cubes

2 garlic cloves, chopped finely

1 tablespoon seeded and minced jalapeño pepper

½ cup red onion that has been sliced thinly into half-moons

2 tablespoons chopped fresh cilantro

¾ cup fresh lime juice

2 tablespoons fresh lemon juice

½ teaspoon kosher salt

¼ teaspoon freshly ground black pepper

In a medium-size serving bowl, combine fish, garlic, jalapeño, red onion, cilantro, lime juice, lemon juice, salt, and black pepper. Cover and marinate in the refrigerator for at least 30 minutes and up to 4 hours.

Leche de Tigre
(Milk of the Tiger)

Looking for a hangover cure? Peruvians believe the juice left-over from making ceviche will wipe away a previous night's debauchery. Pour the remaining ceviche juices into a sealable jar, refrigerate—and be sure you have the additional ingredients on hand to ease the rough morning-after.

2 ounces ceviche marinade
1 cucumber slice, for garnish
1 slice of lime, for garnish

Add ceviche marinade to a rocks glass filled with ice and garnish with cucumber and lime slices.

Gin-Cured Gravlax

SERVES 10

Gravlax gets its name from the Germanic word for "grave"; originally the fish was buried in the ground to cure. Today, we simply pop the salmon in the fridge. A Nordic delicacy and often served as an appetizer, gravlax can be pricey—but once you make it on your own you'll never go back. It is elegant, easy, and a huge hit at parties. Marinating fish in citrus, spices, and gin makes for a dish that is not only delicious but making it from scratch feels like an accomplishment. Serve with everything bagels or The Cracker (page 167) along with crème fraîche, sliced red onion, and capers. Gravlax is ideal with gin—and aquavit.

½ cup coarse sea salt

¼ cup light brown sugar

1 tablespoon grated lemon zest

1 tablespoon ground white peppercorns

1 tablespoon ground juniper berries

1 teaspoon ground coriander

½ cup chopped fresh dill

¼ cup London Dry gin

2½ pounds salmon fillet, skin on

In a medium-size bowl, combine salt, brown sugar, lemon zest, ground peppercorns, juniper berries, coriander, dill, and gin; the mixture will resemble wet sand. On a baking sheet lined with plastic wrap, spread one-third of the curing mixture. Arrange the salmon fillet, skin side down, on top. Rub the remaining mixture over the salmon; cover with an additional piece of plastic wrap and top with a second baking sheet. Place something heavy, such as a 28-ounce can of tomatoes, on top of the second baking sheet. Refrigerate for 2 days. Rinse excess mixture from salmon and pat dry. Transfer salmon to fresh plastic wrap and refrigerate for another 24 hours. To serve, cut in thin slices at a 45-degree angle. Use within 2 to 3 days.

Swordfish Spiedini

SERVES 4

Spiedini means "skewer" in Italian. In this rendition, swordfish is marinated in spices before being grilled to perfection and finished with sea salt. The result is a quick crowd-pleaser that is simple yet enchanting. What's more, the char on the swordfish makes this a good foil for whiskey-based cocktails. An old-fashioned with . . . fish? Try it.

1 pound swordfish steak, cut into
 1-inch cubes

2 tablespoons extra-virgin olive oil

2 garlic cloves, minced

1 tablespoon dried rosemary

¼ teaspoon freshly ground black pepper

1 teaspoon sea salt

1 lemon, cut into wedges, for serving

In a resealable plastic bag or sealable container, combine swordfish, olive oil, garlic, rosemary, and pepper. Marinate, refrigerated, for 1 hour. If using wooden skewers, presoak four of them while fish is marinating. Thread swordfish onto skewers. Grill over high heat until charred on all sides and cooked through, about 8 minutes. Finish with sea salt and serve with lemon wedges.

Cocktail Pâté

SERVES 4 TO 6

My cocktail pâté is based on Gentleman's Relish, a brand of herbed anchovy paste created in the early 1800s and still sold today. It is a classic British condiment every cocktailer should know. Now, I know you're probably grimacing—but once you sample this spread's intense umami charms, you'll be a believer too! The original recipe is a closely guarded secret, and most re-creations use loads of butter. I've substituted yogurt—the result is still rich but not nearly as heavy. Mace is the secret ingredient here, the perfect spice for rich seafood (unsurprisingly, a major component in Old Bay). This relish can be served on crackers, cucumber slices, or stuffed into tomatoes—but the real cocktailers' delight is to sandwich the spread between two pecan halves. Legendary.

1 (4-ounce) can sardines in olive oil

1 teaspoon fresh lemon juice

½ cup plain yogurt

¼ teaspoon Dijon mustard

1 to 2 teaspoons grated onion

⅛ teaspoon ground mace or freshly grated nutmeg

⅛ teaspoon ground white pepper

1 tablespoon finely chopped fresh flat-leaf parsley, for garnish

In a food processor, combine sardines and their oil, lemon juice, yogurt, mustard, onion, mace, and white pepper until smooth. Serve in a small dish and garnish with parsley.

Piri-Piri Shrimp Cocktail

SERVES 6

Boiled and bland makes way for charred and spicy in this shrimp cocktail for the new millennium. When the Portuguese first reached South America in the sixteenth century, they discovered a bird's eye pepper. This pepper then spread far and wide throughout their empire to spots as far-flung as Malaysia and Africa, where it became known as the piri-piri. In the US, you often find piri-piri sauce on chicken, and it is fantastic on shrimp. After visiting Portugal and bringing a bottle of piri-piri sauce back, it wasn't long before I was including it at happy hour. Here, an old-school cocktail staple meets the brave new spice world. Try with martinis.

SHRIMP:

1 tablespoon olive oil

2 tablespoons fresh lemon juice

1 tablespoon peeled and
 minced fresh ginger

2 garlic cloves, minced

½ teaspoon salt

½ teaspoon freshly ground black pepper

¼ teaspoon piri-piri sauce

2 pounds medium-size or large peeled
 and deveined shrimp (tails on)

In a medium-size bowl, combine olive oil, lemon juice, ginger, garlic, salt, black pepper, and piri-piri sauce. Add shrimp and toss to coat. Marinate, covered and refrigerated, for 30 minutes to 1 hour. Arrange an oven rack in top position and spread shrimp on a sheet pan. Broil shrimp on HIGH for 2 minutes, flip, and broil for an additional 2 minutes. Transfer shrimp to a dish and serve with cocktail sauce (recipe follows).

COCKTAIL SAUCE:

½ cup ketchup

2 tablespoons prepared horseradish

2 teaspoons fresh lemon juice

¼ teaspoon piri-piri sauce

Combine all sauce ingredients in a small bowl and refrigerate until needed.

Origin of the Shrimp Cocktail

Ever wonder why there is a classic appetizer called shrimp cocktail? Every American knows the combination of boiled shrimp served cold with "cocktail" sauce—a mix of ketchup and horseradish that James Beard dubbed "the red menace" (he wasn't a fan). One theory is that it began in England; fancy Victorian dinner parties commenced with a first course of cold shellfish accompanied by sherry or brandy. According to this theory, the word *cocktail* simply fused with shellfish over time because the two were served together. But there is good evidence that the dish has a lowlier, and more interesting, origin. In this alternate version, the oyster cocktail has its origins in San Francisco, where a combination of oysters and red sauce were consumed as a drink in the morning. This concoction appeared in the 1860s and then morphed into the (not slurpable) shrimp cocktail as shrimp became more popular around the turn of the twentieth century.

Pickled Shrimp

SERVES 4 TO 6

A southern classic, pickled shrimp is as delightful to behold as it is to eat; the layering effect of the shrimp, fennel, and lemon will thrill guests. This is an ideal dish to make well in advance of company, and may become one of your staple finger foods—simple but elegant. The vinegary shrimp is ideal with such cocktails as juleps and bourbon sweet tea.

SHRIMP:

¼ cup fresh lemon juice

2 tablespoons sugar

1 cup sliced onion

2 tablespoons kosher salt

1 pound raw shrimp, peeled and
 deveined with tails on

PICKLING MARINADE:

½ lemon, sliced thinly

1 cup thinly sliced fennel bulb

2 garlic cloves, halved lengthwise

1 tablespoon capers and their juice

2 teaspoons yellow mustard seeds

½ teaspoon celery seeds

½ teaspoon crushed red pepper flakes

½ teaspoon kosher salt

¾ cup cider vinegar

1 cup extra-virgin olive oil

In a large saucepan, combine lemon juice, sugar, onion, and salt with 5 cups water and bring to a boil. Prepare a large bowl of ice water. Add shrimp to boiling water and cook, uncovered, until cooked through, about 3 minutes. Remove shrimp from boiling water and plunge into ice water. Remove shrimp from ice water and set aside.

Layer cooked shrimp, lemon slices, and sliced fennel into a 1-quart canning jar or crock. Add capers, mustard seeds, celery seeds, red pepper flakes, and salt. Pour in cider vinegar and oil; seal jar and shake gently to combine. Chill jar in refrigerator overnight for flavors to blend; serve chilled.

Potted Shrimp

SERVES 4

A classic English preparation traditionally found at teatime, this dish features sweet shrimp ensconced in seasoned butter. The result is a true delight that is also practical—the shrimp is preserved in the butter and can last in the refrigerator for weeks. That means potted shrimp can be made well in advance of a cocktail party. The dish is also a favorite of a certain well-known spy. Ian Fleming transferred his love of potted shrimp to his fictional character, James Bond. The right move here is to fix a round of Vespers (recipe follows) and dive into this venerable delicacy.

8 ounces (2 sticks) unsalted butter

1 tablespoon minced shallot

⅛ teaspoon ground mace

⅛ teaspoon cayenne pepper

1 pound shrimp, shelled and chopped

½ teaspoon anchovy paste

1 tablespoon fresh lemon juice

¼ teaspoon kosher salt

In a medium-size pan over medium heat, cook butter and shallot together until shallots are translucent, about 3 minutes. Add mace and cayenne, stirring to combine. Add shrimp and cook until pink and just cooked in the center, about 5 minutes. Remove from heat and add anchovy paste, lemon juice, and salt. Using a slotted spoon, transfer shrimp to a ramekin or bowl (or divide between two smaller ramekins) and spoon the remaining butter over them. Be sure shrimp does not break the surface of the liquid; add more melted butter if necessary. Chill in refrigerator until butter sets; potted shrimp will keep for 2 weeks in the refrigerator, and can also be frozen. Bring to room temperature before serving with lemon wedges and toast or The Cracker (page 167).

Vesper

Named for evening prayers—the golden hour when serious cocktailing begins—the Vesper may be the most famous drink in fiction. The original James Bond recipe calls for Gordon's gin and vodka plus a half-measure of Kina Lillet. A couple of changes are required to make the drink today because Kina Lillet is no longer available, and Gordon's gin is no longer 94-proof as it was in Ian Fleming's time: switch to Cocchi Americano and Tanqueray instead. Also, forgo shaking (that was Fleming having a laugh at Americans' expense) and stir the drink.

3 ounces Tanqueray
1 ounce vodka
¼ ounce Cocchi Americano
Lemon twist, for garnish

Stir all ingredients, except garnish, with ice and strain into a chilled martini glass. Garnish with a lemon twist.

Génépy Trout Rillette

SERVES 4

Rillette is a French method of preserving meat in fat. A common example is pork, but this velvety trout version is easier to accomplish and a wonderful cocktail snack—plus, it travels well. This is a classy spread guests will adore. While sometimes made with absinthe, I use génépy instead, a wonderful alpine liqueur that is less bitter and slightly minty. Note that the crème fraîche can be replaced with cream cheese. Génépy is a lovely ingredient in refreshing summer cocktails; try a simple génépy and tonic for a stellar pairing.

8 ounces smoked trout
1 tablespoon minced shallot
½ cup crème fraîche
1 tablespoon minced fresh dill
1 tablespoon génépy
Zest of ½ lemon
1 teaspoon fresh lemon juice
⅛ teaspoon ground mace
¼ teaspoon freshly ground black pepper

In a medium-size bowl, combine trout, shallot, crème fraîche, dill, génépy, lemon zest and juice, mace, and pepper. Transfer to a serving bowl and serve with toast or The Cracker (page 167).

Cornmeal–Encrusted Oysters

SERVES 4

Raw oysters are one of the most famous cocktail accompaniments; think cold bivalves and martinis or Pimm's Cups. But what about cooked ones? Over the years, after many a Rockefeller, I've found that adding cornmeal brings a flavor I crave. Plus, it takes oysters in a more rum- and whiskey-friendly direction—ideal for backyard barbecues. Pair these with classic New Orleans cocktails.

1 tablespoon panko bread crumbs

1 tablespoon cornmeal

2 tablespoons grated Parmesan cheese

1 teaspoon lemon zest

1 dozen fresh oysters on the half shell

3 tablespoons melted unsalted butter

Preheat oven to 425°F. On a large plate, combine bread crumbs, cornmeal, cheese, and lemon zest. Remove oysters from shell, reserving shells; dip oysters in melted butter and roll in bread crumb mixture. Arrange oysters on their shells on a baking pan. Bake for 10 minutes, or until golden and crispy.

Fried Mussels
with Aleppo Pepper Sauce

SERVES 4

What is a mussels dish from Armenia doing in a cocktail food book? I became interested in Armenia because it is a Christian nation on the edge of the Muslim world—and as such, does not have the same interdiction against alcohol. This makes it an especially fascinating locale to explore with regard to drinking food. This crave-worthy conversation starter—meant to be consumed alongside cocktails—is adapted from the great cookbook author Sonia Uvezian. It is spectacular—all crunch and delicious sauce wrapped in fresh lettuce leaves. What more could you want from a cocktail bite?

FRIED MUSSELS:

2 cups vegetable oil

½ cup all-purpose flour

2 large eggs, beaten

24 mussels (out of their shell)

12 butter lettuce leaves

In a Dutch oven or saucepan, heat oil to 365°F. Spread flour on a plate and place eggs in a medium-size shallow bowl. Wash, drain, and dry mussels. Toss mussels in flour to coat thoroughly and then dip in egg. Fry in batches until golden brown, about 1 minute. Transfer to a wire rack or plate lined with paper towels to drain. Serve hot in lettuce leaves with Aleppo pepper sauce (recipe follows).

ALEPPO PEPPER SAUCE:

½ cup walnuts

1 garlic clove

2 slices white bread, crusts removed

½ cup extra-virgin olive oil

1 tablespoon red wine vinegar

½ teaspoon Aleppo pepper

¼ teaspoon kosher salt

In a food processor, pulse walnuts and garlic until finely chopped. Add bread and pulse until combined. Add olive oil, vinegar, Aleppo pepper, and salt; process until smooth. Refrigerate for a few minutes before serving.

Salt Cod Fritters

SERVES 6

Salt cod originated as a way for sailors to preserve their catch. It can be difficult to work with because it must be rehydrated in water—and done incorrectly can leave the cod too salty. This is likely my favorite way to prepare salt cod, one I feel is absolutely worth the time and effort. A version of these delicious fritters exists in many spots in the Caribbean, and a single taste will transport you to a world where your toes are in the sand and there is a lagoon-blue horizon. I've based my recipe on *accras de morue* from the island of Martinique. One of the world's greatest cocktail snacks, it pairs perfectly with rhum agricole cocktails, such as Ti' Punch (recipe follows).

8 ounces salt cod

3 cups peanut or vegetable oil

1 cup all-purpose flour

1 large egg

1½ teaspoons baking soda

½ cup water

¼ cup chopped fresh flat-leaf
 parsley leaves

3 scallions, chopped roughly

½ Scotch bonnet or habanero pepper,
 seeds and stem removed, minced

In a large bowl, soak salt cod for at least 8 hours or overnight in enough cold water to cover it, changing water several times. In a Dutch oven or saucepan, heat oil to 365°F. Drain cod and puree in a food processor. Add flour, egg, baking soda, and water; pulse until thoroughly combined. Transfer mixture to a medium-size bowl and stir in parsley, scallions, and Scotch bonnet pepper. Using a spoon, form teaspoon-size balls and fry in batches until fritters are golden brown on all sides and cooked through, 3 to 4 minutes. Using a slotted spoon, transfer to drain on a wire rack or plates lined with paper towels. Serve hot.

Ti' Punch

Ti' Punch is the national cocktail of Martinique. It is based on rhum agricole, which is distilled from fresh rather than fermented cane juice or a by-product, such as molasses. Often, the ingredients for Ti' Punch will be put in front of the imbiber so they can assemble it themselves. As they say on the island, "*Chacun prépare sa propre mort*," or "Prepare your own death." It's a fun ritual to set up for guests—simply set out all the ingredients and let them construct the drink. Note that cane syrup, such as Steen's, can be purchased at liquor stores or online.

1 lime wheel
1½ ounces rhum agricole
1 bar spoon cane sugar syrup

Squeeze lime wheel into a rocks glass. Add rum and syrup. Top with ice, if desired.

Sichuan-ish Salmon

SERVES 4 TO 6

Welcome, imbiber. Here, I present a Sichuan-inspired salmon recipe that will be your new best hangover friend. Life-giving, collagen-rich salmon gives its body and spirit so that you might live to see another day. The sauce is sweet and addictive, and there's a bite of Sichuan peppercorns to enliven your senses. With rice, this dish makes for an impressive meal, and you may find yourself returning to it again and again. Note that many fish counters sell scraps inexpensively by the pound.

1 tablespoon Sichuan peppercorns

1 tablespoon cornstarch

⅜ cup water

1 tablespoon peanut oil

1 tablespoon sesame oil

2 teaspoons red pepper flakes

3 garlic cloves, sliced

10 thin slices fresh ginger, peeled

2 pounds salmon, cut into bite-size pieces

2 tablespoons soy sauce

1½ teaspoons honey

3 tablespoons Shaoxing wine

2 scallions, minced

Toast peppercorns in a saucepan or cast-iron skillet over medium heat, about 3 minutes; grind in a mortar and pestle or on a cutting board with a glass and set aside. Combine cornstarch with ⅛ cup of the water and set aside. In a medium-size sauté pan, heat peanut and sesame oils over medium-high heat and fry red pepper flakes, garlic, and ginger until fragrant, about 3 minutes. Add salmon and cook, stirring occasionally. While the salmon is cooking, combine remaining ¼ cup of water, soy sauce, honey, and Shaoxing wine. Add mixture to salmon and simmer, stirring occasionally, until salmon is cooked through, about 8 minutes. Add cornstarch mixture and simmer for 2 to 3 minutes until sauce thickens. Top with Sichuan peppercorns and scallions.

CHAPTER 7

POULTRY

Wings and chicken salad. That's likely what comes to mind when Americans think poultry and drinks. In this chapter, you will find gloriously global versions for both of these venerable bar and cocktail party staples, plus additional inspiring recipes from Japan. In my travels, I've found that the Land of the Rising Sun has most perfected the fine art of cocktailing with birds. From yakitori (skewers) to *karaage* (fried), Japanese drinking food features masterful poultry dishes. In this chapter, you will find informal, easy-to-prepare recipes that are perfect for both making a midweek meal and wowing guests.

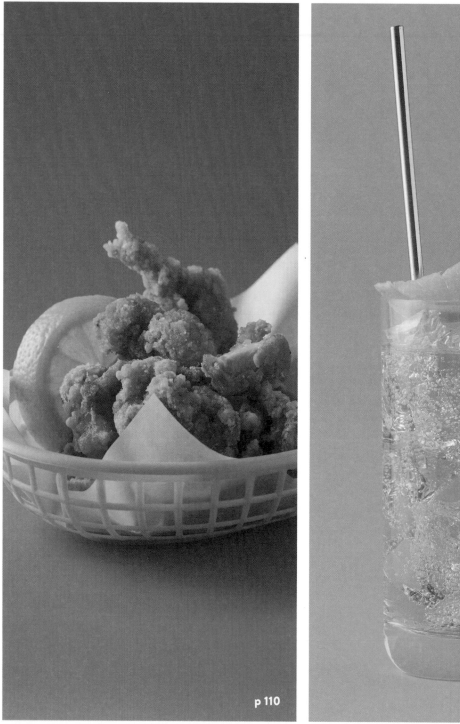

p 110

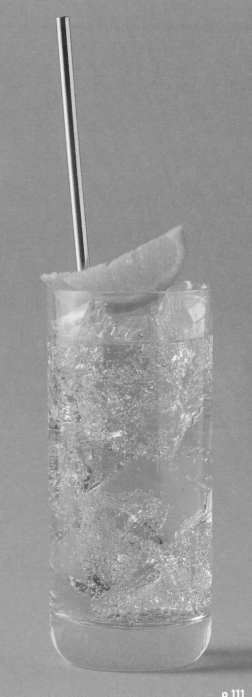

p 111

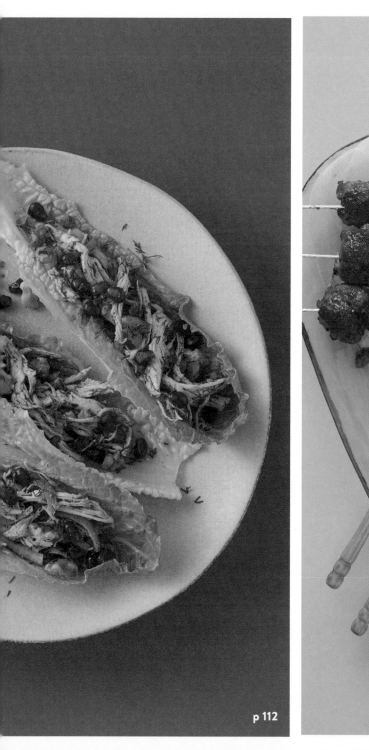
p 112

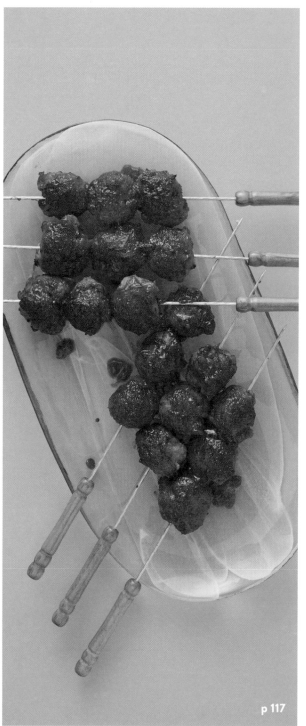
p 117

Toki Chicken Nuggets

SERVES 4 TO 6

Step into one of the many fried chicken joints in Tokyo and you will find yourself with a Toki highball in hand (recipe follows) along with karaage—bites of double-fried chicken. The nuggets are impossibly crispy and juicy. A big part of the dish's success is that the Japanese use more flavorful thighs and not breast meat. Although karaage recipes often require double-frying, this recipe employs potato starch to achieve the best possible crunch without the trouble of refrying. These nuggets are best served warm but also make great leftovers.

2 tablespoons peeled and
 minced fresh ginger
4 garlic cloves, minced
½ cup soy sauce
¼ cup sake
1 tablespoon sugar
2 pounds boneless, skinless chicken
 thighs, cut into 1-inch pieces
⅓ cup potato starch
3 cups peanut oil or vegetable oil
Lemon wedges, for serving

In a large bowl, combine ginger, garlic, soy sauce, sake, and sugar. Add chicken and stir to coat thoroughly. Cover and marinate in refrigerator for 1 hour. Drain chicken from marinade and return chicken to bowl. Add potato starch and stir to coat chicken completely. In a Dutch oven or saucepan, heat oil over medium-high heat until it is 365°F. Working in batches, fry chicken until crispy and cooked through, about 3 minutes. Transfer to a wire rack or plates lined with paper towels to drain. Serve with lemon wedges.

Toki Highball

The Japanese are very passionate about their whiskey and soda, a format that became popular in the 1950s. It is always served in a cold highball glass at the perfect temperature with the perfect ratio of whiskey to water (1:4). It may be the ultimate pairing to fried chicken.

1 ounce whiskey
4 ounces club soda
Lemon wedge, for garnish

In a cold highball glass, combine whiskey and club soda. Stir gently and garnish with a lemon wedge.

Georgian Chicken Salad

SERVES 6

Chicken salad has haunted cocktail gatherings in America since it's inception. This is likely because when cocktail parties began supplanting formal dinners, chicken was the protein everyone could agree on. Classic recipes are often bland and boring, however, and involve way too much mayonnaise. I set about hunting for a novel version I could serve at my parties and found inspiration in Georgia (the country, not the state). Similar to many of the best American salads, it includes nuts and fruit—but is livelier and not clichéd. Impressively, it includes pomegranate, which plays well with cocktails. Pair with a Brown Derby or a Singapore Sling.

2 pounds boneless chicken breasts
½ teaspoon kosher salt
¼ teaspoon freshly ground black pepper
1 tablespoon extra-virgin olive oil
4 teaspoons ground coriander
¼ teaspoon crushed red pepper flakes
½ cup thinly sliced red onion
½ cup walnuts, toasted
½ cup pomegranate seeds
½ cup chopped fresh dill
3 tablespoons red wine vinegar
Romaine lettuce leaves, for serving

Place chicken on a cutting board and cover with plastic wrap. Pound until thin and season both sides with salt and black pepper. In a large sauté pan, heat oil over medium-high heat and add chicken. Cook for 1 minute per side. Lower heat to low, cover, and cook for 8 minutes. Turn off heat and leave chicken covered and undisturbed for an additional 10 minutes. Do not lift lid or you will release the steam. Transfer to a large bowl or a stand mixer and shred chicken. Add coriander, red pepper flakes, red onion, walnuts, pomegranate seeds, dill, and vinegar. Serve immediately accompanied by lettuce leaves.

Vietnamese Chicken Wings

SERVES 4

I believe these may be the best wings in the world for cocktails. Once you taste the garlicky sweet-and-sour coating—fish sauce being the sauce's secret umami-bomb ingredient—it is difficult to return to other wings. The trick here is to fry them and then sauce them afterward, keeping the wings crispy but doused in addictive flavor. Vietnamese wings, or *cánh gà chiên nước mắm*, are ideal with rum-based cocktails but also work well with gin and whiskey.

WINGS:

1½ teaspoons garlic powder

1½ teaspoons salt

¼ teaspoon freshly ground black pepper

3 pounds chicken wings

1 cup cornstarch

In a medium-size bowl, combine garlic powder, salt, and pepper. Add chicken and toss until coated thoroughly. Cover and refrigerate for 1 hour and up to four. In a Dutch oven or sauté pan, heat oil until 365°F. Drain off excess moisture from chicken and add cornstarch, tossing to coat thoroughly. Working in batches, fry chicken until just beginning to brown and cooked through, about 8 minutes. Transfer chicken to a wire rack or plates lined with paper towels. Toss in sauce (recipe follows) and serve hot.

SAUCE:

2 tablespoons Asian fish sauce

2 tablespoons sugar

1 tablespoon fresh lemon juice

2 tablespoons water

In a small saucepan, heat together all sauce ingredients until just boiling. Turn off heat and allow sauce to cool slightly and thicken. Toss fried chicken and sauce together in a large bowl and transfer to a serving plate.

Butter Chicken Wings

SERVES 4

Butter chicken is an Indian classic that likely originated in Delhi in the 1950s. It features what may be the country's most popular sauce—which I discovered makes for impressive wings. If there's one lesson Westerners can learn from Indian cuisine, it's that we don't use enough spices in our cooking. These wings are an invigorating slap in the face to all that American blandness—they are maximal. I must admit, the name is a bit misleading because I've replaced most of the butter with yogurt in this recipe. I also like to bake the wings instead of frying them; although not entirely guilt-free, they are much lighter this way. Pair with gin and tonics or rum cocktails.

WINGS:

3 pounds chicken wings

2 tablespoons baking powder

½ teaspoon salt

¼ teaspoon freshly ground black pepper

½ cup butter sauce (recipe follows)

Preheat oven to 450°F and arrange an oven rack in the upper-middle position. Line a baking pan with foil and top with a wire rack. Pat chicken dry with paper towels, removing as much moisture as possible. In a large bowl, combine baking powder, salt, and pepper. Toss wings in mixture until evenly coated. Arrange chicken on wire rack so they are not touching and bake for 30 minutes. Flip and bake until crisp and golden brown, about 20 minutes. Remove from oven and serve with butter sauce on the side.

BUTTER SAUCE:

1 tablespoon unsalted butter

⅓ cup tomato puree

2 tablespoons spice blend (recipe follows)

1 cup plain yogurt

In a medium-size saucepan, melt butter over medium-high heat. Add tomato puree and spices; bring to a simmer. Stir in yogurt until thoroughly combined and remove from heat.

SPICE BLEND: MAKES ½ CUP BLEND

1 tablespoon garam masala

1 tablespoon light brown sugar

1 tablespoon ground cumin

1 tablespoon ground coriander

1 tablespoon onion powder

1 tablespoon garlic powder

1 tablespoon ground ginger

1 tablespoon kosher salt

In a medium-size bowl, stir together all spice blend ingredients until thoroughly combined. Store in an airtight container.

Planter's Punch

Originating in the American South, Planter's Punch is an old cocktail that has become popular again. The combination of sweet and sour make the drink ideal with Indian cuisine, particularly Butter Chicken. There are many variations of the cocktail, and several are based on the old saying, "One of sour, two of sweet, three of strong, four of weak." I prefer equal measures of sour and sweet, as listed here, but you can add sugar if you find it too puckering.

3 ounces rum
¾ ounce simple syrup
¾ ounce fresh lime juice
1 bar spoon grenadine
3 dashes Angostura bitters
1 ounce club soda

Shake rum, simple syrup, lime juice, grenadine, and Angostura bitters with ice and strain into a highball glass filled with crushed ice. Top with club soda.

Turkey Tsukune (Meatballs)

SERVES 4 TO 6

Tsukune is a Japanese-style meatball that is typically cooked yakitori style over live coals and accompanied by a rich dipping sauce. They are most often made with ground chicken thighs for rich flavor. At my parties, however, I have switched to ground turkey—US groceries sometimes won't even sell ground chicken, let alone ground thighs, and turkey is both readily available and inexpensive. The following recipe finishes the meatballs under the broiler, but they are also marvelous grilled.

TSUKUNE:

1 pound ground turkey

1 large egg, lightly beaten

1½ tablespoons grated onion

1 teaspoon peeled and finely grated
 fresh ginger

1 teaspoon soy sauce

2 teaspoons mirin

½ teaspoon kosher salt

In a medium-size bowl, combine all the tsukune ingredients thoroughly. Cover and allow to rest in refrigerator for 20 minutes. If using wood skewers, soak in water for 20 minutes. Fill a wide, shallow pan halfway with water and bring to a boil. Form meat mixture into roughly 1½-inch balls and lower into the boiling water. Working in batches if necessary, boil meatballs until cooked through, 4 to 6 minutes. Transfer to an oiled wire rack to drain. Place oven rack in top position and preheat broiler. Thread three meatballs to a skewer and arrange skewers on a baking sheet. Brush meatballs with sauce and broil for 3 minutes. Flip meatballs, basting a second time, and broil until beginning to brown, about an additional 3 minutes. Serve immediately with sauce (recipe follows).

SAUCE:

3 tablespoons tamari

3 tablespoons mirin

1½ teaspoons sugar

In a small saucepan, bring all sauce ingredients to a boil. Lower heat and simmer until reduced by one-third, about 5 minutes.

CHAPTER 8

MEAT

If there is one thing I find imbibers crave above all others while drinking, it is meat—preferably charred or doused in an unctuous sauce. It's unclear why this is, exactly—maybe the brain is hardwired to want protein with alcohol. Maybe liquor brings out our primal side. I've repeatedly watched as cocktailers—either at restaurants or parties—down a few drinks and start the prowl for barbecue, hunting for bones to gnaw. I suppose what I am trying to say is that you should expect the recipes in this chapter to live up to the challenge. The following dishes run from quick (chorizo in cider) to the more complicated (ham croquettes), and all offer a spectacular experience alongside mixed drinks. What they have in common is an intense explosion of flavor and texture—crispy, sticky, gooey, and even soupy. Whether cooking for yourself or a crowd, meat can be the single centerpiece of a cocktail session. Don't be afraid to do less; if you are making *cevapcici*, perhaps the world's greatest casing-less sausage, little else is required to make dinner or a party a success.

p 130

p 123

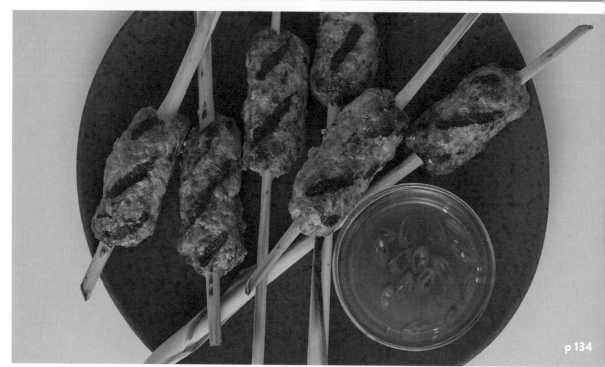

p 134

p 136

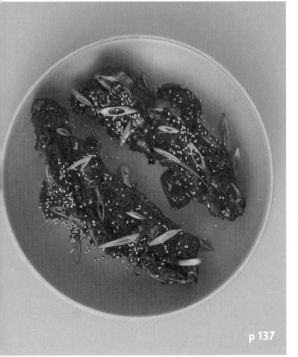

p 137

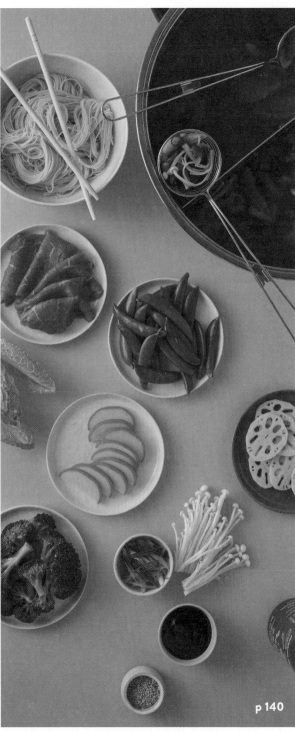

p 140

Chorizo in Cider

SERVES 4

Chorizo a la sidra hails from the Basque region of Spain, an area known for its excellent ciders, which can be acquired at cider houses called *sagardotegi*. This is a frequent go-to party or meal starter for me, as it is simple and quick. Note that Spanish chorizo is distinct from Mexican; it is firmer, flavored with paprika rather than chiles, and less fatty. You will be pleasantly surprised at the contrast between spice and the residual sweetness from the reduced cider. This is a great pairing with calvados- or applejack-based cocktails, such as the Stone Fence. But really it works with most cocktails, including the gin and tonic.

1 pound semicured Spanish chorizo

1 tablespoon extra-virgin olive oil

1 cup dry hard cider

1 bay leaf

1 tablespoon chopped fresh flat-leaf parsley, for garnish

Slice chorizo into ½- to 1-inch pieces and set aside. In a medium-size sauté pan, heat olive oil over medium heat. Add chorizo and fry until starting to brown on all sides, about 5 minutes. Add cider and bay leaf; stir to coat chorizo. Lower heat and simmer for 30 minutes, or until cider has reduced and thickened. Spoon into a serving dish, remove bay leaf, and garnish with parsley.

Pho Marrow Bones

SERVES 4

The popularity of marrow bones in the US can be traced back to Fergus Henderson, an English chef who has exerted an enormous influence on American cuisine. The famous version at his London restaurant, St. John, is a lesson in contrasts and panache—it is an elegant composition of roasted whole marrow bones buried in a parsley salad. Similar marrow dishes seeped onto bar menus in America until, at some point, bartenders used the spent bones as a vehicle for shots (recipe follows). The "bone luge" became an unforgettable craze. With its buttery texture and fattiness, the marrow itself is a stupendous cocktail pairing. I like to prepare marrow bones pho style, resulting in flavors that are reminiscent of the Vietnamese soup. If you're looking for a real showstopping statement dish at your next party—this is the one.

¼ teaspoon ground ginger

¼ teaspoon sugar

¼ teaspoon freshly ground black pepper

⅛ teaspoon ground cinnamon

⅛ teaspoon ground star anise

¼ teaspoon kosher salt

3 pounds marrow bones, cut lengthwise

1 small red onion, sliced thinly

2 tablespoons chopped fresh cilantro

1 jalapeño pepper, sliced into thin rounds

1 lime, cut into wedges

Preheat oven to 450°F. In a small bowl, combine ginger, sugar, black pepper, cinnamon, star anise, and salt. Place marrow bones, cut side up, on a baking sheet or ovenproof skillet and sprinkle with the spice mixture. Roast until bones are lightly browned, about 15 minutes. Serve immediately with red onion, cilantro, jalapeño, and lime wedges.

Sherry Bone Luge

The bone luge may have its detractors, but it works. As liquor descends through a cooked marrow bone, it becomes infused with exquisite flavor from the bits of fat and char. The best candidates for sipping through a luge are ones that will meld well with cooked fat and saltiness; aged whiskey, rum, and port are all great. So are tequila, calvados, and such cocktails as Manhattans and Negronis. Many cocktailers believe sherry is the ultimate luge liquid, preferably amontillado—but test that theory with your own choices.

1 marrow bone, cooked and free of marrow
and other obstructions
2 ounces sherry

Raise a marrow bone at a 45-degree angle to your mouth and pour sherry at the top, allowing the liquid to go through the sluice and into your mouth. Don't wear your favorite shirt.

Cuban Ham Croquettes

MAKES 20 CROQUETTES

Ham croquettes are a popular bar tapa in Spain. Their shatteringly crisp exterior yields a soft and creamy interior suspending bits of salty ham—truly heavenly. Croquettes also appear in Cuban cuisine, where they sport a minor-yet-game-changing difference: a squeeze of fresh lime juice. When I had my very first bite of the Cuban version, I felt like the dish was utterly transformed, becoming what it had always meant to be; the lift of fresh acidity takes a wonderful experience into the sublime. I think you will agree—this is peak cocktailing food, brilliant with island drinks such as daiquiris and Mojitos.

4 tablespoons (½ stick) unsalted butter
2 tablespoons minced onion
1 cup all-purpose flour
1 cup whole milk, at room temperature
¼ teaspoon freshly grated nutmeg
½ teaspoon freshly ground black pepper
1 tablespoon white wine or sherry
1 pound cooked ham, diced
2 large eggs, lightly beaten
1 cup bread crumbs
3 cups vegetable oil, for frying
Lime wedges, for garnish

In a medium-size saucepan, melt butter over medium heat. Add onion and sweat for 1 minute. Add ½ cup of the flour and slowly whisk in milk until mixture forms a paste. Add nutmeg and pepper; continue to whisk until the sauce thickens. Add wine and ham. Lower heat to low and simmer for 5 minutes. Transfer mixture to a medium-size bowl and refrigerate, covered, for 2 hours. Place eggs in a shallow bowl and set aside. Spread the remaining ½ cup of flour on a plate; do the same with the bread crumbs on a separate plate. Form filling mixture into 1 x 3-inch cylinders. Roll each croquette in the flour, then the egg, and coat in bread crumbs. In a Dutch oven or saucepan, heat oil to 365°F. Working in batches, fry croquettes until golden brown, 3 to 4 minutes. Using a slotted spoon, transfer to a wire rack or plates lined with paper towels to drain. Serve hot with lime wedges.

Seven-Year Pork Belly

SERVES 6 TO 8

I love teasing guests with a bite of something when they first arrive. This is the oldest trick in the book, getting guests excited for what's to follow with an initial gift from the kitchen. There is no better dish to do this than crispy pork belly slathered with a version of an eighteenth-century recipe for ketchup. Here, I've adapted a recipe for seven-year ketchup from the *Colonial Williamsburg Cookbook*—seven years being long enough that "it will carry to the East Indies" on a sailing vessel unspoiled. This is a cocktail soirée starter like no other and goes with nearly all libations. Pair with rum-based drinks for the full maritime experience (recipe for Bumbo follows).

PORK BELLY:

2 pounds pork belly

1 tablespoon sugar

1 tablespoon salt

Score the top of the belly with a knife, being careful not to penetrate all the way into the meat. Sprinkle belly with sugar and salt, cover, and refrigerate overnight. Preheat oven to 425°F and place a wire rack on a baking sheet lined with tinfoil. Cut belly into roughly 1-inch-wide strips. Baste belly with ketchup (recipe follows) and cook, fat side up, for 30 minutes. Lower temperature to 325°F, baste again, and roast for 2 hours. Transfer belly to a cutting board and cut into 1-inch cubes. Serve immediately.

KETCHUP:

2 tablespoons molasses

2 tablespoons cider vinegar

2 teaspoons Asian fish sauce

1 teaspoon ground mace

1 teaspoon ground ginger

½ teaspoon ground cloves

½ teaspoon garlic powder

1 teaspoon kosher salt

In a small bowl, combine all ketchup ingredients.

Of Cocktails and Ketchup

It is important that we mixed-drink imbibers remember where we came from. Today, bars may be using roto-evaporators, centrifuges, and other advanced equipment, but the cocktailer's other foot will always be planted firmly in the seventeenth century. That is when maritime spice routes were established in earnest, beginning with the Portuguese and continuing with the Spanish, Dutch, and English. Punch was born during this era, as was the El Draque—named for Sir Francis Drake—which transformed into the daiquiri. Also during this time, rum-swilling sailors picked up what we now know as ketchup in the East Indies. The condiment was originally a spicy vegetable and fish sauce used to flavor bland rations. Only later would ketchup become the sugary tomato sauce we now know. Early colonial "catchups" were made with mushrooms, cucumbers, and even blueberries.

Bumbo

Here be the cocktail of pirates. Think of bumbo—also known as bumbu and bumboo—as Navy Grog (rum and water) gone fancy. The base ingredients are rum, water, sugar, nutmeg, and sometimes cinnamon. The result tastes a bit like a toddy . . . well, exactly like a toddy. But add any fruit juice—as pirates likely did when they could—and the drink takes a tiki turn that makes bumbo the world's first umbrella drink. Heck, go a little crazy—swap in coconut water. Rest assured, the corsairs did—there is no pirate cocktail code. Modern versions often add grenadine, but I find guava or passion fruit to be better fruit juice additions. Yarrr!

2 ounces rum
1 ounce fruit juice
1 ounce water
½ ounce simple syrup
¼ ounce fresh citrus juice
Pinch of freshly grated nutmeg, for garnish
Pinch of ground cinnamon, for garnish

Combine ingredients in a mug and stir. Garnish with nutmeg and cinnamon.

Beef Negimaki

SERVES 6 TO 8

There is nothing in the global cocktail food repertoire quite like these Japanese hand rolls. They are beautiful to behold—reminiscent of a pink and green sushi roll—but also have divine flavor and texture. Think buttery charred steak and sharp scallion together with a sweet-and-sour sauce. And while the recipe may seem fussy, they are not that difficult. Ideal for whiskey cocktails, such as the-old fashioned and Manhattan, but also perfect with tequila- or sake-based drinks.

¼ cup soy sauce
¼ cup sake
¼ cup mirin
1 tablespoon peanut or vegetable oil
24 scallions, trimmed to 6 inches in length (remove whites and tips)
1 pound flank steak

In a small bowl, combine soy, sake, and mirin; set aside. Heat oil in a sauté pan over high heat and cook scallions until they are bright green, about 1 minute; set aside. Using a sharp knife set at a 30-degree angle, cut flank steak with the grain into 1½-inch-wide slices (will make about eight). Arrange slices, a few inches apart, on plastic wrap, cover with a second piece of plastic wrap, and pound to ⅛-inch thickness. Brush one side of the meat slices liberally with marinade; lay two or three scallion sections on the marinade and roll the meat around them, using a toothpick to hold the rolls closed. Set up grill for direct grilling over medium-high heat.

Reserving marinade, grill rolls until browned on all sides, about 2 minutes per side or 5 minutes total. Transfer rolls to a cutting board. In a small saucepan, bring remaining marinade to a boil and reduce until slightly thickened, about 4 minutes. Cut each roll into six 1-inch slices, arrange on a serving platter, and drizzle with sauce.

Italian Riviera Meatballs

SERVES 6 TO 8

Meatballs are the perfect snack or meal—low commitment, high protein and enjoyment. A cocktailer's kind of food. These meatballs rise above the crowd due to a few tricks. First, they employ fresh bread instead of dried bread crumbs. You won't believe the difference this little change makes! Second, I add butter for even more flavor and juiciness. And, last but not least, since I like a rich sauce, I've taken inspiration from the Italian Riviera, where cooks use a ménage à trois of anchovies, walnuts, and tomatoes. The sauce employed here is typically found on pasta with clams, but I believe the combination of the nuts and anchovies doubles down on the meaty, umami-ness of the meatballs.

MEATBALLS:

1 cup fresh white bread cubes

¼ cup buttermilk

1 medium-size onion, diced

1 cup chopped fresh flat-leaf parsley

1 pound ground beef

1 pound ground pork

2 tablespoons unsalted butter,
 at room temperature

¼ cup grated Parmesan-Reggiano cheese

4 large egg yolks

4 garlic cloves, minced

1½ teaspoons kosher salt

1 teaspoon dried oregano

1 teaspoon ground fennel seeds

SAUCE:

2 tablespoons olive oil

3 garlic cloves

1 tablespoon anchovy paste

1 teaspoon red pepper flakes

6 plum tomatoes, squashed

1 tablespoon tomato paste

½ cup dry white wine

½ cup finely chopped toasted walnuts

¼ teaspoon kosher salt

¼ teaspoon freshly ground black pepper

In a small bowl, soak bread in buttermilk. In a food processor, process the onion and ½ cup of the parsley. Place beef, pork, butter, cheese, eggs, garlic, salt, oregano, and fennel in a large bowl. Add bread crumb and onion mixture; mix with your hands. Place an oven rack in the highest position and preheat broiler on HIGH. Form meatball mixture into Ping-Pong-size balls and arrange on a baking sheet. Broil meatballs until browned on top, about 7 minutes; switch oven to bake. Bake at 350°F another 7 to 10 minutes or until done. Garnish with remaining parsley.

Heat oil in a medium-size saucepan over medium-high heat. Add garlic, anchovy paste, and red pepper flakes; sauté until garlic softens. Add tomatoes and tomato paste; stir to combine. Add wine, walnuts, salt, and black pepper; stir thoroughly. Serve sauce over meatballs.

Cherry Kofte

SERVES 4 TO 6

Spicy, tender, and juicy, Turkish meatballs are a great companion to cocktail o'clock; they are essentially a finger (or toothpick) food that takes very little prep. This recipe is inspired by Turkish kebabs, which are sometimes accompanied by cherry sauce. Why not incorporate the fruit into meatballs so there is no sauce required? Not only is it a ridiculously satisfying way to use extra Amarena cherry juice, but the flavor bridge makes it ideal with Manhattans. You could make a yogurt dip, but these meatballs don't really need it.

½ pound ground beef

½ pound ground lamb

2 tablespoons bread crumbs

2 tablespoons cherry juice (from Amarena cocktail cherries)

¼ cup finely chopped onion

2 garlic cloves, minced

2 tablespoons chopped dried cherries

½ teaspoon baking soda

½ teaspoon chili powder

½ teaspoon Aleppo pepper or crushed red pepper flakes

½ teaspoon dried thyme

⅛ teaspoon ground cinnamon

1 teaspoon kosher salt

½ teaspoon freshly ground black pepper

3 tablespoons olive oil

In a medium-size bowl, mix together all ingredients, except oil, until thoroughly combined. Let rest, covered, in refrigerator for at least 2 hours and up to 12 hours. Form mixture into 2-inch balls. Heat oil in a sauté pan or skillet over medium-high heat. Working in batches, cook meatballs until they are browned on all sides and cooked through, 8 to 10 minutes. Let meatballs cool for a couple of minutes before serving.

Cevapcici
(Sausage)

SERVES 6 TO 8

I remember well the first time I made sausage from scratch with friends. After researching for days, selecting the right meats, grinding said meats by hand, figuring out the appropriate fat ratio, and ordering additional supplies, we began loading a casing using the sausage attachment on a KitchenAid mixer. We were so excited with our initial success that no one had the presence of mind to know what came next (which was to either coil or twist and spin the sausages into links). Ours just kept getting longer—and before we knew it, a monster sausage had to be supported by helpers as it extended out of the kitchen and well across the adjacent room before someone stopped it. And then . . . it burst under its own weight. Much easier is this casing-less sausage that will wow your guests (and you) with your DIY skills. This Balkan treat is typically served with flatbread and onions, similar to souvlaki, but is just as delicious without. The best part? They don't even require skewers.

1 pound ground beef

8 ounces ground lamb

8 ounces ground pork

½ cup minced onion

3 garlic cloves, minced

¼ teaspoon crushed red pepper flakes

1½ teaspoons baking soda

1½ teaspoons paprika

1 teaspoon kosher salt

1½ teaspoons freshly ground black pepper

In a large bowl, mix together all ingredients until thoroughly combined. Let rest, covered, in refrigerator for at least 2 hours or overnight. Firmly press meat into 3 x ¾-inch cylinders. Grill sausages over medium-high direct heat until cooked through, about 8 minutes. Let rest 5 minutes before serving.

Vietnamese Lemongrass Skewers

SERVES 4 TO 6

A popular snack in central Vietnam, these incredibly succulent and flavorful pork skewers, *nem lụi Huế*, make for thrilling cocktail party fare. What's more, they feature lemongrass stalks that work as serving utensils. In the Vietnamese city of Huế, the skewers are often served with a peanut sauce. However, they are also fantastic with *nuoc cham*, a type of sweet, sour, and salty vinegar sauce that I use here. The sausages can be removed from the lemongrass skewers and eaten with lettuce leaves or made into a sandwich with baguette bread. Best paired with sours such as a daiquiri.

PORK SKEWERS:

1 pound ground pork

2 teaspoons sugar

2 tablespoons soy sauce

2 teaspoons Asian fish sauce

1 tablespoon minced garlic

1 tablespoon minced red onion

½ teaspoon freshly ground black pepper

12 to 15 lemongrass stalks, outermost
 layer removed

In a medium-size bowl, combine all ingredients, except lemongrass, and refrigerate, covered, for at least 2 hours or overnight. Set up a grill for direct grilling over medium-high heat. Form pork mixture into 2- to 3-inch sausages around tip of the lemongrass stalks. Grill until just beginning to brown and cooked through, 6 to 10 minutes. Serve immediately with nuoc cham (recipe follows).

NUOC CHAM:

½ cup hot water

¼ cup sugar

3 tablespoons Asian fish sauce

1 Thai bird's eye chile, sliced thinly

2 garlic cloves, minced

¼ cup fresh lime juice

In a small bowl, combine hot water and sugar; stir until dissolved. Add fish sauce, chile, garlic, and lime juice; stir to combine.

Filipino-Style Barbecue Pork Skewers

SERVES 6

The appeal of this Filipino barbecue is twofold. One, you can use shoulder meat, meaning you can feed skewers to an army inexpensively (shoulder is a tough cut, however, so it is usually braised, but in this recipe, it breaks down in the marinade). The second bonus is the incredible flavor. This is one grilled piggy you will find yourself craving again just a few days later. Just beware that no matter how many skewers you make, they will be gone in minutes. Charred pork on a stick? If there is a cocktail it won't pair with, I dare you to find it. Note that banana ketchup is readily available in Asian markets and online.

¾ cup soy sauce

½ cup banana ketchup

½ cup light brown sugar

¼ cup distilled white vinegar

¼ cup pure lemon juice

3 tablespoons oyster sauce

1 teaspoon sesame oil

12 garlic cloves, minced

1 tablespoon freshly ground black pepper

3 pounds pork shoulder, sliced thinly into 2-inch-long strips

In a large bowl, combine soy sauce, banana ketchup, brown sugar, vinegar, lemon juice, oyster sauce, sesame oil, garlic, and pepper. Transfer ½ cup of the marinade to a sealed container and refrigerate. If using wood skewers, soak in water for 20 minutes before grilling. Add pork to remaining marinade, cover, and refrigerate for at least 4 hours or overnight. Set up a grill for direct grilling over medium-high heat. Thread pork onto skewers. Grill pork, basting with the unused marinade until cooked thoroughly, 2 to 3 minutes per side. Remove from grill and serve.

Antrim Cocktail

Famed drinks writer Charles H. Baker Jr. circumnavigated the globe between the two World Wars. He wrote about it in *The Gentleman's Companion*, a funny, erudite book detailing his many travels, including to the Far East. At the time, the Philippines were a hotbed for good cocktailing, and Baker frequently mentions bartender Monk Antrim at the Manila Hotel. Walter "Monk" Antrim's signature cocktail from the late 1920s is a great accompaniment to grilled meats. I follow NYC bartender Selma Slabiak in adding orange bitters to the original so as to give the drink additional focus. Note that spirituous drinks are typically stirred and not shaken, but the original instructions lead to great results. Note that if you would like fresher flavor, use ruby port.

1 ounce cognac
1 ounce tawny port
¼ ounce simple syrup
2 dashes orange bitters

Shake ingredients with ice and strain into a cocktail glass.

Sticky Flanken Ribs

SERVES 6

Flanken ribs are the same section of beef as short ribs and spare ribs but are instead cut across the bones in 2-inch sections—a popular cut for Korean barbecue. Done right, flanken ribs are flavorful and tender. This foolproof method calls for cooking the ribs slowly, grilling them for char, and then tossing them in a sticky sauce. Warning: these are highly addictive and love to pair with an old-fashioned or sour, such as a daiquiri. I use sambal olek—a chili paste that is widely available at Asian grocery stores and online—but, alternatively, you can use 2 teaspoons of red pepper flakes.

1 (3-inch) knob fresh ginger,
 peeled and minced

4 garlic cloves, minced

3 tablespoons light brown sugar

1 teaspoon toasted sesame oil

⅓ cup peanut oil

1 tablespoon sambal olek

2 teaspoons Asian fish sauce

2 tablespoons hoisin sauce

3 tablespoons cider vinegar

½ cup soy sauce

4 pounds beef ribs, cut flanken style

2 teaspoons cornstarch

1 tablespoon water

¼ cup sliced scallions, for garnish

1 tablespoon toasted sesame seeds,
 for garnish

In a large bowl, mix together ginger, garlic, sugar, sesame oil, peanut oil, sambal, fish sauce, hoisin sauce, vinegar, and soy sauce until thoroughly combined. Add ribs and stir to coat completely. Marinate ribs, covered, in refrigerator for at least 8 hours or overnight.

Preheat oven to 325°F. Reserving marinade, place ribs on a foil-lined baking sheet. Make a packet with the foil around the ribs, sealing tightly, and bake for 2 hours.

Set up grill for direct grilling over medium-high heat. Grill ribs until charred, 5 to 7 minutes per side. Transfer to a large bowl and set aside. In a small bowl, combine cornstarch with water. In a small saucepan, heat reserved marinade over medium-high heat until it boils. Lower heat, add cornstarch and water mixture; reduce until sauce thickens, about 2 minutes. Pour sauce over ribs and stir to coat. Transfer ribs to a serving platter and garnish with scallions and toasted sesame seeds.

Ropa Vieja

SERVES 8

Cuba's national dish is one of those one-pot wonders that can feed an entire party of hungry cocktailers. Although it's usually made with flank steak, I've made the switch to slow-cooked, inexpensive chuck roast to achieve the same effect. Serve with rice and beans alongside Mojitos or other Cuban cocktails; also great with Harissa Plantain Chips (page 17) and Seedy Guacamole (page 31). Despite its name, Mexican oregano is from a different plant family than Italian oregano, and is readily available, dried, at grocery stores and online. If you don't have it on hand, it's better to omit entirely.

2 tablespoons olive oil

3 pounds chuck roast

1 large yellow onion, sliced thinly

1 green bell pepper,
 seeded and sliced thinly

1 red bell pepper, seeded and sliced thinly

1 yellow bell pepper,
 seeded and sliced thinly

8 garlic cloves, minced

2 teaspoons dried Mexican oregano

2 teaspoons ground cumin

1 tablespoon paprika

1 teaspoon smoked paprika

¼ teaspoon ground allspice

¼ teaspoon ground cloves

2 teaspoons kosher salt

½ teaspoon freshly ground black pepper

½ cup dry white wine

1 (28-ounce) can diced tomatoes

1 cup water

1 large carrot, cut in half lengthwise

1 large celery stalk, washed and trimmed

2 bay leaves

¾ cup pimiento-stuffed olives,
 rinsed and drained

2 tablespoons capers, drained and rinsed

1 teaspoon distilled white vinegar

⅓ cup chopped fresh cilantro, for garnish

Preheat oven to 300°F. Heat olive oil in a Dutch oven or large ovenproof saucepan over high heat. Pat the beef dry and add to pan, browning on all sides. Remove and set aside. Lower heat to medium-low and add onion and bell peppers; cook until caramelized, about 12 minutes. Add garlic, Mexican oregano, cumin, paprikas, allspice, cloves, salt, and black pepper, stir thoroughly to combine, and cook for 1 minute more. Add wine and deglaze pan, scraping any bits that have stuck to the bottom of the pan. Add tomatoes and water.

Bring mixture to a boil, lower heat, and simmer for 5 minutes. Return the roast to the pot and nestle it in the tomato sauce with the carrot, celery, and bay leaves. Cover and roast in the oven for 3 hours, or until tender. Remove from oven, uncover, and let rest for 10 minutes. Discard the celery, carrot, and bay leaves. Shred the beef, using two forks. Stir in olives, capers, and vinegar. Serve garnished with cilantro.

Singapore Steamboat

SERVES 2 TO 4

A hot pot is a perfect setting for having cocktails. It's a communal meal that leads to great conversation and conviviality. This recipe is based on the mushroom hot pot at famed restaurant chain Haidilao, which is open late and a popular bar time destination in such locales as Singapore. Want a manicure while you wait for your table? How about tableside hand-drawn noodles? All this is possible at Haidilao, which is something like a Chuck E. Cheese for adults (in the best possible way). Don a bib and set to work on one of the best drinking experiences you can have in the world—the drunken steamboat. Just add whatever meat (or veggies) you like!

2 cups roughly chopped
 shiitake mushrooms
2 cups enoki mushrooms, separated
2 cups oyster mushrooms, separated
2 cups button mushrooms, quartered
6 cups vegetable stock
2 tablespoons goji berries
1 teaspoon black vinegar
2 tablespoons Shaoxing wine
3 scallions, chopped
2 garlic cloves, sliced
1 tomato, quartered

In a large pot over medium-high heat, combine all ingredients and bring to a rolling boil. Move pot to a burner at the table or transfer to a steamboat.

HOT POT ADD-INS:
Thinly sliced pork and beef tenderloin
 (freeze meat for 30 minutes and cut
 across the grain; dip in boiling broth until
 pink disappears, about 10 seconds)
Frozen fish cakes and crab sticks
Broccoli
Snap peas
Lotus root
Noodles
Tofu

Bak Kut Teh
(Pork Rib Broth)

SERVES 8

Singapore is one of the very top cocktail spots in the world. It's also famously one of the greatest places to eat; thousands of hawker stalls serve inexpensive cuisine. In fact, it is such a cultural phenomenon that Singapore's hawker centers have been recognized by UNESCO. Importantly for cocktailers, many food stalls are dedicated to dishes perfect for chasing away hangovers. Chief among them is likely *bak kut teh*, a peppery meat "tea" redolent of garlic and star anise. If you're in the city, you can consume it as often as you need to—it seems to be available on every street corner. The broth is served with a couple of pork ribs and cilantro and is one of Earth's great pick-me-ups. Note that dark soy sauce is an essential Chinese pantry ingredient and widely available in grocery stores and online.

8 cups water

2 tablespoons ground white pepper

1 tablespoon freshly ground black pepper

3 whole star anise pods

¼ teaspoon fennel seeds

1 teaspoon light brown sugar

1 teaspoon kosher salt

2 tablespoons peanut or vegetable oil

2 garlic bulbs, broken into unpeeled
 cloves (about 20 cloves)

2 pounds pork ribs, cut into 1-rib pieces

2 tablespoons dark soy sauce

¼ cup chopped fresh cilantro,
 for garnish

In a large stockpot over high heat, bring water, white pepper, black pepper, star anise, fennel seeds, brown sugar, and salt to a boil. Meanwhile, heat 1 tablespoon of the oil in a large sauté pan over medium-high heat and fry garlic cloves for 3 minutes. Transfer garlic to stockpot. Heat the second tablespoon of oil in the sauté pan over medium-high heat and sear pork ribs until browned, about 3 minutes. Add dark soy sauce to ribs, stirring to coat thoroughly, and transfer ribs to stockpot. Lower heat to low and simmer for 1½ hours, or until pork is tender. Serve stock in bowls with a couple of ribs in each bowl. Garnish with cilantro.

Monkey Gland Sauce

MAKES 2 CUPS SAUCE

Monkey gland sauce is a popular South African condiment with beef. Astute imbibers will recognize there is a cocktail similarly named and its origin is the same: Russian doctor Serge Voronoff. Voronoff had a peculiar theory that surgically introducing monkey testicles into humans would cure impotence and even prolong life. The good doctor frequented the Savoy Hotel in London in the 1920s, and this sauce's name is thought to have originated there among the snickering staff. At the same time, hearing stories of the doctor's exploits, Paris bartender Henry MacElhone created a Voronoff-inspired drink (recipe follows). Serve the sauce—and juicy steaks—with Monkey Gland cocktails for a true off-color experience.

2 tablespoons olive oil

1 onion, chopped finely

2 garlic cloves, minced

2 tablespoons tomato paste

4 tomatoes, chopped

1 cup fruity chutney

2 tablespoons Worcestershire sauce

2 tablespoons red wine vinegar

2 tablespoons sugar

1 teaspoon Tabasco sauce

Heat oil in a sauté pan over medium-high heat. Sweat onion and garlic until onion is translucent, about 2 minutes. Add remaining ingredients and bring to a boil. Lower heat and simmer for 30 minutes; serve warm or cold. Sauce will last in the refrigerator for 2 weeks or freeze for up to 3 months.

Monkey Gland

Harry MacElhone, proprietor of Harry's Bar in Paris, created this Prohibition-era favorite. Named for doctor Serge Voronoff's experiments in "male enhancements," it became a big hit; the *Washington Post* even printed the recipe as a special cable dispatch. While the name may be off-putting, the cocktail itself is delightful—it is an able, fruit-forward accompaniment to a steak slathered in Monkey Gland Sauce.

Absinthe, to rinse the glass
2 ounces London Dry gin
1 ounce fresh orange juice
1 teaspoon grenadine
Orange twist, for garnish

Rinse a glass with absinthe. Shake gin, orange juice, and grenadine with ice and strain into the prepared glass. Garnish with an orange twist.

CHAPTER 9

RICE

Cocktails and . . . rice? Surprising as it may be, rice snacks have been associated with mixed drinks for nearly as long they've been around. No, not biryani and rum punch—think *calas* on the streets of nineteenth-century New Orleans. These rice fritters are similar to beignets (but better). Calas appeared when New Orleans was the third-largest city in the United States and a hotbed for cocktails. We can only imagine imbibing patrons frequenting the cala-hawkers to cure a hangover. In this chapter, you'll find recipes for winning rice dishes, such as the similarly handy Japanese snacks, *onigiri*, as well as the Nigerian party staple, jollof rice—aces with summery drinks and a miracle for stabilizing guests. You'll also find a drinks-ready take on Italian rice balls, *suppli*.

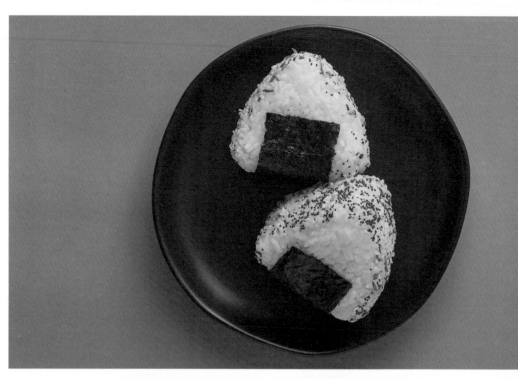

p 148

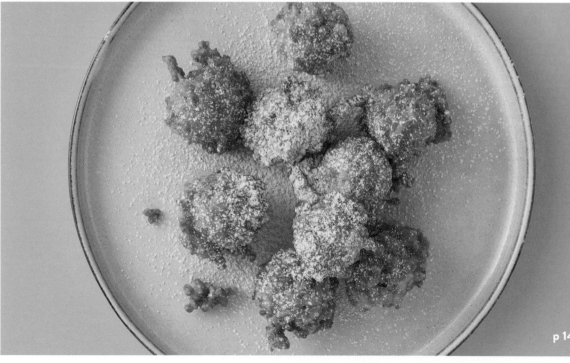

p 149

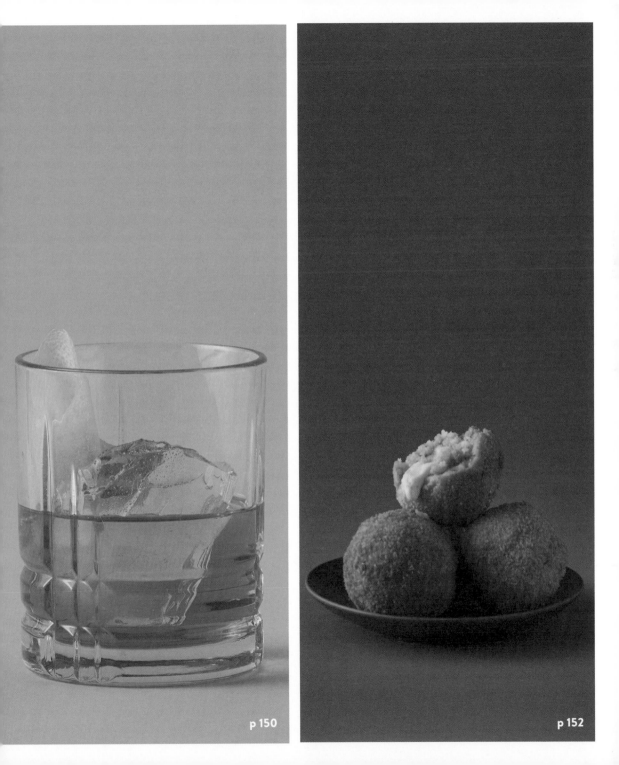

p 150

p 152

Everything Onigiri

MAKES 12 ONIGIRI

Like pasta frittata (page 72), onigiri is a fantastic to-go snack. These little Japanese rice balls—er, triangles, rather—are filled with meat or fruit. They travel well and are consumable standing, walking, or, of course, cocktailing. I have a passion for "everything" bagels and this fun recipe includes a surprise cream cheese filling to complete the experience. Onigiri are easy to make in advance—and when you serve them, watch as your guests' eyes light up with delight. Oh, and did I mention? They're gluten-free. Pairs well with shochu- and sake-based cocktails.

2 sheets roasted nori

2 cups uncooked Japanese
 short-grain rice

2½ cups water, to cook rice

4 ounces cream cheese

2 tablespoons everything bagel blend

Using kitchen shears, cut nori sheets into thirds, then cut those strips in half to produce twelve squares. In a medium-size bowl, soak rice in water for 15 minutes and drain. Transfer rice to a medium-size saucepan with 2½ cups fresh water; cover and bring to a boil. Lower heat to low and cook, still covered, for 12 minutes. Transfer rice to a medium-size bowl, fluff with a spoon, and allow to cool.

When cooled enough to touch, spread about ⅓ cup rice in the palm of your hand. Place 2 teaspoons cream cheese in the middle and gently form rice in a ball or disk around it. Place a square of nori in the center of one side. Sprinkle everything bagel blend on top of each onigiri. Serve immediately or refrigerate, tightly sealed, for up to 2 days. Serve at room temperature.

Calas

MAKES 16 CALAS

The name *cala* likely comes from the Nupe (upper Nigerian) word *kara*, which means "fried cake." Newspaper clippings from nineteenth-century New Orleans tell us that hawkers carried baskets of the rice fritters on their heads, calling out, "*Bel calas, tout chauds!*" ("Beautiful calas, very hot!"). And though these tasty morsels fell into obscurity for some time, calas are now made in New Orleans during Mardi Gras and are even available at some restaurants. They are a singular delight alongside such NOLA creations as the Vieux Carré and Absinthe Frappe, but I personally prefer them with a Sazerac (recipe follows).

3 large eggs

3 tablespoons sugar

¼ teaspoon ground cinnamon

¼ teaspoon freshly grated nutmeg

½ teaspoon salt

2 teaspoons baking powder

2 cups cooked rice, cooled

1 teaspoon pure vanilla extract

1 cup all-purpose flour

3 cups peanut or vegetable oil

¼ cup confectioners' sugar

In a medium-size bowl, beat eggs well with sugar, cinnamon, nutmeg, salt, and baking powder. Add rice and vanilla; stir until thoroughly combined. Add flour slowly until thick enough to make a batter. Heat oil in a Dutch oven or saucepan to 365°F. Working in batches, drop batter by the tablespoon into the oil. Fry until golden brown on all sides, about 4 minutes. Using a slotted spoon, transfer calas to a wire rack or plates lined with paper towels to cool. To serve, transfer to a platter and sprinkle with confectioners' sugar.

Sugarcane Sazerac

The Sazerac is famous for its two-glass method of manufacture: First, wash a rocks glass with absinthe. Then, in a separate glass, stir together sugar, bitters, and rye; you then add the contents of the second glass to the first. This version features the amped-up flavors of cane syrup, which is more complex than plain old granulated sugar. Also used in Ti' Punch (page 104), cane syrup makes for a rich, unforgettable Sazerac that reminds us of New Orleans's ancestral ties to the Caribbean and Africa.

1 bar spoon absinthe, to rinse the glass
2 ounces cognac
1 bar spoon cane syrup (such as Steen's)
4 dashes Peychaud's bitters
1 lemon peel

Coat a chilled rocks glass with absinthe. In a mixing glass, stir cognac, cane syrup, and bitters with ice and strain into prepared glass. Express lemon peel over the drink and discard.

Zobo

Zobo is a Nigerian punchlike drink made by boiling hibiscus petals, sugar, orange wedges, pineapple chunks, and ginger root to form a kind of punch. Versions of Zobo are also found in the Caribbean, notably in Jamaica. The following recipe re-creates the refreshing flavors of this winning concoction in cocktail form.

1½ ounces rum
1 ounce fresh pineapple juice
½ ounce hibiscus simple syrup (recipe follows)
½ ounce ginger liqueur (such as Canton)
½ ounce fresh lemon juice
Lemon twist, for garnish

Shake all ingredients, except garnish, with ice and strain into a cocktail glass. Garnish with a lemon twist.

HIBISCUS SIMPLE SYRUP:

1 cup sugar
1 cup water
½ cup culinary-grade hibiscus petals

In a small saucepan, bring water to a boil. Remove from heat, add sugar, and stir until thoroughly combined. Add hibiscus and let steep for 15 minutes. Strain and discard petals; store, sealed, in the refrigerator for up to a week.

Buffalo Supplì

SERVES 6 TO 8

Supplì are small rice balls that were once a Roman street food. Originally, they were filled with chicken liver or mozzarella—the latter playfully called *telefono* because the cheese resembled the cord of a telephone when pulled apart—but these days, supplì are often filled with a bit of tomato sauce and cheese. Not to be confused with *arancini*—the Sicilian rice balls that are larger and often teardrop-shaped— oblong supplì are a delicious snack with aperitivo cocktails. Here, I've Americanized them with the addition of Frank's RedHot sauce . . . and apologies to all Romans, but the update makes guests squeal with delight. Further apologies for how I cook arborio rice, which typically takes more than an hour of slow simmering; I just boil it like any other rice. Trust me—this works, and your guests will be none the wiser. It's a little hack for your kitchen shortcuts file.

2 cups water

2 tablespoons unsalted butter

1 cup uncooked arborio rice

2 whole (canned) tomatoes, chopped

1½ tablespoons hot sauce
 (such as Frank's RedHot)

2⅛ cups bread crumbs

3 tablespoons freshly grated
 Parmesan cheese

2 large eggs

¼ teaspoon salt

¼ teaspoon freshly ground black pepper

½ cup cubed mozzarella cheese

3 cups peanut or vegetable oil

½ cup all-purpose flour

4 fresh basil leaves, chopped, for garnish

In a medium-size saucepan over high heat, bring water and butter to a boil. Add rice, cover, and lower heat to low. Simmer until liquid is absorbed, about 20 minutes. Remove from heat and allow to cool. In a medium-size bowl, combine tomatoes, hot sauce, ⅛ cup of the bread crumbs, Parmesan, one egg, and salt and pepper. Stir in rice and combine thoroughly. In the palm of your hand, measure out 1 heaping tablespoon of the rice mixture and flatten. Place a cube or two of mozzarella in the middle; cover with more rice mixture, and form into a ball.

In a Dutch oven or saucepan, heat oil to 365°F. Set out separate plates or low bowls with flour, second egg (whisked lightly), and remaining 2 cups of bread crumbs. Dredge each supplì in flour, egg, and then bread crumbs. Working in batches, fry until golden brown. Using a slotted spoon, transfer to a wire rack or plates lined with paper towels to drain. Serve on a platter garnished with basil leaves.

Smoked Jollof Rice

SERVES 8

No Nigerian gathering is complete without jollof rice, a communal dish made with a special fried tomato sauce. Originating in the 1300s, this still-popular West African party food is wonderful with a variety of mixed drinks—from sours, such as daiquiris, to New Orleans cocktails that employ cinnamon-inflected Peychaud's bitters. They are traditionally made in a pot over an open fire, to which I give a nod to the old-school method by smoking the rice. The difference is remarkable and elevates this dish to sublime. Best served with fried chicken.

3 Roma tomatoes, diced

3 red bell peppers, seeded and cut
 into quarters

½ Scotch bonnet or habanero pepper

¼ cup olive oil

1 large red onion, diced

2 tablespoons tomato paste

2 teaspoons curry powder

½ teaspoon dried thyme

1 bay leaf

1 teaspoon kosher salt

3 cups chicken stock

2 cups smoked rice (recipe follows)

In a blender, combine tomatoes, bell pepper, and Scotch bonnet pepper until smooth. In a medium-size saucepan over medium-high heat, reduce mixture by half, stirring occasionally, about 10 minutes. In a medium-size sauté pan over medium-high heat, heat olive oil and cook red onion until translucent, about 2 minutes. Add reduced tomato mixture and cook until fragrant, burning off any extra moisture, about 4 minutes. Stir in tomato paste, curry powder, thyme, bay leaf, and salt; cook for an additional 2 minutes. Add chicken stock and bring mixture to a boil. Add smoked rice and stir. Cook, covered, over low heat for 17 to 20 minutes. Turn off heat and let rest, covered, for an additional 4 minutes. Fluff and serve.

SMOKED RICE:

1 pound uncooked white rice
 (such as basmati)

Soak two chunks of hardwood (such as apple) in water for at least 30 minutes, then drain.

In a grill or grill box, light three charcoal briquettes; top with the two chunks of wood. Pour rice into a medium-size cake pan or baking dish. When the wood begins to smoke, place the rice on the main cooking grate as far away from the charcoal and wood as possible. Cover grill and smoke rice for 1 hour, stirring at 30-minute point. Remove rice from the grill and store in an airtight container until ready to use.

CRACKERS, BISCUITS, DUMPLINGS, NOODLES, AND BREAD

What would an American cocktail gathering be without some form of cracker or bread? Canapés and sandwiches have coexisted with mixed drinks since the beginning. At one time, there were strict, unwritten rules governing cocktail party accompaniments: (1) never serve anything difficult to handle with fingers; and (2) don't top canapés with anything that can fall off easily. These days, gatherings are more relaxed and informal—but that doesn't mean we've severed historic ties completely. In this chapter, you'll find a go-to cracker recipe as well as an updated version of the once-ubiquitous cocktail puff. You'll also find an elegant take on fry jacks (Caribbean fry bread), as well *momos* (dumplings) and soba noodles—each a delicious way to bring worldly flavors into your home.

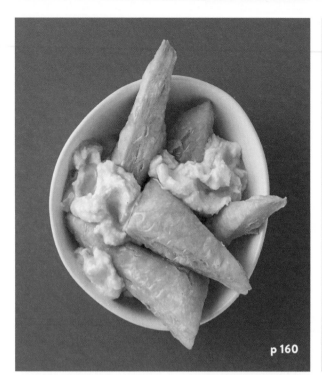

p 160

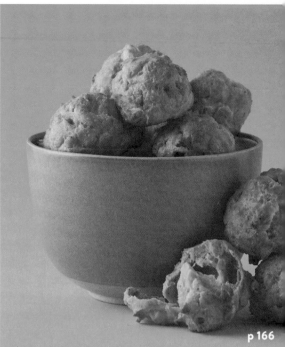

p 166

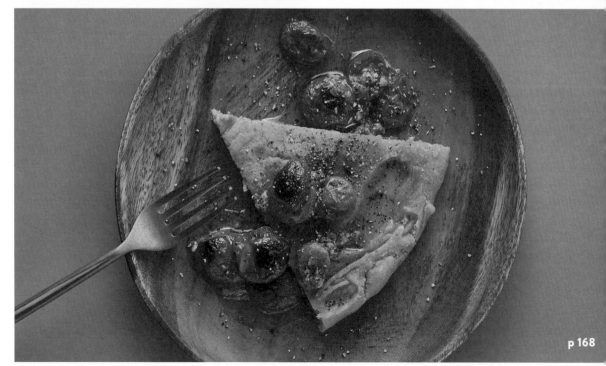

p 168

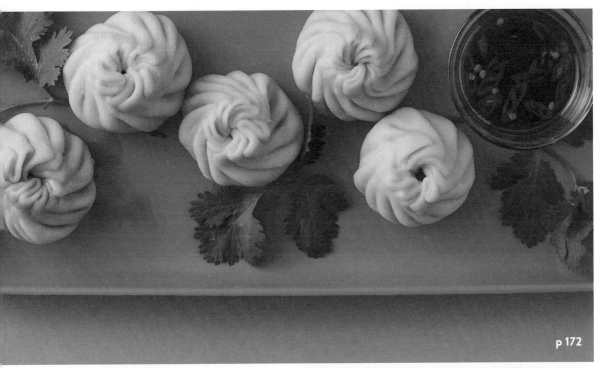

p 172

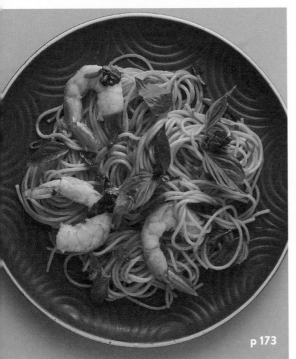

p 173

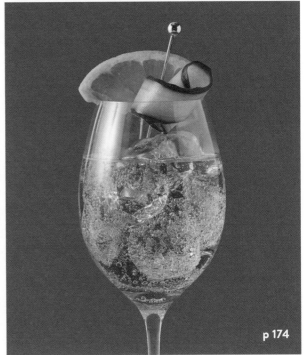

p 174

Fry Jacks with Honey-Whipped Ricotta

SERVES 4

Fried bread is found around the world, each with its own regional moniker; for example, you'll find *sopapillas* in Mexico, *frittelle* in Italy, and *mandazi* in Africa. Fry jacks—one of my favorite versions—hail from Belize, and are cousins to beignets. Italians sometimes serve fried bread as a starter to accompany drinks—which is where I drew inspiration from when I began making batches of these treats at cocktail hour. They're simple, elegant, and exciting . . . and let's face it—no one can resist hot fried bread. Served with honey and ricotta, fry jacks are always a stunning success at gatherings. Plus, they are easy to make, even if you aren't a bread baker or lack skill with dough. Serve with tropical cocktails.

1 cup whole-milk ricotta cheese

2 tablespoons honey

2 cups all-purpose flour,
 plus more for dusting

1 tablespoon baking powder

½ teaspoon salt

1 tablespoon coconut oil

¾ cup water, plus more if needed

3 cups peanut or vegetable oil

In a medium-size bowl, whip together ricotta and honey until combined and fluffy. Cover and set aside. In a separate medium-size bowl, combine flour, baking powder, and salt. Add coconut oil and mix it in with your fingers until well combined. Slowly add water and stir until dough is soft but not tacky, adding more water if necessary. Divide dough in half and let rest, loosely covered for 15 to 20 minutes.

In a Dutch oven or saucepan, heat oil to 365°F. Flour a surface and roll dough into 12-inch-diameter rounds. Cut dough into 3-inch strips and again crosswise to make triangles. Working in batches, fry dough until golden brown on both sides, 3 to 4 minutes. Using a slotted spoon, transfer fry jacks to a wire rack or plates lined with paper towels to drain. Serve immediately with ricotta mixture.

Festival
(Jamaican Dumplings)

MAKES 24 FESTIVALS

Jamaican festivals are slightly sweet, oblong cornbread dumplings. Like their name, they make for a very happy party. There is just something about the hint of cornmeal with sugar that hits the right flavor balance—plus, they are crunchy with a soft, yielding interior. In Jamaica, you'll always find festivals for sale at jerk joints. Fans of hush puppies take note—festivals are as indulgent and satisfying with less work. These are aces with rum cocktails and likely most often consumed with Wray and Ting (recipe follows).

2 cups all-purpose flour,
 plus more for dusting
½ cup cornmeal
½ teaspoon baking powder
½ teaspoon kosher salt
2 tablespoons sugar
½ teaspoon pure vanilla extract
⅛ teaspoon ground allspice
1 cup water
3 cups peanut or vegetable oil

In a medium-size bowl, combine flour, cornmeal, baking powder, salt, sugar, vanilla, and allspice. Slowly add water to form dough. Cover dough with plastic wrap and let rest at room temperature for 30 minutes. In a Dutch oven or saucepan, heat oil to 365°F. On a floured surface, divide dough into two dozen balls and roll into 4 x 1-inch pieces. Working in batches, fry festivals until just beginning to brown on all sides, about 7 minutes. Using a slotted spoon, transfer to a wire rack or plates lined with paper towels to drain. Serve immediately.

Wray and Ting

Wray and Nephew is a brand of Jamaican overproof rum. It is consumed everywhere on the island, from beach bars to roadside shacks—most often with Ting. Ting is a grapefruit soda that has pleasant flavor and acidity, perfect for mixing with white rum. It is available in groceries and online. This cocktail is the unofficial drink of Jamaica; but fair warning: overproof rum can make for a runaway drinking session.

1½ ounces Wray and Nephew rum
4 to 5 ounces Ting
Lime wedge, for garnish

In a highball glass filled with ice, add rum and Ting. Stir gently and garnish with lime wedge.

Fig & Blue Cheese Biscuit Coins

MAKES ABOUT 30 COINS

These elegant slice-and-bake coins are a magnificent cocktail party guest. The earthy fruitiness of the fig and umami of the blue cheese make for a stellar flavor combination. Rich and crispy, they are just the right bite with Manhattans, old-fashioneds, and martinis. They also love port and madeira. You can keep rolls of the dough in the freezer and slice off a few coins whenever you like. Serve drizzled with honey if you want an extra pop.

3 tablespoons unsalted butter,
 cut into small pieces
4 ounces blue cheese, at room
 temperature
1 teaspoon honey
¾ cup all-purpose flour,
 plus more for dusting
¼ teaspoon baking soda
½ teaspoon kosher salt
¼ teaspoon freshly ground black pepper
¼ cup finely chopped dried figs

In a medium-size bowl, cream the butter, cheese, and honey together until combined. Add flour, baking soda, salt, and pepper; mix until combined. Stir in figs. Turn out dough onto a floured surface and form into a 1-inch-diameter roll. Refrigerate, covered, for 4 hours. At this step, dough can be frozen for later use.

Preheat oven to 350°F. Cut ¼-inch-thick coins and arrange on an ungreased baking sheet. Bake until golden brown, about 10 minutes. Transfer to a wire rack or plates lined with paper towels and allow to cool before serving.

Jalapeño-Corn Sablés

MAKES ABOUT 24 COOKIES

What is spicy pepper and cornmeal doing in a French shortbread cookie? Well, thanks to nontraditional ingredients, these sablés tick all the boxes; sweet, savory, buttery, crispy, spicy, and the cornmeal provides a delightful texture. What I like best is how versatile these biscuits are; they can be used as an appetizer, dessert, or even as a special side dish to pass at holiday gatherings. These sablés are unbelievably good with whiskey cocktails, such as David's Derby (recipe follows).

8 ounces (2 sticks) salted butter,
 cut into ½-inch pieces
½ cup confectioners' sugar
¼ cup granulated sugar
1 teaspoon freshly ground black pepper
¼ teaspoon salt
2 large egg yolks
1 teaspoon pure vanilla extract
1½ cups all-purpose flour,
 plus more for dusting
½ cup cornmeal
½ jalapeño pepper,
 seeded and minced finely

Using a stand or hand mixer, cream the butter. Add sugars, black pepper, and salt; beat 1 minute to combine. Add egg yolks and vanilla; combine thoroughly. Slowly add flour and cornmeal; mix until dough is soft. Using a spoon, stir in jalapeño. On a floured surface, knead dough gently into a ball and cut in half. Form into two 8-inch-long logs. Wrap dough in plastic wrap and refrigerate for at least 2 hours.

Preheat oven to 325°F. Cut dough into ¼-inch slices and arrange on an ungreased baking sheet. Bake until sablés are light brown on the edges but still pale on top, about 15 minutes. Remove from oven and let cookies rest on their baking sheet for 2 to 3 minutes. Transfer to a wire rack or plates lined with paper towels to cool.

David's Derby

A whiskey daiquiri? This cocktail is the result of my experiments in combining two favorite mixed drinks: the Brown Derby and the Larchmont. The former is a bourbon and grapefruit number that originated in early-twentieth-century Los Angeles; the latter is a daiquiri variation by legendary drinks writer David Embury. The resulting concoction is dependent on the grapefruit's level of sweetness; if the drink is too sour or bitter for your taste, simply add a bar spoon of simple syrup or honey.

1½ ounces bourbon
½ ounce Grand Marnier liqueur
1 ounce fresh grapefruit juice
1 bar spoon simple syrup (optional)
Lime wheel, for garnish

Shake all ingredients, except garnish, with ice and strain into a cocktail glass. Garnish with a lime wheel.

Garam Masala Cocktail Puffs

MAKES ABOUT 2 DOZEN PUFFS

Ladies and gents, I submit here an updated version of the venerable cocktail puff, a popular party guest dating back at least as far as the mid-twentieth century, when they captured America's attention in Fannie Farmer's cookbooks. These cocktail party staples were piped with filling combinations, such as blue cheese and onion juice (whatever that is) or shrimp and mayonnaise. Delightful. But using the same choux pastry, we can make spiced gougères instead—those delicate French puffs that are all air and rich cheesy goodness. Light, crispy, and loaded with flavor, these deserve to be a cocktail party staple again. Serve with all things gin.

½ cup water

½ cup milk

8 tablespoons (1 stick) unsalted butter

½ teaspoon kosher salt

1 cup all-purpose flour

4 large eggs

1 cup shredded sharp Cheddar cheese

1 teaspoon garam masala

Preheat the oven to 400°F and line two baking sheets with parchment paper. In a medium-size saucepan over low heat, simmer together water, milk, butter, and salt until butter is melted. Add the flour, stirring until it forms a dough. Transfer dough to a large mixing bowl and beat in eggs, one at a time, until fully combined. Using a spoon, fold in cheese and garam masala. Spoon dough in 1-inch balls onto prepared baking sheets and bake until puffy and just beginning to brown on the bottom, about 25 minutes.

The Cracker

SERVES 4 TO 6

Crackers. Those party must-haves that are often disappointing, but too laborious to make. Right? Not necessarily. My hack is to use a pasta roller to get perfect, paper-thin sheets. Now, if this seems fussy, you should know that, despite having the tendency to become bound like a cellophane mummy every time I pick up plastic wrap, I can easily manage these . . . and with a bit of practice, so can you. I will admit, however, that it is far easier to execute this recipe with a helper, so grab a buddy and enjoy your handiwork as you churn out cracker after faultless cracker. Also, a bit of party advice? People love a task and a sense of accomplishment, so at an informal gathering, prep the dough and let guests take a turn cranking the wheel.

1½ cups all-purpose flour,
　　plus more for dusting
½ cup cold water
1 teaspoon kosher salt
2 tablespoons extra-virgin olive oil
½ teaspoon flaky sea salt

In a medium-size bowl, mix flour, water, and salt; turn out on a floured surface and knead for 4 minutes. Wrap dough in plastic wrap and let rest for 1 hour at room temperature.

Preheat oven to 400°F and line two baking sheets with parchment paper; remove dough from plastic and divide into four equal-size balls. On a floured surface, roll first ball of dough into a strip roughly 4 inches wide and ½ inch thick. Set a pasta machine to its widest setting; dust dough lightly with flour on both sides and roll through pasta machine. Reduce machine's width to its second-widest setting and feed the dough through again. Continue rolling dough through pasta machine, reducing roller width one setting each time, until dough has passed through the narrowest setting, dusting dough with flour to prevent sticking as needed. Transfer to prepared baking sheet. Repeat entire process for the remaining dough balls. Brush the four dough sheets with olive oil and sprinkle with sea salt.

Bake crackers for 10 minutes or until just beginning to brown, flipping halfway through. Transfer crackers to wire rack to cool for 10 minutes before serving.

Farinata with Blistered Tomatoes

SERVES 4

Farinata is a flatbread originally hailing from Genoa, Italy. A heftier cousin to the crepe, farinata is crispy, with a nutty flavor from chickpea flour. Hot out of the oven with a sprinkle of sea salt, freshly ground black pepper, and a splash of good olive oil, they are divine. Farinata is also gluten-free, which is why they've been appearing on American restaurant menus. I like them because they're fast to make and a perfect foil for garden cherry tomatoes. I make my cherry tomatoes even sweeter by roasting them (also a great trick for store-bought tomatoes that aren't so flavorful); I also add a blast of umami with anchovies. The result is something truly special that will transport you to the Mediterranean—and is a great recipe for an evening of light cocktails.

FARINATA:

2 cups chickpea flour

2 cups water

1½ teaspoons sea salt,
 plus more for garnish

½ teaspoon freshly ground black pepper,
 plus more for garnish

½ teaspoon ground dried rosemary

5 tablespoons extra-virgin olive oil

BLISTERED TOMATOES:

3 anchovy fillets, chopped coarsely,
 or 1 tablespoon anchovy paste

2 tablespoons extra-virgin olive oil

1 garlic clove, minced

Pinch of ground mace

Pinch of cayenne pepper

Pinch of ground white pepper

1 pint cherry tomatoes

In a medium-size bowl, combine chickpea flour, water, salt, pepper, rosemary, and 3 tablespoons of the olive oil. Cover and let sit at room temperature for at least 2 hours. Arrange a rack second from top and preheat oven to 425°F. Switch it to broil on HIGH and leave oven rack in second from top position. Pour enough oil on the preheated 10-inch cast-iron skillet to cover the bottom of the pan and return to the oven to heat, about 3 minutes. Once hot, pour enough batter in the pan to just cover the bottom, swirling to coat. Roast farinata until starting to crisp and brown on the edges. Transfer to a cutting board, drizzle with olive oil, and sprinkle with salt and pepper. Repeat by spreading olive oil around the pan and heating the pan again in the oven.

With the oven still hot from the farinata, reset to 425°F. In a food processor, combine anchovies, olive oil, garlic, mace, cayenne, and white pepper. Transfer to a bowl, add tomatoes, and stir to coat. Transfer tomatoes to a baking sheet or an oven-proof skillet. Roast in the oven until tomatoes just begin to split, shaking the pan occasionally, 15 to 20 minutes. Remove from the oven. Serve with the farinata.

Crispy Flatbread

SERVES 4

Flatbread is infinitely useful and can serve as the perfect backdrop for inventive toppings. Make a batch, set out some ingredients, and let guests enjoy building their own fun meal. Go Italian, Spanish, or Middle Eastern with the toppings and serve alongside a help-yourself gin-and-tonic bar for a ready-made DIY night.

1 teaspoon active dry or instant yeast

1 teaspoon sugar

¾ cup warm water

2 cups all-purpose flour or bread flour, plus more for dusting

1 tablespoon extra-virgin olive oil, plus more for bowl and 1 teaspoon for brushing dough

1 teaspoon minced garlic

1 teaspoon kosher salt

In a large bowl or bowl of a stand mixer, combine yeast and sugar. Add warm water and whisk to combine. Cover and let mixture sit for 5 minutes. With mixer on low speed, or with a spoon, stir in flour, 1 tablespoon of the olive oil, and garlic and salt until well combined; dough should be thick. Turn out onto a floured surface and knead dough until it becomes smooth, about 2 minutes. Transfer dough to an oiled bowl, cover, and allow to rest for 45 minutes at room temperature.

Preheat oven to 475°F; prepare any toppings, and line two baking sheets with parchment. Punch down dough and divide into two halves. On a floured surface, stretch and roll the dough until it is ¼ inch thick. Repeat with second dough half; don't worry if they are not uniform in shape. Transfer dough to baking sheets.

Using a fork, prick holes in dough and then brush each flatbread with ½ teaspoon olive oil. Add toppings, if desired. Bake until crust and toppings are browned, 15 to 20 minutes. Slice on a cutting board and serve immediately.

Orange Pan con Tomate

SERVES 4 TO 6

Pan con tomate, translated as "tomato bread," is served in bars across Spain. It is a simple dish that is more than the sum of its parts; the crispy bread, tomato, sea salt, and hefty drizzle of olive oil make for an arid flavor and textural wonderland that is incredible with cold Manzanilla sherry. In fact, this dish practically requires sherry as its partner. The pairing just gets to you. But like so many dishes that lose a little something in translation, my attempts rarely gave me the same chills as it would at a bar in, say, Seville. I wanted pan con tomate, but without slavishly trying to re-create a specific experience stateside. Enter orange marmalade. It makes all the difference—bringing both additional bitterness and sweetness to the tomato. This version plays well with cocktails of all kinds, from sherry to gin, but also sours, such as daiquiris.

4 Roma tomatoes, cold

2 tablespoons orange marmalade

1 loaf ciabatta, split in half horizontally lengthwise and cut crosswise into 3- to 4-inch slices

1 cup extra-virgin olive oil (preferably Spanish)

Flaky sea salt (such as Maldon or fleur de sel)

Using a box grater, rub tomatoes over the grates; the flesh will grate off while most of the skin remains intact in your hand. Discard skin, transfer tomatoes to a bowl; add marmalade and whisk until combined. Refrigerate mixture. Adjust oven rack to top position and preheat broiler to HIGH. Place bread, cut side up, on a baking sheet and broil until crisp and starting to brown, 2 to 3 minutes. Remove bread from the oven and spoon on tomato mixture. Drizzle liberally with extra-virgin olive oil and season with flaky sea salt.

Momos

SERVES 4

Momos are dumplings from Tibet and Nepal that are popular as far afield as India and Southeast Asia. They are unique in that, rather than a bland dumpling interior, they offer a spicy curry kick. Momos are a popular drinking snack in Hong Kong, where imbibers can even get them delivered to bars. In Nepal, the dumplings are served with tomato chutney, whereas in Hong Kong, they are served alongside dumpling sauce. I don't find these need a sauce at all. Although store-bought wonton wrappers work well here, momo dough is easy to make and a useful master recipe to know for other dumplings. Momos love sours, such as daiquiris, but also go well with gin-based mixed drinks.

MOMOS:

2½ cups all-purpose flour,
 plus more for dusting
1 cup water
½ teaspoon vegetable oil,
 plus more for steamer
1 teaspoon salt
2 cups filling (recipe follows)

FILLING:

1 pound ground pork
4 scallions, chopped finely
5 garlic cloves, minced
1 (1-inch) piece fresh ginger,
 peeled and chopped finely
½ cup chopped fresh cilantro leaves
1 teaspoon ground turmeric
1 teaspoon ground cumin
1 teaspoon ground coriander
½ teaspoon curry powder
2 teaspoons salt

In a large bowl or bowl of a stand mixer, combine flour, water, oil, and salt. Mix until dough becomes soft; cover, and let rest for 30 minutes at room temperature. Turn out dough onto a floured surface, knead until smooth, and portion into 1-inch balls. Flatten balls into disks the size of your palm. Oil the surfaces of a steamer basket, and place over boiling water. Fill each wrapper with a small amount of filling (recipe follows) and pinch closed. Arrange momos in steamer, cover, and steam until cooked through, about 12 minutes. If your steamer has more than one rack, cook for 10 minutes, switch the bottom steamer rack to the top, and cook for 2 to 3 more minutes.

In a large bowl, combine pork, scallions, garlic, ginger, and cilantro until mixed. Add turmeric, cumin, coriander, curry, and salt; mix until combined.

Spaghetti Kee Mao

SERVES 2

No global cocktail food book would be complete without *pad kee mao*, which translates as "drunkard" noodles—often seen as "drunken noodles" on menus. It's thought the dish is so-named because the spicy noodles are perfect after a big night of drinking and can prevent a hangover. But some say the name is derived from the fact that the noodles' punchy flavor clears the foggy minds of the inebriated. The dish is typically made with rice noodles, but a popular version uses European pasta instead—ideal for bar-time when you have to use pantry staples on hand. This recipe is infinitely variable—while shrimp is standard, any proteins or vegetables are fair game.

4 ounces dried spaghetti

2 tablespoons peanut or vegetable oil

3 garlic cloves, chopped

1 serrano or jalapeño pepper, chopped

2 Thai bird's eye chiles, sliced thinly

2 tablespoons oyster sauce

1 tablespoon Asian fish sauce

1 tablespoon dark soy sauce

1 teaspoon sugar

½ teaspoon ground white pepper

12 shrimp, peeled and deveined

1 cup fresh Thai basil leaves

Cook spaghetti according to package instructions. In a medium-size saucepan, heat oil over medium-high heat and add garlic and chiles; cook until fragrant. Add oyster sauce, fish sauce, soy sauce, sugar, and white pepper and stir to combine. Add shrimp and cook until just turning pink. Add spaghetti and Thai basil, stir thoroughly, and cook until basil wilts completely. Serve immediately.

Sake-Lillet Spritz

A sake and Aperol spritz is a beautiful thing, elegant and low-proof. Combined with a splash of the French liqueur Lillet, the cocktail becomes light and refreshing—a cucumber peel and a grapefruit twist rounds out the zesty concoction. This chic cocktail pairs well with noodles, such as soba, and sushi.

2 ounces sake
½ ounce Lillet
½ ounce Aperol
3 ounces club soba
Cucumber peel, for garnish
Grapefruit twist, for garnish

Combine all ingredients, except garnishes, in a wineglass filled with ice. Garnish with cucumber wheel and grapefruit twist.

Soba Noodles

SERVES 2

Although ramen gets all the press in the United States, there are far more soba shops in Japan. Soba is a buckwheat noodle that is often served cold with a dipping sauce. It is as much ritual as food, and boasts an entire culture of *sobamae*—pre-soba snacks that are consumed while imbibing (it's good to be a little buzzed before consuming the noodles). This recipe may look like a lot of prep, but it is dead easy. It all starts with a dashi stock—a useful skill to learn as dashi is the first building block for a lot of Japanese cuisine. Note that this recipe is technically for *zaru soba*, which is most often consumed in summer months but can also be found gracing menus year-round. Soba pairs well with sake and shochu, but can also work with whiskey-based drinks. On a hot day, try a Sake-Lillet Spritz (page 174).

2 bunches dried soba noodles

¼ teaspoon sesame oil

1 sheet yaki nori, sliced finely, for garnish

2 tablespoons finely chopped scallion

2 teaspoons wasabi

Prepare a medium-size bowl with ice-cold water. Bring a stockpot of water to a boil. Add soba and cook for 4 minutes. Plunge soba into ice water, drain, and toss noodles with sesame oil. Arrange soba on two plates or in shallow bowls and garnish with yaki nori. Serve accompanied by dipping sauce (recipe follows). Before eating, add scallion and wasabi to the dipping sauce.

DIPPING SAUCE:

½ cup dashi stock (recipe follows)

2 tablespoons mirin

2 tablespoons soy sauce

In a small saucepan, combine all sauce ingredients, bring to a boil, and turn off heat; allow to cool. Serve divided between two cups.

DASHI STOCK:

1 (6-inch) piece kombu

2 cups water

1 cup loosely packed bonito flakes

In a medium-size saucepan, soak kombu in water for 30 minutes. Bring water to a boil, turn heat to low, and simmer for 10 minutes. Add bonito flakes and simmer for an additional 10 minutes. Remove saucepan from heat, let stock cool, then strain. Stock will keep in the refrigerator for 2 to 3 days. You may also freeze in 1-cup amounts; frozen, it will keep for 3 months.

CHAPTER 11

DESSERT

Sweets accompanying cocktails should be simple, elegant, and a bit naughty. But let me be clear from the outset: you don't have to have a sweet tooth to enjoy the recipes in this chapter. Many of the selections here ride the line between sweet and savory, leaving plenty of room for accompanying cocktails to have a touch of sugar. These are desserts that will leave your guests agog—and you reveling in your accomplishment to the last bite. From Ginger "Schnapps" to Caribbean Black Cake, every cocktailer should have these classics in their arsenal.

p 181

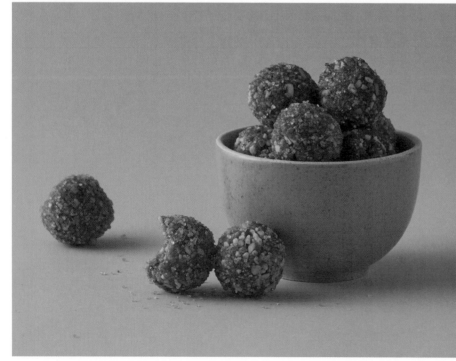

p 183

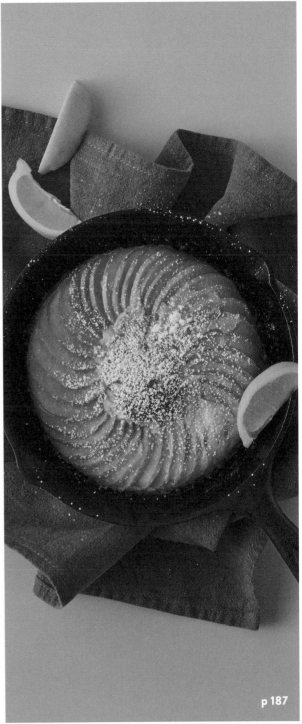

p 187

Oleo-Saccharum Sorbet

SERVES 8

Oleo-saccharum is a fancy word for the oil that results from macerating citrus peel in sugar. It is a key ingredient in classic punches and worth learning how to make. The oils in the lemon rind bring a world of extra flavor—rest assured this sorbet will be one of the most lemony things you'll ever eat. Why do I love this recipe so much? Well, for starters, it makes a great dessert. But it also doubles as a palate cleanser, and—get this—it is fantastic as a cocktail ingredient. A dollop transforms a French 75 and just a bite makes a heavenly Sgroppino (an Italian combination of sorbet and Prosecco). With this delightful sorbet in the freezer, you will always be armed with a delicious cocktail element.

2 cups sugar

Peels of 12 lemons

2 cups hot water

1¾ cups fresh lemon juice

In a medium-size bowl, combine sugar and lemon peels. Mash lightly with a spoon and let mixture rest, covered, overnight. Strain out the peels, pressing them to release their oils. Add to hot water and stir until dissolved. Add lemon juice and pour into the bowl of an ice-cream maker. Churn according to manufacturer instructions. When the sorbet has frozen into ice crystals—it will still be soft—transfer to a storage container, cover, and freeze until ready to serve.

Negroni Panna Cotta

SERVES 4

Recipes that have cocktails *in* them can be gimmicky. Not this one. The bitterness of the Negroni cocktail and sweet cream work together here for a decadent, boozy dessert. The gelatin may sound complicated, but this easy recipe comes together in mere minutes. It's a little bitter, a little orangey, and a lotta soft pudding luxuriousness.

2 ounces gin
½ ounce Campari
½ ounce sweet vermouth
2¼ teaspoons unflavored gelatin
2 cups heavy cream
¼ cup sugar
½ vanilla bean, split and seeded, or 1
 teaspoon pure vanilla extract
Orange zest, for garnish

In a medium-size bowl, combine gin, Campari, and sweet vermouth; stir, and sprinkle gelatin over the surface. Let mixture stand for 5 to 10 minutes for the gelatin to dissolve and soften. In a medium-size saucepan, heat cream, sugar, and vanilla over medium-high heat; bring to a boil just until sugar dissolves. Remove from heat and discard vanilla bean. Whisk gelatin mixture and stir into cream mixture until smooth. If the gelatin hasn't fully dissolved, return the saucepan to the stove and heat gently over low heat, stirring constantly, taking care not to let the mixture boil. Divide among bowls and refrigerate for 2 to 4 hours, or until completely set. Garnish with orange zest and serve.

Mezcal Pudding

SERVES 6

I was finishing a meal in a humble cantina in Oaxaca, Mexico, when the proprietor asked me whether I wanted a shot of mezcal (I'm sure you don't need me to say what my response was). He set down the mezcal alongside a small bowl of pudding, indicating it should be eaten along with the shot. The combination was so mind-blowing that I'm surprised it hasn't become a craze in the US. We all know alcohol loves anything fatty—but let me tell you, it REALLY loves pudding. This light vanilla version brings out all sorts of exotic flavors in mezcal that you wouldn't necessarily taste otherwise. And whereas tequila is associated with lime, mezcal producers choose an orange wedge as their accompaniment of choice. It works flavorwise, and a little orange zest on top of this pudding brings complementary citrus into the equation.

3 cups whole milk

¾ cup sugar

¼ cup cornstarch

½ teaspoon salt

1 large egg

2 large egg yolks

1 teaspoon pure vanilla extract

1 tablespoon mezcal

Orange zest, for garnish

In a large saucepan, heat 2½ cups of the milk over medium heat until starting to steam. In a large bowl, combine sugar, cornstarch, and salt. Add egg and yolks and remaining ½ cup milk; whisk to combine. To temper the egg mixture, add half of the hot milk and whisk until smooth, then pour entire tempered mixture back into the saucepan with the remaining hot milk. Increase heat to medium-high and bring mixture to a boil, stirring constantly until it thickens into a puddinglike consistency, 3 to 4 minutes. Remove from heat, add vanilla and mezcal; stir until combined. Remove from heat and transfer to a serving bowl. As pudding cools, stir to prevent a skin from forming, about 5 minutes. Cover pudding with plastic wrap touching the entire surface to remove air. Refrigerate until cooled, about 4 hours; stir again before serving.

Almond, Date, and Fig Balls

MAKES ABOUT 20 BALLS

Think of these as travel confections. That's how fruit and nut balls likely developed—along the Spice Route where traders needed a fortifying bite while hiking across steppe and desert. These balls are transportive—pop a bottle, mix a drink, and float away in dreams of Marco Polo and Ibn Battuta. My favorite pairing here is the Coffee Cocktail (recipe follows), a once-popular libation that has fallen into relative obscurity; rum cocktails also work well. The grinding required in this recipe can be done with the grinder attachment of a stand mixer, a Vitamix, or a food processor.

2 tablespoons sugar
¼ teaspoon ground cinnamon
1 cup toasted almonds
1 cup dried figs
1 cup pitted dates

In a shallow bowl or on a plate, mix sugar and cinnamon. In a food processor, combine almonds, figs, and dates until finely ground. Form mixture into tablespoon-size balls and roll in the sugar mixture. Serve immediately or store in a sealed container in layers of waxed paper.

Coffee Cocktail

This cocktail from the 1880s is named for its appearance, not for its ingredients or flavor. It is one of the best port-based drinks in the canon. This fun sipper has a flavor reminiscent of figs, with an elegant, frothy texture—and it is a big hit paired with sweets of all kinds—especially anything with fruit.

3 ounces ruby port
1 ounce brandy
1 bar spoon simple syrup
1 small egg
Freshly grated nutmeg, for garnish

Dry shake (no ice) port, brandy, simple syrup, and egg. Add ice, shake again, and strain into a cocktail glass. Garnish with nutmeg.

Ginger "Schnapps"

MAKES 2 DOZEN "SCHNAPPS"

Gingersnaps are thought to have been so named because they were consumed alongside schnapps—also known as brandy. Both words are derived from the German verb *schnappen*, meaning "to snap up or grab quickly" (think: shots). This recipe offers a glimpse into what these cookies were like hundreds of years ago—chock-full of candied orange, caraway seeds, and other treats from the far reaches of the Dutch trading empire. These showstoppers are perfect companions to genever (Dutch gin) and dry curaçao.

⅓ cup granulated sugar

½ cup packed light brown sugar

¾ cup vegetable oil

1 large egg

¼ cup molasses

2 cups all-purpose flour

1 teaspoon baking powder

1 teaspoon baking soda

2 teaspoons ground ginger

½ teaspoon ground cinnamon

½ teaspoon ground caraway seeds

½ teaspoon ground coriander

¼ teaspoon kosher salt

3 tablespoons finely chopped candied orange

¼ cup demerara sugar, for rolling

In a large bowl, beat together granulated and brown sugar and oil until fluffy. Stir in the egg and molasses. In a separate large bowl, combine flour, baking powder, baking soda, ginger, cinnamon, caraway, coriander, and salt. Slowly mix flour mixture into sugar mixture until well combined. With a spoon, stir in candied orange. Let mixture rest in refrigerator, covered, for 2 hours.

Preheat oven to 375°F and line a baking sheet with parchment. Arrange demerara sugar on a plate. Form dough into tablespoon-size balls and roll in demerara sugar. Arrange on prepared baking sheet and bake until just beginning to brown, about 12 minutes. Remove from oven and let cool on baking sheet for 5 minutes before transferring to a wire rack or plates lined with paper towels.

Old-Fashioned Pralines

MAKES ABOUT 24 PRALINES

There are a lot of classic New Orleans foods that pair well with cocktails; pralines top the list. These pralines are not "old-fashioned," as in "retro"—they are made with whiskey and Angostura bitters, reminiscent of the cocktail that shares the name. Many praline recipes will warn you of impending disaster if you haven't made them before—but I say, "hooey!" If you have your equipment ready to go and use a candy thermometer, these will be a success every time. Just pay close attention as the sugar reaches the magic temperature, work fast, and don't panic.

1 cup granulated sugar

1 cup light brown sugar

½ cup heavy cream

¼ teaspoon baking soda

¼ teaspoon salt

2 tablespoons unsalted butter

1 tablespoon bourbon

1 teaspoon Angostura bitters

2 cups pecan halves or pieces, toasted

Line a large baking sheet with parchment paper. In a medium-size saucepan with a candy thermometer attached, stir together granulated and brown sugar, cream, baking soda, and salt; bring to a boil. When the mixture reaches 235°F, immediately remove from the heat. Using a whisk, stir in the butter, bourbon, and bitters until fully combined. Add pecans and vigorously stir for 1 minute. Working fast, drop mixture by heaping tablespoonfuls onto the prepared cookie sheet. Allow to cool until set.

Apple Tansy

SERVES 4 TO 6

The earliest recipe for this classic dessert appears in the very first cookbook published in the United States (mere colonies at the time): *The Compleat Housewife: or, Accomplished Gentlewoman's Companion* by E. Smith was printed in Virginia in 1742. Quick and easy, apple tansy is great with cider cocktails, especially the Stone Fence or Cider Cup No. 1 (recipe follows). The pairing can work either as a dessert or breakfast—and yes, you read that right. Cocktails were originally consumed at breakfast. I can see it now: the old-timers, sitting around as the sun came up, enjoying old-fashioneds and this tansy. While my recipe is close to the original, I dial back the rose water so it doesn't overwhelm.

3 tablespoons unsalted butter
3 apples, cored and sliced thinly
4 large eggs
2 tablespoons heavy cream
¼ teaspoon rose water
⅛ teaspoon freshly grated nutmeg
2 tablespoons granulated sugar
Confectioners' sugar, for garnish
Lemon wedges, for garnish

Preheat the oven broiler. In an 8-inch cast-iron skillet or oven-safe sauté pan, melt butter over medium heat. Add apples (if you want a more aesthetically pleasing presentation, arrange slices to overlap; you will be flipping this over, so this will actually be the top) and cook until softened, about 6 minutes. In a large bowl, whisk together eggs, heavy cream, rose water, nutmeg, and granulated sugar until smooth. Pour mixture over apples and continue to cook until the edges are set, 3 to 4 minutes. Transfer skillet to oven and broil on HIGH until egg is completely cooked and top is lightly browned, 2 to 3 minutes. Remove skillet from oven; using a cutting board or plate over the top of the skillet, flip tansy over. Serve in slices garnished with confectioners' sugar and lemon wedges.

Cider Cup No. 1

The cider cup is an old mixed drink composed of cider, sugar, bitters, and lemon. Sometime around Prohibition, however, the recipe was spruced up with additional liqueurs. The following recipe is standard—except I add back in the Angostura bitters (they'd dropped out over the years). This is a fun postprandial punch that goes well with desserts, especially apple tansy.

1 quart cider
1½ ounces brandy
1½ ounces curaçao
1½ ounces Luxardo maraschino liqueur
6 dashes Angostura bitters
Lemon peels, for garnish

Combine all ingredients, except lemon peels, in a pitcher, add ice, and stir. Garnish glasses with lemon peel. Serves 6.

African Ginger Cakes

MAKES ABOUT 2 DOZEN CAKES

These wonderful cakes boast a big zing that works as a great pairing with mixed drinks of all kinds. A combination of fresh and dried ginger ensures that ginger-holics will be satisfied with the full flavor spectrum on offer—and an additional touch of cayenne brings even more heat. I love the way their concentrated flavor brings out the best in rum and whiskey concoctions. Rum punch and a batch of these ginger cakes? Heaven.

6 tablespoons sugar

8 tablespoons (1 stick) unsalted butter, at room temperature

1 teaspoon pure vanilla

1 tablespoon peeled and minced fresh ginger

½ cup milk

2 cups all-purpose flour, plus more for dusting

2 teaspoons ground ginger

½ teaspoon cayenne pepper

Preheat oven to 350°F and line two baking sheets with parchment. In a stand mixer or medium-size bowl, cream together sugar, butter, vanilla, and fresh ginger. Add milk and stir to combine thoroughly. In a separate medium-size bowl, combine flour, ground ginger, and cayenne. Slowly mix flour mixture into the butter mixture. Turn out dough onto a floured surface and roll to ½-inch thickness. Using a 2-inch biscuit cutter, cut into rounds. Working in batches if necessary, bake cakes until just beginning to brown, about 25 minutes.

Semolina Cake in Boozy Syrup

SERVES 8

A version of semolina cake doused in syrup is found throughout Turkey and Greece; the dessert's widespread popularity is no doubt due to the magical combination of a fluffy, surprisingly light cake enrobed in a deliciously sticky mess. The semolina provides a nice, grainy nuttiness, and the perfumed syrup makes for an alluring confection. This is an especially sexy version, employing orange curaçao over moist cake—a flavorful texture-bomb. Pair with simple gin, rum, and whiskey cocktails that are not too sweet.

½ cup olive oil, plus more for pan

¼ cup sugar

3 large eggs

1 cup all-purpose flour

½ cup semolina flour

1½ teaspoons baking powder

¼ teaspoon baking soda

½ teaspoon salt

⅔ cup plain yogurt

½ teaspoon orange zest

1 teaspoon pure vanilla extract

½ teaspoon ground cinnamon

SYRUP:

½ cup water

¼ cup orange curaçao

½ cup fresh orange juice

1 cup sugar

Preheat oven to 350°F and brush a 9-inch springform pan with olive oil. In a medium-size bowl, combine olive oil and sugar. Add eggs and stir until thoroughly combined. In a separate medium-size bowl, combine flours, baking powder, baking soda, and salt. Slowly add flour mixture to egg mixture and mix until combined. Add yogurt, orange zest, vanilla, and cinnamon; stir until just mixed. Transfer batter to prepared pan and smooth top with a spatula. Bake for 25 minutes, or until a toothpick comes out clean. Drizzle with ½ cup warm syrup (recipe follows). When syrup is absorbed, add another ¼ to ½ cup, as desired. To serve, add remaining syrup as desired.

In a small saucepan, combine water, curaçao, orange juice, and sugar. Bring to a boil, lower heat, and simmer for 10 minutes until reduced and thickening.

Coconut-Cardamom Cake

SERVES 6

Coconuts are one of the world's irresistible foods. In fact, the mutiny on the ship *Bounty* was triggered by Captain Bligh's harsh treatment of coconut theft from the ship's store. Who can blame the luckless sailor who got caught? Coconuts most likely originated around the Indian Ocean and were transported to the west coast of Africa by the Portuguese. Later, they made the crossing to the New World. Coconuts are associated with travel (sailing, in particular) and followed the path of the Spice Route—much like the proto-cocktail, rum punch. This spiced cake will transport you to another age and is ideal with rum drinks of all kinds.

½ cup coconut milk

1 cup milk

1 cup unsweetened coconut flakes

4 tablespoons (½ stick) unsalted butter, at room temperature, plus more for pan

1 cup sugar

2 large eggs

½ teaspoon pure vanilla extract

1¾ cups all-purpose flour

2 teaspoons baking powder

½ teaspoon baking soda

¼ teaspoon ground cardamom

¼ teaspoon salt

Preheat oven to 350°F and butter a 9 x 5-inch loaf pan. In a medium-size bowl, combine milks and coconut flakes; let soak for 10 minutes. In a separate medium-size bowl, cream butter and sugar. Stir in eggs and vanilla until thoroughly combined. Add milk mixture and stir. In a third medium-size bowl, combine flour, baking powder, baking soda, cardamom, and salt. Add dry ingredients to wet ingredients and transfer mixture to the prepared loaf pan. Bake until a cake tester or fork comes out clean, about 50 minutes. Turn cake out onto a wire rack to cool.

Piña Colada
Upside-Down Cake

SERVES 8

Transport yourself and guests to a post–World War II supper club with this take on the classic pine-apple upside-down cake—while experiencing all the fun of a piña colada in dessert form. As the cake cooks, the pineapple caramelizes with sugar to develop a phenomenal, sticky glaze. This dessert loves Caribbean cocktails and popular mid-century drinks like old-fashioneds, martinis, and even margaritas. I love pairing it with the Airmail, a crowd-pleasing 1940s cocktail (recipe follows).

8 tablespoons (1 stick) melted unsalted butter, plus more for pan

½ cup light brown sugar

1 fresh pineapple, peeled and cored

8 tablespoons (1 stick) unsalted butter

1½ cups granulated sugar

1 teaspoon pure vanilla extract

2 large eggs

2¼ cups cake flour

2½ teaspoons baking powder

1 teaspoon salt

1 cup buttermilk

1 tablespoon rum

½ cup unsweetened coconut flakes

Preheat oven to 350°F and place an oven rack in the lower-middle position. Butter a Bundt pan; pour melted butter into pan, and sprinkle brown sugar evenly over butter. Cut pineapple into rings and cut each ring in half. Arrange the half-rings into the indentations of the pan. In a medium-size bowl or the bowl of a stand mixer, mix unmelted butter and sugar until creamy. Add vanilla and eggs; beat until fluffy. In a separate medium-size bowl, stir together flour, baking powder, and salt. Add flour mixture and buttermilk to the butter mixture. Add rum and transfer cake batter to prepared pan. Sprinkle evenly with coconut and bake until a cake tester comes out clean, about 40 minutes. Remove cake from oven and let cool in pan for 15 minutes. Flip cake out onto a platter and serve warm.

Airmail

The Airmail may be as old as the turn of the twentieth century, but it wasn't until the late '40s that the drink really came to public attention, thanks to David Embury's book, *The Fine Art of Mixing Drinks* (1948). Think of it as a French 75 gone tropical. However, this is a classic in its own right—a kind of luxurious daiquiri—and fun to serve with desserts.

2 ounces rum
¾ ounce fresh lime juice
¾ ounce honey syrup (recipe follows)
1½ ounces sparkling wine

Shake rum, lime juice, and honey syrup with ice and strain into a cocktail glass. Top with sparkling wine.

HONEY SYRUP: 1 cup warm water
1 cup honey

Shake water and honey vigorously until thoroughly combined.

Caribbean Black Cake

SERVES 16

This is the best fruitcake in the world. A cousin of British plum pudding, black cake is traditionally served around the holidays and is made with dried fruit, such as prunes, raisins, and cherries, all decadently steeped in rum and brandy for months. The dried fruit swells with booze and is then incorporated into thick molasses cakes studded with nuts. In this version, I've replaced the brandy with Cherry Heering, that venerable cocktail ingredient (think: Blood and Sand) that always seems to spend a little too long on the shelf. Each year I employ my leftover Heering in this confection, and the result always brightens the holidays. Serve with rum punch, glögg, or other wintertime mixed drinks.

1 cup pitted prunes

1 cup raisins

1 cup golden raisins

1 cup dried cherries

1 cup dark rum, plus more for
brushing cake

1 cup Cherry Heering

1 cup roughly chopped almonds

8 ounces (2 sticks) unsalted butter,
plus more for pans

1½ cups packed light brown sugar

5 large eggs

1 teaspoon pure vanilla extract

Zest of 2 limes

1 teaspoon Angostura bitters

2 cups all-purpose flour,
plus more for dusting

2 teaspoons baking powder

1 teaspoon ground cinnamon

½ teaspoon freshly grated nutmeg

2 tablespoons molasses

Marinate prunes, raisins, golden raisins, and cherries in rum and Cherry Heering for at least 4 days and up to 6 months, stirring occasionally.

Preheat oven to 225°F. Butter two 9-inch round cake pans and line bottoms with parchment. Butter the parchment and dust the interior of the cake pans with flour, tapping out excess. In a food processor, combine soaked dried fruit and their liquid with almonds. Pulse until a rough paste forms and set aside. In a stand mixer or medium-size bowl, cream butter and brown sugar until fluffy, about 8 minutes. Add eggs to butter mixture, one at a time, combining thoroughly after adding each egg. Add vanilla, lime zest, and bitters; stir. In a separate medium-size bowl, combine flour, baking powder, cinnamon, and nutmeg and slowly add to the batter, stirring until combined. Add molasses and stir to combine thoroughly. Add fruit mixture and stir until combined. Divide dough evenly between prepared pans and bake for 2½ to 3 hours, or until a toothpick inserted into center comes out clean.

Turn out the cakes onto wire racks or large plates. Cakes can be stored, tightly wrapped in waxed paper and tinfoil at room temperature, for a month.

Chocolate Manhattan Cake

SERVES 8

Dense, rich, and decadent, this is the chocolate cake to rule them all. If you are a chocolate lover, you will appreciate the singularity of purpose—deliver a chocolate payload with as little resemblance to cake as possible. Why let too firm a texture get in the way? What we have here is essentially cocoa powder, flour, and a cocktail combined just enough to hold together to resemble something fork-edible. Now, *that* is an entirely unreasonable recipe every boozy chocoholic can appreciate.

8 tablespoons (1 stick) unsalted butter, plus more for pan
½ cup unsweetened cocoa powder, plus more for dusting
1½ cups sugar
1 cup all-purpose flour
⅛ teaspoon salt
3 large eggs, whisked
1 tablespoon bourbon
1 tablespoon sweet vermouth
1 tablespoon Amarena cherry juice
2 dashes Angostura bitters
2 tablespoons roughly chopped Amarena cherries

Preheat oven to 350°F. Butter a 9-inch spring-form pan and dust bottom with cocoa powder. In a medium-size saucepan, melt butter. Remove from heat and slowly add cocoa powder, sugar, flour, and salt. Add eggs and mix until thoroughly combined. Stir in bourbon, sweet vermouth, cherry juice, and bitters until combined; fold in cherries. Bake until top of the cake is firm, 20 to 25 minutes. Cake will remain gooey in the middle.

Party Menus

SPRING PARTY

Génépy Trout Rilette (page 100)

Edamame with Pecorino and Caraway (page 127)

Strawberry-Ham Bocaditos (page 78)

Fried Artichokes with Lemon and Mint
(page 37)

Kuku Sabzi (page 69)

Oleo-Saccharum Lemon Sorbet (page 180)

MARTINI PARTY

Gilda (page 88)

American Cocktail Pecans (page 7)

Piri-Piri Shrimp Cocktail (page 95)

Cocktail Ramen Eggs (page 66)

Rohkostplatte (page 28)

White Bean Dip with Herbes de Provence
(page 32)

Georgian Chicken Salad (page 112)

Cherry Kofte (page 132)

Semolina Cake in Boozy Syrup (page 190)

SUMMER BACKYARD BARBECUE

Pickled Shrimp (page 97)

Cornmeal-Encrusted Oysters (page 101)

Red Devils (page 43)

Filipino-Style Barbecue Pork Skewers (page 135)

Piña Colada Upside-Down Cake (page 192)

SUMMER TEQUILA-FRIENDLY PARTY

Crudo (page 89)

Seedy Guacamole (page 31)

Boozy Watermelon Slices with Tajín and Lime
(page 24)

Greek Tomato Fritters (page 41)

Ropa Vieja (page 138)

Mezcal Pudding (page 182)

RUM PARTY

Fry Jacks with Honey-Whipped Ricotta
(page 160)

Seven-Year Pork Belly (page 126)

Cuban Chickpea Fritters with Avocado Dipping
Sauce (page 42)

Vietnamese Lemongrass Skewers (page 134)

Coconut-Cardamom Cake (page 191)

CARD-TABLE PARTY

Zesty Chili Popcorn (page 14)

Fried Peanuts and Lime Leaves (page 4)

Smoky Spanish Mushrooms (page 35)

Liptauer Cheese (page 54)

Toki Chicken Nuggets (page 110)

African Ginger Cakes (page 189)

EXTRA-EASY PARTY

Citrus and Fennel Olives (page 11)

Chorizo in Cider (page 122)

Cacio e Pepe Frittata (page 72)

Apple Tansy (page 187)

AUTUMN PARTY

Deviled Cashews (page 8)

Fig & Blue Cheese Biscuit Coins (page 163)

Fergese (page 158)

Crispy Flatbread (page 170)

Eggplant Caviar (page 30)

Italian Riviera Meatballs (page 130)

Sticky Flanken Ribs (page 137)

Chocolate Manhattan Cake (page 196)

HOLIDAY SOIRÉE

Smoky Rosemary Almonds (page 6)

Potted Shrimp (page 98)

Cocktail Pâté (page 94)

Jalapeño-Corn Sablés (page 164)

The Cracker (page 167)

The Cheese Ball, Reimagined (page 52)

Garam Masala Cocktail Puffs (page 166)

Turkey Tsukune (page 117)

Almond, Date, and Fig Balls (page 183)

Ginger "Schnapps" (page 185)

Caribbean Black Cake (page 194)

Pantry Essentials
& Key Equipment

Making mixed drinks does not necessarily involve a lot of fancy equipment or ingredients. But investing in a few fundamental items will make your life a whole lot simpler—and your cocktails better. Here are a few essentials that every cocktailer should have on hand.

Pantry Essentials

Bitters

Angostura, Peychaud's, and orange bitters are required for classic cocktails. These three are the minimum; also consider adding pimiento, chocolate, and celery bitters.

Citrus

The cocktailer's pantry is similar to any well-equipped kitchen except that it should *always* sport fresh citrus. Keep lemons and limes on hand; consider adding oranges, strawberries, and grapefruits for parties. What's more, using citrus in your food as well as mixed drinks will bring new life to dishes.

Olives

Spanish Manzanilla olives were once the classic martini garnish in the US. However, Castelvetranos are increasingly becoming the go-to olive variety because of their rich texture and robust flavor. It may be time to switch if you haven't yet.

Amarena Cherries

Over the past couple decades, Amarena cherries have become standard in cocktails, such as the Manhattan. Nowadays, there are a few brands making decent cocktail cherries. Avoid ones that use red dye unless you're intentionally being campy or retro.

Soda Water

Seltzer, mineral, and soda waters are not identical. Seltzer is water that has been carbonated and mineral water is bottled from natural springs. Club soda includes additives—such as sodium and potassium—for additional flavor. It is the preferred choice for cocktails.

Sugar

Most classic cocktails are best-served, flavor-wise, by white granulated sugar. Natural or raw sugars are good for drinks that can handle extra flavor. A nice compromise is organic, unbleached sugar—which won't impart extra vanilla or molasses notes. Also keep sugar cubes on hand for Sazeracs and old-fashioneds. Other common sweeteners for cocktails are honey, molasses, and cane syrup.

Ice

Don't think of ice as an afterthought in your cocktails—it is a crucial component. Be sure to make fresh ice if it has been in the freezer with food. If you want nice squares, purchase a few silicone trays. Pick up a Lewis bag and mallet for making crushed ice.

Eggs

Eggs make for great texture in cocktails. Pro tip: to prevent shells in your cocktail, crack eggs on a hard, clean surface and not on the edge of a shaker. If you have a compromised immune system, use powdered egg whites: 2 teaspoons powder to 1 ounce water will approximate a single white.

Orange Blossom Water

Orange blossom water is required for making orgeat as well as a few classic cocktails, most famously the Ramos Gin Fizz and the Pisco Sour.

Nutmeg

Nutmeg is necessary for tropical drinks and toddies. Keep whole nutmeg on hand and grate them using a fine grater, such as a Microplane.

Sea Salt

Use kosher or fine-grain sea salt for baking and seasoning. Use a flaky sea salt for finishing and garnishing. I use Diamond Crystal kosher salt or Baleine for fine-grain salt, and I like Jacobson for finishing.

Black Pepper

Always grind whole black peppercorns.

Red Pepper Flakes

Crushed red pepper flakes (the kind you shake on pizza) are versatile and can bring a pleasant, medium heat to a dish without extra effort or sauces.

Olive Oil

Extra-virgin olive oil should be fresh and taste fruity, bitter, and bit (or a lot) peppery. To be economical, consider buying very good-quality olive oil by the liter.

Peanut Oil

With a high smoking point, peanut oil is a fantastic and flavorful oil in which to fry foods.

Bread Crumbs

Not all bread crumbs are created equal. While it can be a pain, making your own from stale bread will yield the best results.

Fresh Ginger

A little grating of fresh ginger makes cocktails—and food—come alive. It's worth keeping a knob in the vegetable drawer of the refrigerator for adding a quick hit of fresh flavor.

Makrut Lime Leaves

Lime leaves can be kept frozen, and they're worth having for Southeast Asian curries—but also for cocktails. Try steeping them in simple syrup, or using them for garnishing. Their flavor is irreplaceable and addictive.

Sambal Oelek

This Indonesian chili paste is versatile and can add a blast of flavor to any dish. Once you get hooked, you'll keep it in the refrigerator door right next to the ketchup and mustard.

Mustard

Mustard—Dijon might be the most useful for cooking—and mustard powder are both essentials.

Dark Soy Sauce

Thicker, darker, and a little sweeter than regular soy sauce, dark soy sauce is an essential ingredient in many Chinese dishes. In this book, it's employed in Bak Kut Teh (page 141) and Spaghetti Kee Mao (page 173).

Shaoxing Wine

This cooking wine is an essential ingredient for innumerable Chinese dishes. In this book, it appears in Sichuan-ish Salmon (page 105) and Singapore Steamboat (page 140).

Miso

Great for dressings and marinades, miso packs a wallop of flavor like no other—and having it on hand means you can smear it on vegetables, fish, or meat. White paste is the most versatile.

Coconut Milk

No coconut milk, no piña coladas. Keep a few cans on hand for cocktails—and coconut milk can also work as a replacement for dairy milk.

Tinned Fish

Cocktails (alcohol) loves fat and umami (that extra flavor). This means tinned fish—sardines, anchovies, mackerel—are great items to keep on hand when you want a little nosh with your martini. If you want to be a pro, keep a tube of anchovy paste in the refrigerator for adding to sauces, such as marina.

White Beans

Think of white beans as the chicken of the legume world (sorry, white beans). They have universal appeal and can make a meal in a snap. Keep a few cans on hand—along with chickpeas—for emergencies.

Key Equipment

Mortar and Pestle

I could write a whole book singing the praises of mortars and pestles, an item useful for grinding spices and making mixes into a paste. Get an inexpensive one at an Asian grocery store and fall in love with it.

Fine Grater, Such as Microplane

Use for finely grating citrus, cheese, and garlic.

Y-Peeler

Y-style peelers are by far the best peelers for citrus. They are also unbeatable for other applications, such as carrots and potatoes. I grew up with other kinds of peelers; what were we thinking?

Jigger

Measuring is a must for quality cocktails. The standard unit of measure for cocktails in the US is ounces—be suspicious of any cocktail recipe that does not use them (unless it is a large batch).

Boston Shaker

The classic three-part martini shaker is good for just that: martinis. The preferred piece of equipment for bartenders is a metal, two-part Boston shaker. They are widely available at kitchen stores and online.

Mixing Glass

Use a mixing glass for all stirred drinks, such as martinis, Manhattans, and Negronis. They used to be expensive, but are now widely available in a variety of styles.

Bar Spoon

A good bar spoon is not just for stirring drinks or measuring small amounts; be sure it has enough heft at the end to crack ice.

Strainers

There are two styles of strainers: julep and Hawthorne. Hawthorne strainers are typically used for shaken drinks, whereas julep strainers are employed for stirred drinks. If you are in doubt, use and buy a Hawthorne, which works just fine for both purposes.

Muddler

Choose a wood muddler. Avoid plastic or metal muddlers, as well as ones that are painted.

Citrus Press

A small hand juicer works for small amounts of liquid. If you are cocktailing frequently, it is worth investing in a quality juicer.

Dutch Ovens

I use my 312-quart Dutch oven almost daily for braising, frying, and making soups. I also recommend having a larger one—in the 7- to 8-quart range.

Rimmed Baking Sheets

Rimmed half sheets are the workhorses of the kitchen. Drying fruit, baking cookies, toasting nuts—it all happens on a rimmed baking sheet.

Wire Rack

Placing a wire rack in a rimmed baking sheet is the easiest way to drain fried foods. No more paper towel hassle or waste.

Candy/Deep-Fry Thermometer

Attach a deep-frying/candy thermometer to the side of your frying vessel. Please don't try to use a meat thermometer.

Slotted Spoon or Spider

Slotted spoons are the ideal utensil for frying because you can scoop out a lot of material at once. These efficient spoons are inexpensive at Asian grocery stores.

Tongs

Long tongs mean you don't get burned. They are great for flipping food while frying, but also for grilling.

Scale

If you want to bake, it is important to own a scale; measurements in pro baking recipes are by weight. But a scale is also important to a cocktailer—professional bars, and some cocktail books, also measure dry ingredients by weight because it is most accurate.

Cocktail Techniques

Stirring

Stir cocktails that are spirituous, such as martinis, Manhattans, and Negronis. This cools and blends a drink without aerating it.

Shaking

Shake cocktails that contain citrus, eggs, or dairy. Sometimes, eggs are shaken alone in the shaker first, and this is called a "dry shake" (see next technique).

Dry Shaking

Dry shaking is a way to emulsify eggs into cocktails—such as in a Ramos Gin Fizz.

Muddling

Use gentle pressure to express oils in citrus and herbs. Herbs should not be destroyed—there is nothing worse than shredded mint getting stuck in your teeth—just gently press. Overmuddling can make a drink bitter.

Rinsing a Glass

Rinse a glass by pouring in a small amount of liquid and then rolling the glass around until the interior is coated. Alternatively, some bartenders put ice in the glass and then pour the rinsing liquid over it. This both chills and rinses the glass at the same time.

Batching for a Crowd

An individual-size drink can be batched by converting ounces to cups in the recipe.

Select Bibliography

Acurio, Gastón, *Peru*, Phaidon, 2015.

Baker, Charles H. Jr., *The Gentleman's Companion*, Martino Fine Books, 2013.

Beard, James, *Hors d'Oeuvre and Canapés*, M. Barrows and Company, 1945.

Burros, Marian, and Lois Levine, *Come for Cocktails, Stay for Supper*, Macmillan, 1970.

Dagdeviren, Musa, *The Turkish Cookbook*, Phaidon, 2019.

Day, Avanelle, and Lillie Stuckey, *The Spice Cookbook*, David White Co., 1964.

Dyer, Ceil, *The Perfect Dinner Party Cookbook*, David McKay, 1974.

Embury, David, *The Fine Art of Mixing Drinks*, Doubleday & Company, 1948.

Gray, Patience, *Honey from a Weed*, Prospect Books, 1986.

Gutierrez, Sandra A., *Latin American Street Food*, UNC Press, 2013.

Harris, Jessica B., *The Africa Cookbook*, Simon & Schuster, 1998.

Henderson, Fergus, *The Whole Beast*, Ecco, 2004.

Kijac, Maria Baez, *The South American Table*, Harvard Common Press, 2003.

Meier, Frank, *The Artistry of Mixing Drinks*, Fryam Press, 1934.

Ortiz, Yvonne, *A Taste of Puerto Rico*, Plume, 1997.

Slater, Nigel, *Real Fast Food*, Overlook, 1996.

Thompson, David, *Thai Food*, Ten Speed, 2002.

Uvezian, Sonia, *The Cuisine of Armenia*, Siamanto Press, 1974.

Walton, Stuart, and Norma Miller, *Spirits & Liqueurs Cookbook*, Lorenz Books, 1997.

Wells, Patricia, *Bistro Cooking*, Workman, 1989.

Index

Note: Page references in *italics* indicate photographs.

A

Absinthe
 Monkey Gland, 143
 Sugarcane Sazerac, *147*, 150
Adonis, 16
African Ginger Cakes, 189
Airmail, 193
Aleppo Pepper Sauce, 102
Almond(s)
 Caribbean Black Cake, 194–195
 Date, and Fig Balls, *178*, 183
 Smoky Rosemary, 6
Anchovy(ies)
 Gilda (Spanish Pintxo), *86*, 88
 paste, uses for, 203
Angostura Ricotta-Stuffed Dates, 10
Antrim Cocktail, *121*, 136
Aperol
 Colibri, 60
 Sake-Lillet Spritz, *159*, 174
Apple Tansy, *179*, 187
Artichokes, Fried, with Lemon and Mint, 37
Averna
 Big Chief, 39
Avocado(s)
 Dipping Sauce, 42
 Seedy Guacamole, 31

B

Bacon–Japanese Enoki Mushroom Rolls, 36
Bak Kut Teh (Pork Rib Broth), 141
Balik Ekmek (Fish Sandwich), 81
Bar spoon, 204
Batching for a crowd, 206

Bean(s). *See also* Chickpea(s)
 White, Dip with Herbes de Provence, *23*, 32
 white, for recipes, 203
Beef
 Beef-Egg Pancakes (Goji Jeon), 70
 Cevapcici (Sausage), 133
 Cherry Kofte, 132
 Italian Riviera Meatballs, *120*, 130–131
 Negimaki, 129
 Ropa Vieja, 138–139
 Sticky Flanken Ribs, *121*, 137
Bhel Puri, Hurried (Savory Indian Snack), 19
Big Chief, 39
Bitters, 201
Black pepper, 202
Blue Corn Tortillas, 59
Bocaditos, Strawberry-Ham, *76*, 78
Boozy Watermelon Slices with Tajín and Lime, 24
Boston shaker, 204
Bourbon
 Big Chief, 39
 cheese pairings, 51
 Chocolate Manhattan Cake, 196
 David's Derby, 165
 Old-Fashioned Pralines, 186
Brandy
 Cider Cup No. 1, 188
 Coffee Cocktail, *179*, 184
 JBF, *77*, 80
 Katzenjammer, 68
 Sour, Cypriot, *47*, 56
Bread crumbs, 202
Breads
 Crispy Flatbread, 170
 Farinata with Blistered Tomatoes, *158*, 168–169

Breads (*continued*)
 Fry Jacks with Honey-Whipped Ricotta,
 158, 160
 Orange Pan con Tomate, 171
Buffalo Supplì, *147*, 152–153
Bumbo, 128

C
Cakes
 African Ginger, 189
 Caribbean Black, 194–195
 Chocolate Manhattan, 196
 Coconut-Cardamom, 191
 Piña Colada Upside-Down, 192
 Semolina, in Boozy Syrup, 190
Calas, *146*, 149
Candy/deep-fry thermometer, 205
Cardamom-Coconut Cake, 191
Caribbean Black Cake, 194–195
Cashews, Deviled, 8
Cauliflower "Wings" with Gochujang Sauce,
 23, 40
Cevapcici (Sausage), 133
Ceviche, *86*, 90
Cheese
 Angostura Ricotta–Stuffed Dates, 10
 Ball, Reimagined, *46*, 52
 Blue, & Fig Biscuit Coins, 163
 Blue Corn Quesadillas, 59
 Buffalo Supplì, *147*, 152–153
 Cacio e Pepe Frittata, *65*, 72
 Cheese-Stuffed Polenta (Shepherd's Bulz), 61
 and cocktail pairings, 51
 Edamame with Pecorino and Caraway, 27
 Everything Onigiri, *146*, 148
 Fergese (Feta Fondue), *47*, 58
 Frico Manchego, 48
 Fried Halloumi with Carob Syrup, *47*, 55
 Fry Jacks with Honey-Whipped Ricotta, *158*,
 160
 Garam Masala Cocktail Puffs, *158*, 166
 Greek Tomato Fritters, 41

 Liptauer, 54
 Queso Frito with Guava Dipping Sauce, 57
 Sky, 50
 Strawberry-Ham Bocaditos, *76*, 78
 Sweet-and-Sour Burrata, *46*, 49
Cherry(ies)
 Amarena, about, 201
 Caribbean Black Cake, 194–195
 Chocolate Manhattan Cake, 196
 Kofte, 132
 Sweet-and-Sour Burrata, *46*, 49
Chicken
 Nuggets, Toki, *108*, 110
 Salad, Georgian, *109*, 112
 Wings, Butter, 114–115
 Wings, Vietnamese, 113
Chickpea(s)
 Crunchy North African, 13
 Fritters, Cuban, with Avocado Dipping Sauce,
 42
Chiles
 Jalapeño-Corn Sablés, 164
 Smoked Jollof Rice, 154–155
 Spaghetti Kee Mao, *159*, 173
Chocolate Manhattan Cake, 196
Chorizo in Cider, 122
Cider
 Chorizo in, 122
 Cup No. 1, 188
Citrus, 201
Citrus press, 205
Cocktails
 Adonis, 16
 Airmail, 193
 Antrim Cocktail, *121*, 136
 Big Chief, 39
 Bumbo, 128
 cheese pairings, 51
 Cider Cup No. 1, 188
 Coffee Cocktail, *179*, 184
 Colibri, 60
 Cynar Spritz, 12

Cypriot Brandy Sour, *47*, 56
David's Derby, 165
food pairing guidelines, xviii–xix
Honey-Ginger Daiquiri, *2*, 5
Indian Gin Old-Fashioned, 83
JBF, *77*, 80
Katzenjammer, 68
Leche de Tigre (Milk of the Tiger), 91
Monkey Gland, 143
Planter's Punch, 116
quick food pairings, xxi
renewed interest in, xiii–xv
Sake 75, *22*, 26
Sake-Lillet Spritz, *159*, 174
Sherry Bone Luge, 124
Soju-to, *65*, 71
Sugarcane Sazerac, *147*, 150
Ti' Punch, 104
Toki Highball, *108*, 111
Vermouth and Grapefruit, 33
Vesper, *85*, 99
Ward 8, 53
Wray and Ting, 162
Zobo, 151
Cocktail Sauce, 95
Cocktail techniques, 206
Coconut
 Coconut-Cardamom Cake, 191
 Piña Colada Upside-Down Cake, 192
Coconut milk, 203
Cognac
 Antrim Cocktail, *121*, 136
 cheese pairings, 51
 Sugarcane Sazerac, *147*, 150
Colibri, 60
Cookies
 Ginger "Schnapps," 185
 Jalapeño-Corn Sablés, 164
Cornmeal
 Cornmeal-Encrusted Oysters, 101
 Festival (Jamaican Dumplings), 161
 Jalapeño-Corn Sablés, 164

Red Devils (Thai-Inflected Hush Puppies), 43
Shepherd's Bulz (Cheese-Stuffed Polenta), 61
The Cracker, 167
Croquettes, Cuban Ham, 125
Crudo, 89
Cuban Chickpea Fritters with Avocado Dipping
 Sauce, 42
Cuban Ham Croquettes, 125
Cucumber(s)
 Hurried Bhel Puri (Savory Indian Snack), 19
 Kombu, *22*, 25
 Leche de Tigre (Milk of the Tiger), 91
Curaçao
 Cider Cup No. 1, 188
 Semolina Cake in Boozy Syrup, 190
Cynar Spritz, 12
Cypriot Brandy Sour, *47*, 56

D
Daiquiri, Honey-Ginger, *2*, 5
Dark soy sauce, 203
Dashi Stock, 175
Date(s)
 Almond, and Fig Balls, *178*, 183
 Angostura Ricotta–Stuffed, 10
David's Derby, 165
Dips
 Eggplant Caviar, 30
 Fergese (Feta Fondue), *47*, 58
 White Bean, with Herbes de Provence,
 23, 32
Dry shaking cocktails, 206
Dumplings
 Jamaican (Festival), 161
 Momos, *159*, 172
Dutch ovens, 205

E
Edamame with Pecorino and Caraway, 27
Eggplant
 Caviar, 30

Eggplant (*continued*)
 Fries, Crispy, with Honey, 38
Egg(s)
 Beef-Egg Pancakes (Goji Jeon), 70
 Cacio e Pepe Frittata, *65*, 72
 Cocktail Ramen, *64*, 66
 for drinks, 202
 Katzenjammer, 68
 Kuku Sabzi (Herbed Frittata), *64*, 69
 Pickled, 67
 Wrap, Breakfast (Rolex), 73
Equipment, 204–205
Everything Onigiri, *146*, 148

F

Farinata with Blistered Tomatoes, *158*, 168–169
Fennel and Citrus Olives, *3*, 11
Fergese (Feta Fondue), *47*, 58
Festival (Jamaican Dumplings), 161
Fig
 Almond, and Date Balls, *178*, 183
 Fig & Blue Cheese Biscuit Coins, 163
Filipino-Style Barbecue Pork Skewers, 135
Fish
 Ceviche, *86*, 90
 Cocktail Pâté, 94
 Crudo, 89
 Génépy Trout Rillette, 100
 Gilda (Spanish Pintxo), *86*, 88
 Gin-Cured Gravlax, 92
 Salt Cod Fritters, 103
 Sandwich (Balik Ekmek), 81
 Sichuan-ish Salmon, 105
 Swordfish Spiedini, 93
 tinned, types of, 203
Fondue, Feta (Fergese), *47*, 58
Frittata
 Cacio e Pepe, *65*, 72
 Herbed (Kuku Sabzi), *64*, 69
Fritters
 Calas, *146*, 149

Cuban Chickpea, with Avocado Dipping Sauce, 42
Greek Tomato, 41
Red Devils (Thai-Inflected Hush Puppies), 43
Salt Cod, 103
Fruit. *See also specific fruits*
 Caribbean Black Cake, 194–195
Fry Jacks with Honey-Whipped Ricotta, *158*, 160

G

Garam Masala Cocktail Puffs, *158*, 166
Génépy Trout Rillette, 100
Georgian Chicken Salad, *109*, 112
Gilda (Spanish Pintxo), *86*, 88
Gin
 cheese pairings, 51
 Gin-Cured Gravlax, 92
 Indian, Old-Fashioned, 83
 Monkey Gland, 143
 Negroni Panna Cotta, *178*, 181
 Sake 75, *22*, 26
 Vesper, *85*, 99
Ginger
 Cakes, African, 189
 fresh, for recipes, 202
 Honey-Ginger Daiquiri, *2*, 5
 "Schnapps," 185
Glassware, rinsing and chilling, 206
Gochujang
 Sauce, Cauliflower "Wings" with, *23*, 40
 Soy- Gochujang Sauce, 70
Goji Jeon (Beef-Egg Pancakes), 70
Grapefruit
 David's Derby, 165
 and Vermouth, 33
Grater, 204
Gravlax, Gin-Cured, 92
Greek Tomato Fritters, 41
Guacamole, Seedy, 31
Guava Dipping Sauce, 57

H

Ham
 Croquettes, Cuban, 125
 Jamón Serrano Potato Chips, 15
 Strawberry-Ham Bocaditos, 76, 78
Hangover helpers, 68
Harissa
 Potato Chips, 3, 17
 Spice Blend, 17
Herbed Frittata (Kuku Sabzi), 64, 69
Herbes de Provence, White Bean Dip with,
 23, 32
Hibiscus Simple Syrup, 151
Highball, Toki, 108, 111
Honey
 Crispy Eggplant Fries with, 38
 Honey-Ginger Daiquiri, 2, 5
 Honey-Whipped Ricotta, Fry Jacks with, 158,
 160
 Katzenjammer, 68
 Syrup, 193
Hush Puppies, Thai-Inflected (Red Devils), 43

I

Ice, for drinks, 201
Indonesian Potato Salad, 34
Italian Riviera Meatballs, 120, 130–131

J

Jalapeño-Corn Sablés, 164
Jamaican Dumplings (Festival), 161
James Beard's Onion Cocktail Sandwiches, 77, 79
Japanese Enoki Mushroom–Bacon Rolls, 36
JBF, 77, 80
Jigger, 204

K

Katzenjammer, 68
Kee Mao, Spaghetti, 159, 173

Ketchup
 Cocktail Sauce, 95
 origins of, 127
 for Pork Belly, 126
Kofte, Cherry, 132
Kombu
 Cucumber, 22, 25
 Dashi Stock, 175
Kuku Sabzi (Herbed Frittata), 64, 69

L

Lamb
 Cevapcici (Sausage), 133
 Cherry Kofte, 132
Leche de Tigre (Milk of the Tiger), 91
Lemongrass Skewers, Vietnamese, 120, 134
Lemon(s)
 Citrus and Fennel Olives, 3, 11
 Cypriot Brandy Sour, 47, 56
 and Mint, Fried Artichokes with, 37
 Oleo-Saccharum Sorbet, 180
 Sake 75, 22, 26
 Soju-to, 65, 71
 Ward 8, 53
Lillet-Sake Spritz, 159, 174
Lime Leaves (Makrut)
 about, 203
 and Fried Peanuts, 2, 4
Lime(s)
 Airmail, 193
 Ceviche, 86, 90
 Colibri, 60
 Honey-Ginger Daiquiri, 2, 5
 Leche de Tigre (Milk of the Tiger), 91
 Planter's Punch, 116
 and Tajín, Boozy Watermelon Slices with, 24
 Ti' Punch, 104
Liptauer Cheese, 54
Lotus Root Chips, Salt and Vinegar, 3, 18

M

Makrut lime leaves. *See* Lime Leaves
Marrow Bones
 Pho, *120*, 123
 Sherry Bone Luge, 124
Meatballs
 Cherry Kofte, 132
 Italian Riviera, *120*, 130–131
 Turkey Tsukune, *109*, 117
Mezcal
 Colibri, 60
 Pudding, 182
Microplane, 204
Miso
 about, 203
 Miso–Malt Vinegar Shishito Peppers, *22*, 29
Mixing glass, 204
Momos, *159*, 172
Monkey Gland, 143
Monkey Gland Sauce, 142
Mortar and pestle, 204
Muddler, 205
Muddling, 206
Mushroom(s)
 Blue Corn Quesadillas, 59
 Japanese Enoki–Bacon Rolls, 36
 Singapore Steamboat, *121*, 140
 Smoky Spanish, *23*, 35
Mussels, Fried, with Aleppo Pepper Sauce, 102
Mustard, 203

N

Negimaki, Beef, 129
Negroni Panna Cotta, *178*, 181
Noodles, Soba, 175
North African Chickpeas, Crunchy, 13
Nuoc Cham, 134
Nutmeg, 202
Nuts. *See also* Almond(s); Pecans; Walnuts
 Deviled Cashews, 8
 Fried Peanuts and Lime Leaves, *2*, 4
 Persian Saffron Pistachios, *2*, 9

O

Oils, 202
Olive oil, 202
Olives, 201
 Avocado Dipping Sauce, 42
 Citrus and Fennel, *3*, 11
 Gilda (Spanish Pintxo), *86*, 88
 Ropa Vieja, 138–139
Onigiri, Everything, *146*, 148
Onion(s)
 Cocktail Sandwiches, James Beard's, *77*, 79
 Hurried Bhel Puri (Savory Indian Snack), 19
 Sky Cheese, 50
Orange blossom water, 202
Oranges
 Adonis, 16
 Big Chief, 39
 Monkey Gland, 143
 Pan con Tomate, 171
 Semolina Cake in Boozy Syrup, 190
 Ward 8, 53
Oysters, Cornmeal-Encrusted, 101

P

Pancakes, Beef-Egg (Goji Jeon), 70
Panna Cotta, Negroni, *178*, 181
Pantry essentials, 201
Party Menus
 Autumn Party, 199
 Card-Table Party, 199
 Extra-Easy Party, 199
 Holiday Soirée, 199
 Martini Party, 198
 Rum Party, 199
 Spring Party, 198
 Summer Backyard Barbecue, 198
 Summer Tequila-Friendly Party, 198
Pâté, Cocktail, 94
Peanut oil, 202
Peanuts, Fried, and Lime Leaves, *2*, 4
Pecans
 American Cocktail, 7

The Cheese Ball, Reimagined, *46*, 52
Old-Fashioned Pralines, 186
Peppers. *See also* Chiles
 Crudo, 89
 Fergese (Feta Fondue), *47*, 58
 Gilda (Spanish Pintxo), *86*, 88
 Ropa Vieja, 138–139
 Shishito, Miso–Malt Vinegar, *22*, 29
 Smoked Jollof Rice, 154–155
Persian Saffron Pistachios, *2*, 9
Pho Marrow Bones, *120*, 123
Pickled Eggs, 67
Pickled Shrimp, 97
Piña Colada Upside-Down Cake, 192
Pineapple
 Piña Colada Upside-Down Cake, 192
 Zobo, 151
Pintxo, Spanish (Gilda), *86*, 88
Piri-Piri Shrimp Cocktail, *87*, 95
Pistachios, Persian Saffron, *2*, 9
Plantain Chips, Harissa, *3*, 17
Planter's Punch, 116
Polenta, Cheese-Stuffed (Shepherd's Bulz), 61
Popcorn, Zesty Chili, 14
Pork. *See also* Bacon; Ham; Sausage
 Belly, Seven-Year, 126
 Cevapcici (Sausage), 133
 Goji Jeon (Beef-Egg Pancakes), 70
 Italian Riviera Meatballs, *120*, 130–131
 Momos, *159*, 172
 Rib Broth (Bak Kut Teh), 141
 Skewers, Filipino-Style Barbecue, 135
 Vietnamese Lemongrass Skewers, *120*, 134
Port
 Antrim Cocktail, *121*, 136
 Coffee Cocktail, *179*, 184
Potato
 Chips, Jamón Serrano, 15
 Salad, Indonesian, 34
 Slider (Vada Pav), *76*, 82
Potted Shrimp, 98
Pralines, Old-Fashioned, 186

Prosecco
 Cynar Spritz, 12
Pudding, Mezcal, 182

Q
Quesadillas, Blue Corn, 59

R
Ras el Hanout Spice Mix, 13
Red Devils (Thai-Inflected Hush Puppies), 43
Red pepper flakes, 202
Rice
 Buffalo Supplì, *147*, 152–153
 Calas, *146*, 149
 Everything Onigiri, *146*, 148
 Hurried Bhel Puri (Savory Indian Snack), 19
 Smoked Jollof, 154–155
Rillette, Génépy Trout, 100
Rimmed baking sheets, 205
Rinsing a glass, 206
Rohkostplatte (a.k.a. Quick-Pickled Vegetables),
 28
Rolex (Breakfast Egg Wrap), 73
Ropa Vieja, 138–139
Rosemary
 Almonds, Smoky, 6
 Swordfish Spiedini, 93
Rum
 Airmail, 193
 Bumbo, 128
 Caribbean Black Cake, 194–195
 cheese pairings, 51
 Honey-Ginger Daiquiri, *2*, 5
 Piña Colada Upside-Down Cake, 192
 Planter's Punch, 116
 Ti' Punch, 104
 Wray and Ting, 162
 Zobo, 151

S
Sablés, Jalapeño-Corn, 164
Saffron Pistachios, Persian, *2*, 9

Sake
 Beef Negimaki, 129
 Sake 75, *22*, 26
 Sake-Lillet Spritz, *159*, 174
Salads
 Georgian Chicken, *109*, 112
 Indonesian Potato, 34
Salmon
 Gin-Cured Gravlax, 92
 Sichuan-ish, 105
Salt Cod Fritters, 103
Sambal oelek, 203
Sandwiches
 Fish (Balik Ekmek), 81
 Onion Cocktail, James Beard's, *77*, 79
 Strawberry-Ham Bocaditos, *76*, 78
 Vada Pav (Potato Slider), *76*, 82
Sardines
 Cocktail Pâté, 94
Sauces
 Aleppo Pepper, 102
 Avocado Dipping, 42
 Cocktail, 95
 Dipping, for Soba Noodles, 175
 Gochujang, *23*, 40
 Guava Dipping, 57
 Ketchup, 126
 Monkey Gland, 142
 Nuoc Cham, 134
 Soy-Gochujang, 70
Sausage
 Cevapcici, 133
 Chorizo in Cider, 122
Sazerac, Sugarcane, *147*, 150
Scale, 205
Sea salt, 202
Seedy Guacamole, 31
Semolina Cake in Boozy Syrup, 190
Shaking cocktails, 206
Shaoxing wine, 203
Shellfish. *See also* Shrimp
 Cornmeal-Encrusted Oysters, 101

Fried Mussels with Aleppo Pepper Sauce, 102
Shepherd's Bulz (Cheese-Stuffed Polenta), 61
Sherry
 Adonis, 16
 Bone Luge, 124
Shrimp
 cocktail, origins of, 96
 Cocktail, Piri-Piri, *87*, 95
 Pickled, 97
 Potted, 98
 Spaghetti Kee Mao, *159*, 173
Sichuan-ish Salmon, 105
Singapore Steamboat, *121*, 140
Sky Cheese, 50
Slider, Potato (Vada Pav), *76*, 82
Slotted spoon or spider, 205
Soba Noodles, 175
Soda water, 201
Soju-to, *65*, 71
Sorbet, Oleo-Saccharum, 180
Soy-Gochujang Sauce, 70
Soy sauce, 203
Spaghetti
 Cacio e Pepe Frittata, *65*, 72
 Kee Mao, *159*, 173
Spanish Mushrooms, Smoky, *23*, 35
Spanish Pintxo (Gilda), *86*, 88
Spice Blends
 Harissa, 17
 Ras el Hanout Spice Mix, 13
Spiedini, Swordfish, 93
Stirring cocktails, 206
Stock, Dashi, 175
Strainers, 204
Strawberry-Ham Bocaditos, *76*, 78
Sugar, for drinks, 201
Supplì, Buffalo, *147*, 152–153
Swordfish Spiedini, 93
Syrups
 Hibiscus Simple, 151
 Honey, 193
 Honey-Ginger, 5

T

Tajín and Lime, Boozy Watermelon Slices with, 24
Tansy, Apple, *179*, 187
Tequila
 Boozy Watermelon Slices with Tajín and Lime, 24
Thai-Inflected Hush Puppies (Red Devils), 43
Thermometer, 205
Ting, Wray and, 162
Tinned fish, 203
Ti' Punch, 104
Toki Chicken Nuggets, *108*, 110
Toki Highball, *108*, 111
Tomato(es)
 Blistered, Farinata with, *158*, 168–169
 Buffalo Supplì, *147*, 152–153
 Fergese (Feta Fondue), *47*, 58
 Fritters, Greek, 41
 Hurried Bhel Puri (Savory Indian Snack), 19
 Italian Riviera Meatballs, *120*, 130–131
 Monkey Gland Sauce, 142
 Orange Pan con Tomate, 171
 Ropa Vieja, 138–139
 Smoked Jollof Rice, 154–155
Tongs, 205
Tortillas
 Blue Corn, 59
 Blue Corn Quesadillas, 59
 Rolex (Breakfast Egg Wrap), 73
Triple sec
 Boozy Watermelon Slices with Tajín and Lime, 24
Trout Rillette, Génépy, 100
Turkey Tsukune (Meatballs), *109*, 117

V

Vada Pav (Potato Slider), *76*, 82
Vegetables. *See also specific vegetables*
 Quick-Pickled (a.k.a. Rohkostplatte), 28
Vermouth
 Adonis, 16

 Chocolate Manhattan Cake, 196
 and Grapefruit, 33
 JBF, *77*, 80
 Negroni Panna Cotta, *178*, 181
Vesper, *85*, 99
Vietnamese Chicken Wings, 113
Vietnamese Lemongrass Skewers, *120*, 134
Vodka
 JBF, *77*, 80
 Vesper, *85*, 99

W

Walnuts
 Aleppo Pepper Sauce, 102
 Frico Manchego, 48
 Georgian Chicken Salad, *109*, 112
 Italian Riviera Meatballs, *120*, 130–131
Ward 8, 53
Watermelon Slices, Boozy, with Tajín and Lime, 24
Whiskey
 cheese pairings, 51
 Toki Highball, *108*, 111
 Ward 8, 53
Wine
 Airmail, 193
 Cynar Spritz, 12
 sparkling, and cheese pairings, 51
Wire rack, 205
Wrap, Breakfast Egg (Rolex), 73
Wray and Ting, 162

Y

Y-peeler, 204

Z

Zobo, 151

Acknowledgments

The recipes for this book were collected, created, and reworked over many years and I may not accurately recall all of the people who generously invited me into their kitchen, showed me tricks, or helped me discover the foods of their native region. I will do a blanket thank-you to all such cooking partners; I owe you a drink and more.

Further, many of the dishes in this book were tested at my home on willing (okay, sometimes unsuspecting) guests. Thank you all for the feedback.

Additionally, I would like to thank a few of the "crew" who have been so generous with their time and friendship over the years: Brian Haltinner, Wade Harrison, Michele Tjader, Jason Denham, Laura Denham, Ken Backus, Michael Reynolds, Sara Kruger, Jennifer Holmes, Joe Sanborn, Jeff Jahnke, Jacqui Jahnke, Dan Fox, Evan Dannells, Neil Stalboerger, Judy James, Charlie Becker, Daniel Bonanno, Vanessa Shipley, Chad Vogel, Erin Leary, Andrea Hilsey, Matthew Stebbins, Jessica Stebbins, Tristan Gallagher, Kay Campitelli, Joe Davis, Connie Davis, and Elizabeth Davis. I would especially like to thank Shannon Berry, the chef at my restaurant, with whom I had such a successful collaboration.

A huge thanks is owed to my editor, Cindy Sipala, for supporting my work with such unwavering enthusiasm over the years. This is our sixth book together and it has been a simply remarkable and life-changing journey. I am also indebted to my agent, Clare Pelino, who has been a source of encouragement and sage advice.

This book would not be what it is if not for Deana Coddaire, who edited an initial draft with great speed, patience, and aplomb. Her sharp eyes and astute observations were invaluable to me. A big thanks also to ace reader Elizabeth Rubin for her excellent fixes and suggestions.

Hats off to senior production editor Cisca Schreefel and copyeditor Iris Bass. Their hard work is deeply appreciated.

I am so grateful to work with designer Josh McDonnell again—our fifth book together. A giant thanks to photographer Neal Santos and stylist Kelsi Windmiller for helping bring this book to life so vividly, plus a shout-out to digital technician Ed Newton and styling assistant Kit Ramsey.

Thanks also to my wonderful publicist Ron Longe for his efforts on behalf of my books. A thanks is also due to former publicist, and now friend, Oleg Lyubner, who continues to offer helpful advice on my projects. Plus, a big thank-you to Running Press publicist Seta Zink and marketing wizard Amy Cianfrone.

A big debt of gratitude is owed to the staff at Isthmus, especially my former editor Linda Falkenstein, who took a chance on me many years ago and whose encouragement put me on the path to this book. Likewise, a huge thank-you is owed to my family—who are all enthusiastic cooks and entertainers—my sister, Tenaya, and parents, Sonja and Mahlon.

However, the biggest thanks of all is reserved for my partner, Janine Hawley, who acted as recipe tester, baker, and coach—and who sometimes had more faith in this giant undertaking than I did.

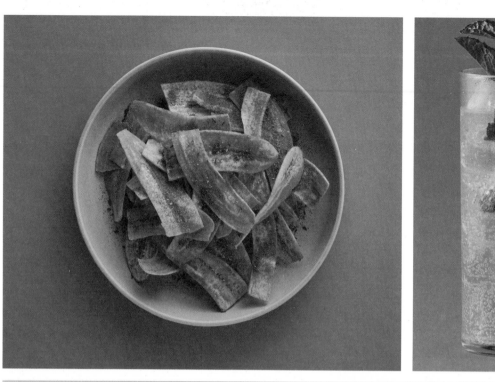

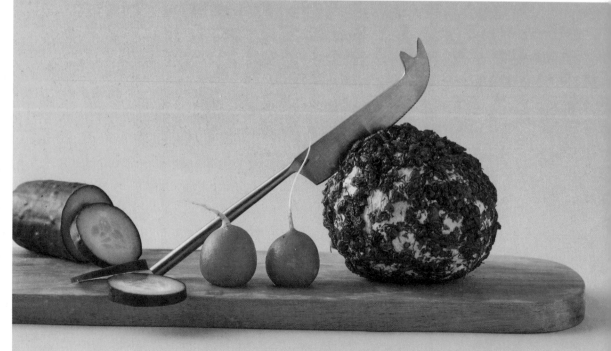